11/98

29.95

11/98

Publisher's Acknowledgements
We would like to thank the following publishers for their kind permission to reprint texts: *Journal of Contemporary Art*, New York; **Kunsthalle Zürich**; *Real Life Magazine*, New York; **John Berger**, Qunicy, France; and the following for lending reproductions: **Bonnefanten Museum**, Maastricht; **British Film Institute**, London; **The Contemporary**, Baltimore; **Jeffrey Deitch Projects**, New York; **Stephan Dillemuth**, Cologne; **Ronald Feldman Fine Arts Inc.**, New York; **Marian Goodman Gallery**, New York; **Jay Gorney Modern Art**, New York; **Hans Haacke**, New York; **Pat Hearn Gallery**, New York; **Laboratoire d'anatomique comparée**, Paris; **Thomas Lawson**, Los Angeles; **Metropolitan Museum of Art**, New York; **Musée national d'histoire naturelle**, Paris; **Museo del Prado**, Madrid; **Phillips Collection**, Washington D.C.; **Pitt Rivers Museum**, Oxford; **Christy Rupp**, New York; **Sonnabend Gallery**, New York; **Caroline Tisdall**, London; **University of Illinois Gallery**, Chicago; **Elke Walford Fotowerkstatt, Hamburger Kunsthalle**, Hamburg; and **Estate of Robert Smithson, John Weber Gallery**, New York. Special thanks to **Erika Moravec**, New York, and **Jackie McAllister**, New York, for researching and compiling the chronology, and to **American Fine Arts, Co.**, New York; **Galleria Emi Fontana**, Milan; **London Projects**, London; **Galerie Metropol**, Vienna; and **Galerie Christian Nagel**, Cologne. Thank you to Paul Barratt at London Projects and to Daniel McDonald at American Fine Arts, Co., New York, for their assistance, and to **Bob Braine**, New York; **J. Morgan Puett**, New York; **Alexis Rockman**, New York; and **William Schefferine**, New York. Photographers: **André Bonheur; Bob Braine; Angela Cumberbirch; Kristien Daem; Vicente De Mello; Stephan Dillemuth; Mark Dion; Karen Grady; Maria Gilissen; Jeff Goldman; Mario Gorni; Hans Haacke; Georg Kargl; Gerhard Koller; Eliane Laubscher; Thomas Lawson; Paul Mellaert; Ernst Moritz; Mark Pokempner; Nathan Rabin; Walter Russell; Ken Schles; Fred Scruton; Andrea Stappert; Caroline Tisdall; Paul Towell; Alexander Troehler; Craig Wadlin;** and **Nic Walster**

Artist's Acknowledgements
I'd like to express my highest appreciation for the dynamic and sheerly brilliant women of Phaidon: Gilda Williams, Iwona Blazwick and Clare Stent, and many thanks to designer Stuart Smith. The authors should be thanked for their generous and accomplished works. For sheer tenacity and rigour Lisa Corrin deserves a special thanks. Erika Moravec and Jackie McAllister performed wizardry by turning a mountain of debris into a complete and thorough chronology.

Without the support and friendship of the following very little of the work featured between these covers would have appeared: Gregg Bordowitz, Moyra Davey, Thomas Lawson, Bob Braine, Simin Farkhondeh, Fareed Amarly, Miwon Kwon, Art Orienté Objet, Alexis Rockman, Jackie McAllister, Jason Simon, Helen Molesworth, Stephan Dillemuth, Christian-Philipp Muller, William Schefferine, Ashley Bickerton, Karola Grässlin, Renée Green, Michel Ritter, John Leslie, James Meyer. I would like to also thank my gallerists Colin De Land of the American Fine Arts, Co., Christian Nagel, Marc Jancou of London Projects, Emi Fontana, Christian Meyer, Renute Kaines and Georg Karger of Gallery Metropol, Fabiènne Leclerc and Christophe Durand-Ruel of Galerie Des Archives and Tanya Rumpff. Finally, I wish to express my unmitigated love and appreciation for my partner J. Morgan Puett.

Phaidon Press Limited
Regent's Wharf
All Saints Street
London N1 9PA

First published 1997
© Phaidon Press Limited 1997
All works of Mark Dion are © Mark Dion.

ISBN 0 7148 3659 1

A CIP catalogue record of this book is available from the British Library.

cover, **Concrete Jungle (The Birds)**
1992
Taxidermic birds, cardboard boxes, tyres, toy truck, wash basin, motor oil cannister, chair cushion, rolled carpet, linoleum flooring, wooden crates, aluminium cans, newspaper, plastic bags, containers, cups, bottles, other assorted rubbish
150 × 420 × 130 cm

backcover, **Les Necrophores – L'Enterrement, from 'Hommage à Jean-Henri Fabre'** (detail)
1997
Synthetic mole, rope, synthetic necrophore beetles, jute rope, eye hooks, books
250 × 125 × 140 cm

page 4, **Les Necrophores – L'Enterrement, from 'Hommage à Jean-Henri Fabre'**
1997
Synthetic mole, rope, synthetic necrophore beetles, jute rope, eye hooks, books
250 × 125 × 140 cm

page 6, A cold February on the Island of Rügen while collecting for **A Tale of Two Seas: An Account of Stephan Dillemuth's and Mark Dion's Journey Along the Shore of the North Sea and Baltic Sea, and What They Found There**
1996

page 36, **The Department of Marine Animal Identification of the City of New York (Chinatown Division)** (detail)
1992
Marine animals collected in New York, Chinatown

page 88, **Project for the Antwerp Zoo**
1993
Majolica tiles
15 × 15 cm each

page 98, **The Great Hunter at Home**
1993
Hat stand, safari jacket and hat, rifle
190 × ø60 cm

page 144, Mark Dion prepares for the exhibit at the Cockscomb Basin Wildlife Sanctuary Visitor Center, 1992

Lisa Graziose Corrin Miwon Kwon Norman Bryson

Mark
Dion

Φ

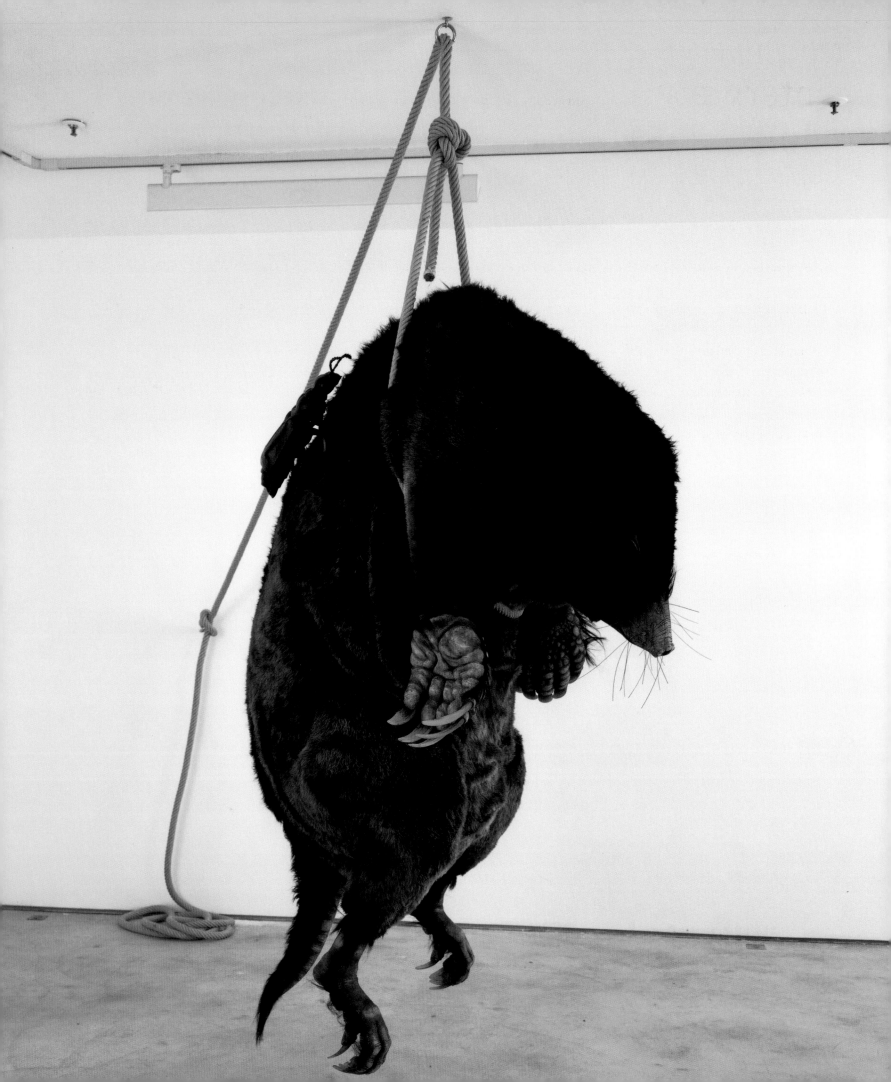

Contents

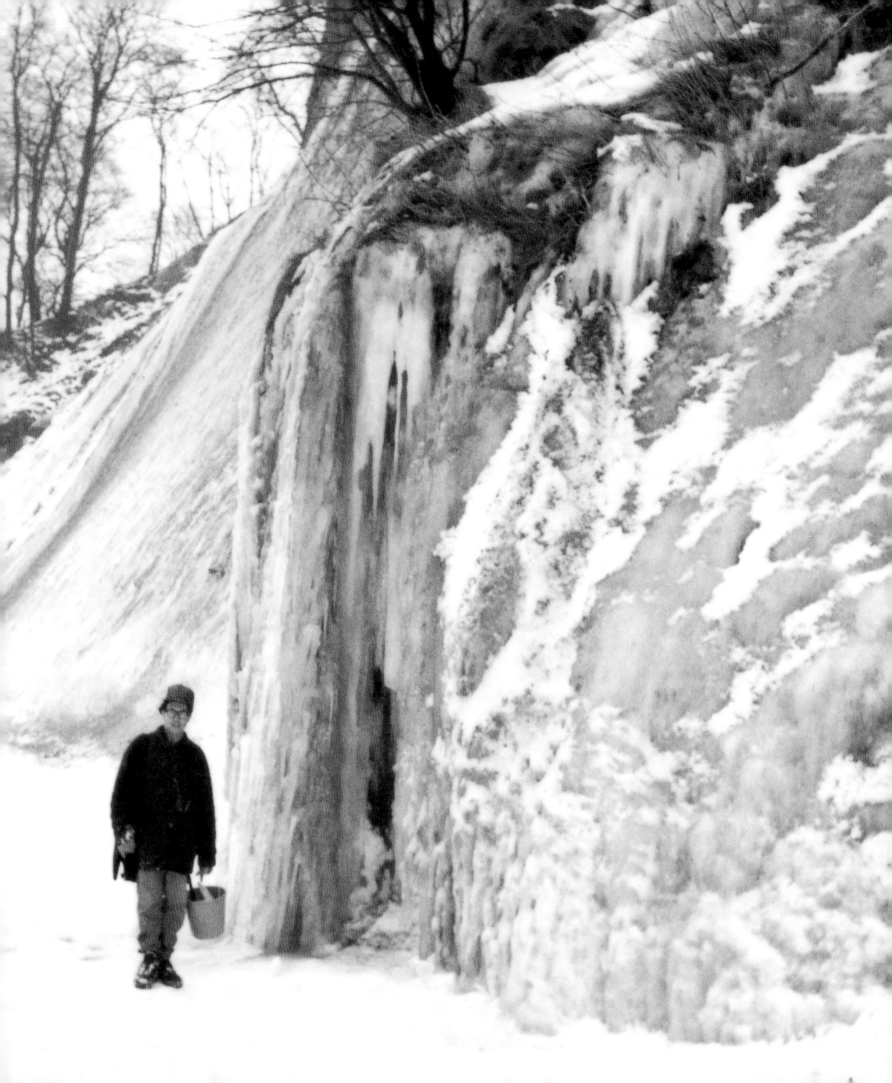

Contents

Miwon Kwon Was your move to New York in 1982 a beginning point of sorts?

Mark Dion **This might sound kind of formulaic, but I'd say there were three major stages to my not so sentimental education. The first was attending the Art School of the University of Hartford, which was a giant leap for me considering my working-class background. My folks were intelligent and supportive, but coming from a small coastal town across the river from the industrial seaport of New Bedford, Massachusetts, I grew up with almost no access to fine art. I was eighteen before I saw my first art exhibition – Chardin – in Boston. After two minutes at the Hartford Art School, I realized how ignorant I was about art. So in addition to my classes, I got a job as an assistant in the slide library and asked a lot of questions.**

The next stage was moving to New York and attending the School of the Visual Arts and then the Whitney Independent Study Program. There I met many of my best friends and extremely generous teachers like Tom Lawson, Craig Owens, Martha Rosler, Joseph Kosuth, Barbara Kruger and Benjamin Buchloh. They were amazingly smart, tough and fiercely protective of us when we needed it. The third stage took the form of my travels in the forests of Central America. That led to my renewed interest in the biological sciences, which I studied at home and at the City College of New York.

Kwon It's one thing to see the art world as a fascinating place of new ideas and another to believe that you have something meaningful to say in that world or engage it in a productive dialogue. When did that shift occur?

Dion **By the time I got out of the Whitney Program in 1985, I sort of knew how to be an artist, because I had been provided with dozens of different models of what artists do and how they do it. But I hadn't figured out where or how I was going to apply the conceptual tools I had acquired. That came much later when I returned to what I was initially interested in long before school: environmentalism, ecology and ideas about nature. In the slick world of Conceptual and media-based art of the early 1980s, no one seemed interested in problems of nature. So it took me some time to get back to it as a viable area for critical and artistic investigation. I had a lot of unlearning to do also.**

Jean-Luc Godard
Letter to Jane
1972
52 mins., colour and black and white
Filmstill

Jean-Pierre Gorin
Tout va bien
1972
95 mins., colour
Filmstill

Kwon Can you talk a bit about your early institutional critique projects coming out of the School of Visual Arts and the Independent Study Program?

Laura Mulvey and Peter Wollen
Riddles of the Sphinx
1977
95 mins., colour
Filmstill

Dion **During my studies, Gregg Bordowitz and I were very close, and we hashed out a lot of ideas together, especially those concerning art and its possibilities. At the time, we were excited by the debates around documentary – the problematics of telling the 'truth'. We were focused on film: the work of Jean-Luc Godard and Jean-Pierre Gorin in particular, as well as Peter Wollen, Laura Mulvey and Chris Marker, and the photography of Allan Sekula, Martha Rosler and others. These people had an enormous influence on us as we tried to imagine an expanded documentary practice. While the belief in truth as unmediated authenticity had waned, there still remained the task of describing the world. Some of my early projects like *This Is a Job for FEMA, or Superman at Fifty* (1988), *I'd Like to Give the World a Coke* (1986), and *Toys 'R' U.S.* (1986) were attempts to translate critical strategies from the field of documentary film and photography to an installational or sculptural field.**

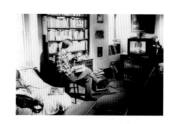

Chris Marker
Sans Soleil
1982
100 mins., colour
Filmstill

This Is a Job for FEMA, or Superman at Fifty, from 'The Pop Project Part IV'
1988
Superman posters and comics, desk, typewriter, telephone, shoes, hat, briefcase, newspapers, nameplate, portable radio, books, bookends, in-tray, paper, plastic wastepaper bin, peanut butter, dark blue suit, coffee mugs
Dimensions variable
Installation, The Clocktower, New York

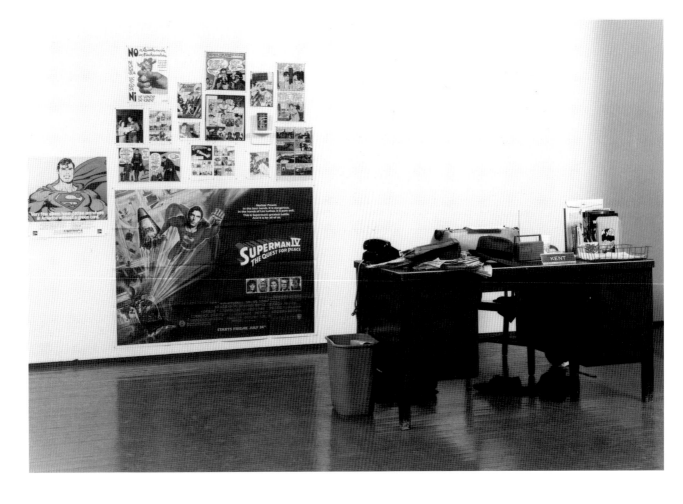

Martha Rosler
The Bowery in Two Inadequate Descriptive Systems
1974-75
45 black and white photographs 20 × 25 cm each, mounted on 24 black matte panels; 130 × 381 cm overall

Allan Sekula
From 'Aerospace Folktales'
1973
Black and white photographs with three separate unsynchronized voice recordings

Kwon How did such concerns lead to what you're known for now, which is art that deals with cultural representations of nature?

Dion It came about as a result of living a dual life. In my 'work' time, I was doing gruelling research to develop various installations like *Relevant Foreign Policy Spectrum (From Farthest Right to Center Right)* (1987) and others. In my 'off' time, I continued to pursue my interest in nature, adding to my personal collections of insects and curiosities, taking trips to the tropics, beaches, salt marshes in Long Island or natural history museums. It wasn't until I began reading a lot of nature writing and scientific journalism that I stumbled onto Stephen Jay Gould, who opened up a huge window for me. Here was someone applying the same critical criterion implicit in the art I aspired to make – which can loosely be described as Foucaultian – to problems in the reception of evolutionary biology. It became very clear to me that nature is one of the most sophisticated arenas for the production of ideology. Once I realized that, the wall between my two worlds dissolved.

Kwon So what projects followed that revelatory moment?

Dion The first works were the *Extinction* series, *Black Rhino, with Head* (1989) and *Concentration* (1989), which explored the problems of environmental disruption in relation to colonial history. It was in these works that I first made use of the shipping crate as a way of addressing the international traffic of material and ideologies and myself. These works were made for shows in Belgium, which has a particularly pernicious relation to Africa as

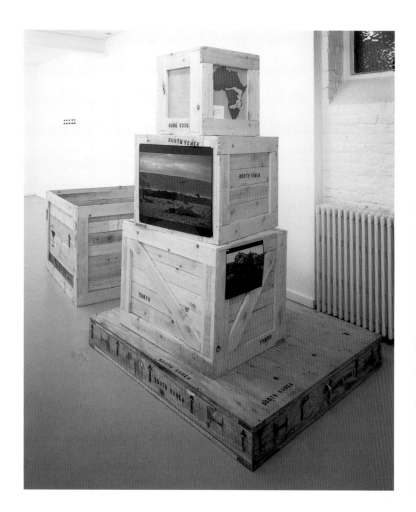

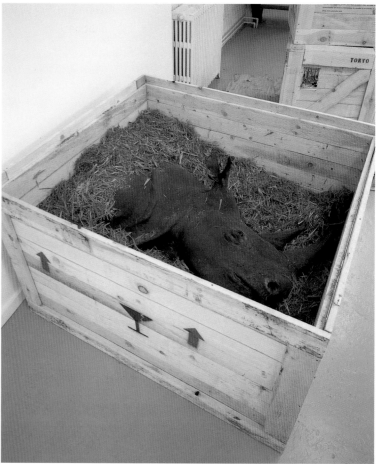

well as a disregard for issues of animal importation and endangered species protection. In both works I was looking at a complex system, trying to examine how the current loss of biological diversity through extinction could be seen as a protracted effect of colonialism, the Cold War, and 'Band-Aid' development schemes. Collaborations with Bill Schefferine, like *Under the Verdant Carpet*, also pointed to the impossibility of untangling any single strand from a web of relations; here we literally compacted ideas on top of each other in a way that mirrored that entanglement.

During my travels in the Central American tropics, I became very concerned with the natural and cultural problems around tropical ecology. On my first visit to a tropical rainforest, I was overwhelmed by its complexity and beauty. The alienness of the jungle, its awesome vitality – I was so impressed. I remember taking a shit during a hike in the bush and having titanic dung beetles and a dozen different flying insects descending down on it before I could get my pants up. What a place!

Anyway, even though they make up only 6-7% of the earth's land mass, tropical rainforests contain well over half of all living species. They are amazing laboratories of evolution, the greenhouses of biological diversity. At the same time, they are enormously affected by postcolonial politics, global economics, sovereignty issues and northern fantasies of paradise and green-hell. In the 1980s, tropical forest debates were like a microcosm of the deepening divide between countries of the northern and southern hemispheres. They were also a map of our assumptions, desires and projections about what constitutes nature.

Kwon What did you think an artist or an artwork could do in the face of such
conditions?

Dion **What a question! Well, one of the fundamental problems is that even if
scientists are good at what they do, they're not necessarily adept in the field
of representation. They don't have access to the rich set of tools, like irony,
allegory and humour, which are the meat and potatoes of art and literature.
So this became an area of exploration for Schefferine and me. Also, the
ecological movement has huge blindspots in that it is extremely uncritical of
its own discourse. At the time, it was evoking images of Eden and innocence,
calling for a back-to-nature ethos. So part of what we did was critique these
ideologically suspect, culturally entrenched ideas about nature.**

**The parade Schefferine and I made for American Fine Arts, Co., in New
York called the *Wheelbarrows of Progress*, was largely a response to the
shockingly bone-headed ways of thinking which we witnessed around 'green'
issues. Each wheelbarrow carried a weighty folly – from the Republican
dismantlement of the renewable energy program, to wildlife conservation
groups pandering to the public with pandas.**

***Tropical Rainforest Preserves* (1990) is a good example of a response to
a double phenomena. On the one hand, zoos in North America were creating
rainforests inside cities as special exhibits. On the other hand, ecological
groups were trying to export notions of a national park – locking up natural
resources in order to protect them. Our piece was meant to reflect on such
conditions in a humorous way by making an absurdly small reserve that was
'captured' and mobile, comically domesticated and reminiscent of the
Victorian mania for ferns, aquariums and dioramas.**

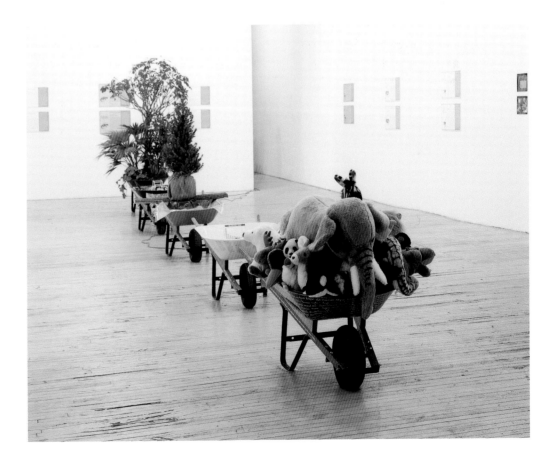

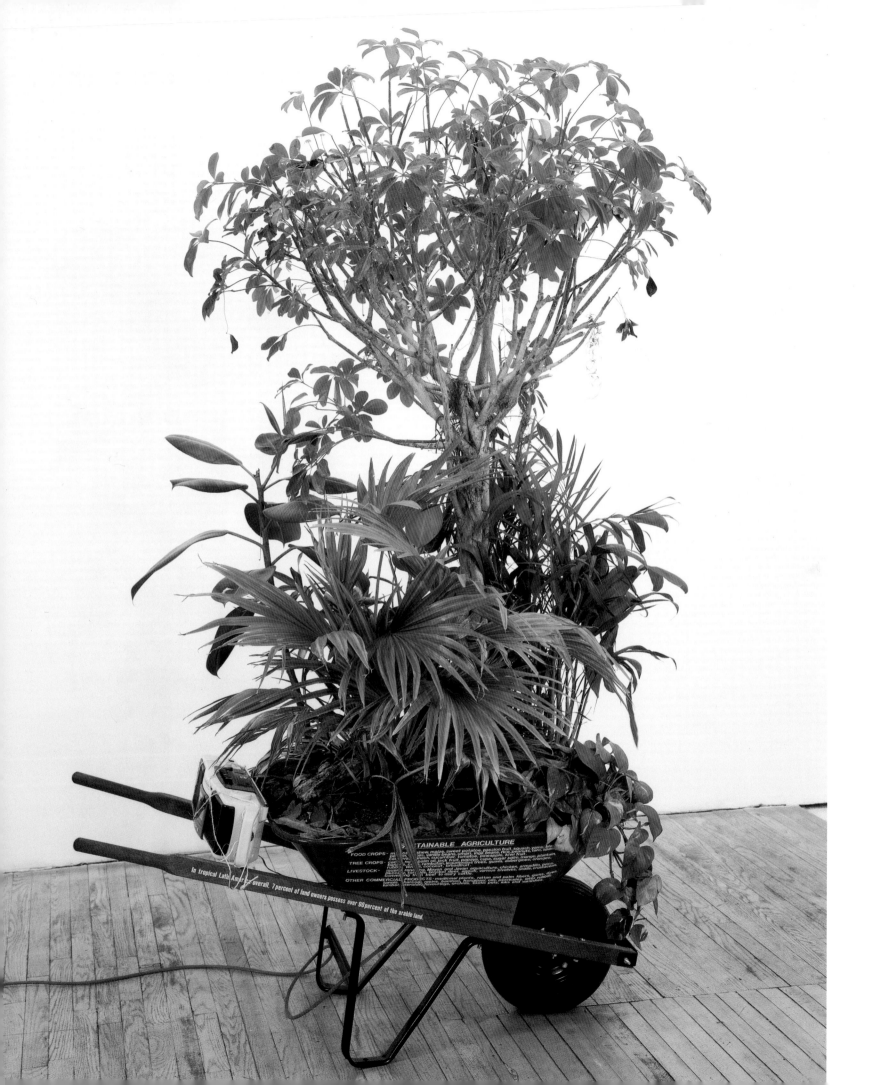

SUSTAINABLE AGRICULTURE

FOOD CROPS- manioc, cashew, maize, sweet potatoes, passion fruit, squash, yams, black pepper, chillies, green beans, various beans, rice, peanuts, taro, squash, cacao, vanilla, peach, cucumber, tomatoes, pineapple, sugar palm, mango, plantain, palm oil, jack fruit, papaya, cupé, sugar, aubergine, oranges.

TREE CROPS- rubber, rambutan, leguminous trees, guava, sugar palm, mango, plantain, coconut, breadfruit.

LIVESTOCK- jaguar, tapir, Mayan and deer agriculture, chicken, armadillo, pacca, peccary, iguana, various deer, agouti, various bivalves, snails, crustaceans, converting forest to cattle.

OTHER COMMERCIAL PRODUCTS- medicinal plants, rattan and palm fibres, game, game lands, resins, bamboo, flangipani, oils, pesticides, latex, rubber, lumber, aerosols, flavourings, orchids, exotic pets, silks and varnishes.

In tropical Latin America overall, 7 percent of land owners possess over 90 percent of the arable land.

**Tropical Rainforest Preserves
(Mobile Version), from
'Wheelbarrows of Progress', with**
William Schefferine
1990
Tropical vegetation, soil, stones,
presstype on red enamel
wheelbarrow
wheelbarrow, 63.5 × 68.5 × 141 cm

**Survival of the Cutest
(Who Gets on the Ark?), from
'Wheelbarrows of Progress', with**
William Schefferine
1990
Toy stuffed animals, white enamel
on red steel, wood and rubber
wheelbarrow
wheelbarrow, 63.5 × 68.5 × 141 cm

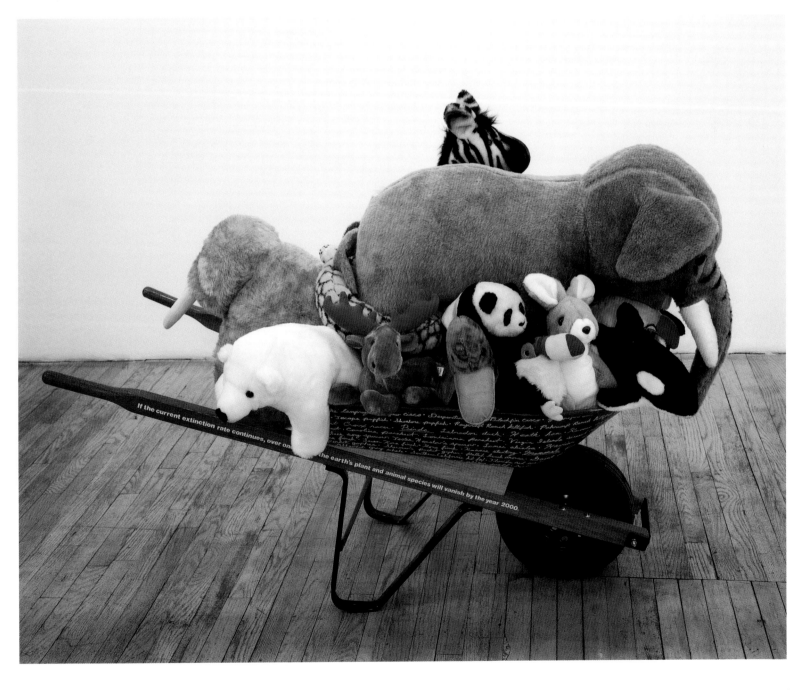

right, **Acid Precipitation, from 'Wheelbarrows of Progress',** with William Schefferine
1990
Bullhead catfish, Adirondack map, Alberta tree, water, water filter, silicon blue enamel wheelbarrow
wheelbarrow, 63.5 × 68.5 × 141 cm

opposite, top, **The Big Payback, from 'Wheelbarrows of Progress',** with William Schefferine
1990
Toy truck, torch, saw, funnel, tools, printed matter, nails, rubber tubing, vice, clamp, spraypaint can, cap, bumperstickers, presstype and ink on black enamel wheelbarrow
wheelbarrow, 63.5 × 68.5 × 141 cm

opposite, bottom, **Iron Fist for Soft Energy, from 'Wheelbarrows of Progress',** with William Schefferine
1990
Solar chips, books, printed matter, feathers, bones, oil, tar, presstype and ink on white enamel wheelbarrow
wheelbarrow, 63.5 × 68.5 × 141 cm

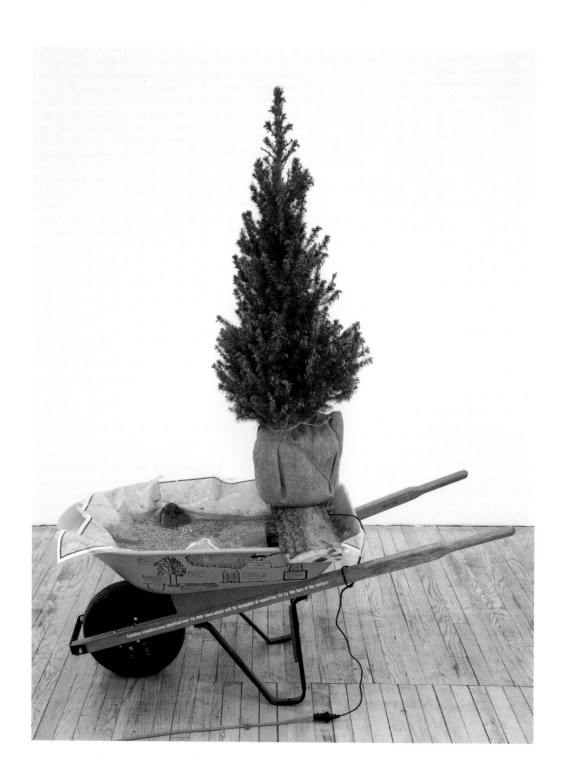

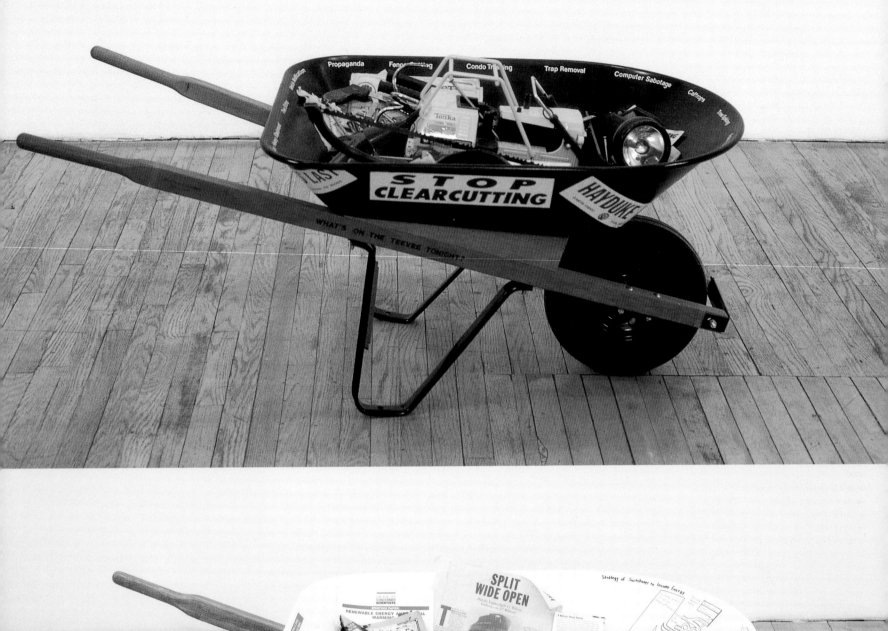

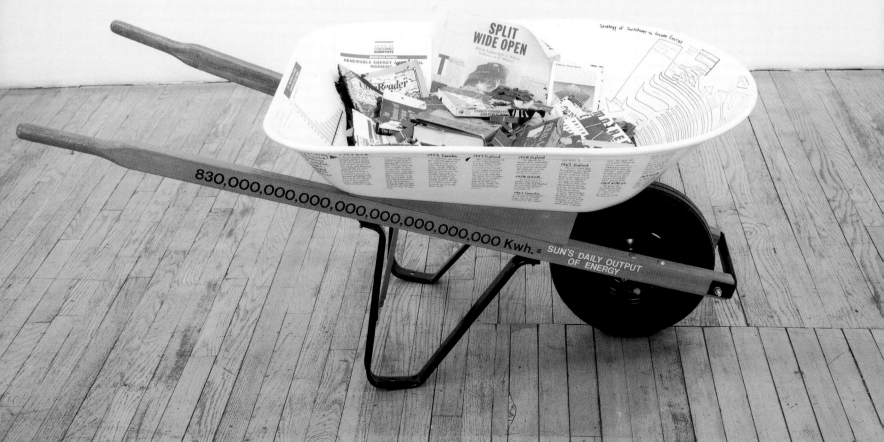

**Selections from the Endangered
Species List (the Vertebrata), or
Commander McBrag Taxonomist**,
with William Schefferine
1989
Desktop, typewriter, plaster
dinosaur, index cards, books,
potted cactus, candlestick, candle,
ceramic bowl, plastic animal
figurines, spoon, butterfly net,
wooden collector's case, canvas
bag, framed picture, drawings,
pen, shell, cork, animal head, tape
player, nautilus shell, glass vials,
dissection kit
Dimensions variable

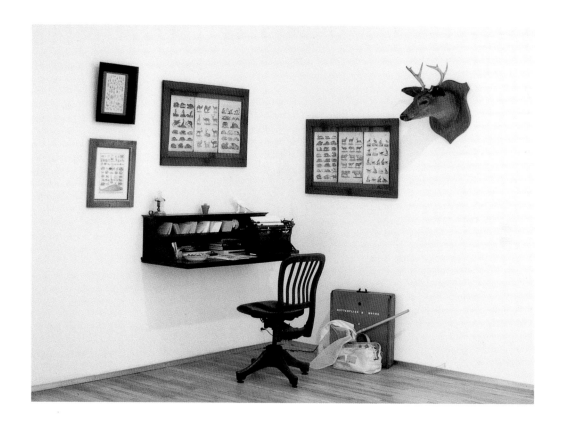

Kwon What is your assessment of such projects in hindsight? To me, they
seemed very didactic.

Dion I think our projects were more complex than they may have seemed at
first glance, less didactic than they appeared. They never spoke monolithically,
and often had counter-arguments built into them. For instance, *Selections
from the Endangered Species List (the Vertebrata) or Commander McBrag
Taxonomist* (1989) tried to visualize two different processes that have a
dialectical relationship to one another – the task of naming animals as one
'discovers' them (as in Linnaeus), and naming animals as they die off and
disappear (as in the endangered species list). It's like Noah hunting down all
the animals he saved on the ark. We wanted our work to convey the reality of
contradictions like that. Moreover, all the works contained massive amounts
of detail and layering. Perhaps they were didactic, but at least they weren't
boring. Humour was an important factor to the success of these works.

Kwon In the early 1990s, the New York art world classified your practice under
the banner of 'green' art. But it seems you've moved away from overt references
to eco-politics in favour of studies of cultural institutions, specifically the
natural history museum, as well as particular modes of display, such as curiosity
cabinets.

Dion I think the politics of representation as it involves the museum has
always been part of my practice. As I see it, artists doing institutional
critiques of museums tend to fall into two different camps. There are those
who see the museum as an irredeemable reservoir of class ideology – the
very notion of the museum is corrupt to them. Then there are those who are
critical of the museum not because they want to blow it up but because they
want to make it a more interesting and effective cultural institution.

Kwon You'd be in the latter category, of course, since you're an avid collector yourself.

Dion Yeah, I love museums. I think the design of museum exhibitions is an art form in and of itself, on par with novels, paintings, sculptures and films. This doesn't mean that I don't acknowledge the ideological aspect of the museum as a site of ruling-class values pretending to be public. Nevertheless, as an institution dedicated to making things, ideas and experiences available to people not based on ownership, I don't think museums are inherently bad, anymore than books or films are bad. It is also clear that people enter the museum with their own agendas. Museum visitors are not mindless subjects of ideology. I think many of them have a healthy skepticism of institutional narratives.

Kwon In 1990 when you interviewed Michel von Praet, one of the people responsible for the reorganization of the Musée d'Histoire Naturelle in Paris, you commented: 'I'm interested in the tension between the museum's position as an educational forum and an entertainment form'. Can you describe how you explore that tension in your work?

Selections from the Endangered
Species List (the Vertebrata), or
Commander McBrag Taxonomist,
with William Schefferine
(details)
1989

Dion As sites of learning and knowledge, museums have traditionally been places of extraordinary seriousness that shut out popular culture. But now there are very concrete pressures for museums to appeal to popular taste because of dire funding situations. For example, museums in England and United States, which once had the benefit of state money, got their funding cut during the Thatcher and Reagan years to the point where they had to cannibalize themselves in order to pull in the admission-paying masses. In many countries, museums are trying to find new ways to remain economically viable as businesses. The explosion of gift shops, restaurants, entertainment programs and public outreach projects are testimony to the museum's redirection towards becoming more popular.

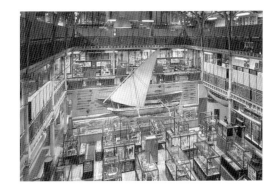

Pitt Rivers Museum, Oxford
View of the interior showing the
outrigger canoe from Zanzibar

Musée d'Histoire Naturelle, Paris
View of the Gallery of Comparative
Anatomy

But a disturbing thing about these shifts is that as the museum has become more 'educational' as part of its popularization efforts, it's also become dumber. The museum seems to conceive of its audience as younger and more childlike now. Rather than a place where one might go to explore some complex questions, the museum now simplifies the questions and gives you reductive answers for them. It does all the work, so the viewer is always passive. A museum should provoke questions, not spoon-feed answers and experiences. Unfortunately, though, that seems to me what museums have become.

When it comes to museums, I'm an ultra-conservative. To me the museum embodies the 'official story' of a particular way of thinking at a particular time for a particular group of people. It is a time capsule. So I think once a museum is opened, it should remain unchanged as a window into the obsessions and prejudices of a period, like the Pitt Rivers in Oxford, the Museum of Comparative Anatomy in Paris and the Teyler Museum in Haarlem. If someone wants to update the museum, they should build a new one. An entire city of museums would be nice, each stuck in its own time.

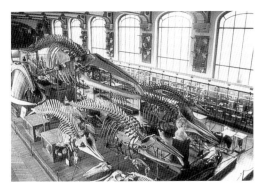

But to get back to your question, I'm excited by the tension between entertainment and education in the idea of the marvellous, especially in pre-Enlightenment collections like curiosity cabinets and *wunderkammers*.

Along with visual games, logic tricks and optical recreations, these collections attempted to rationalize the irrational. They were neither dry didactics nor mindless spectacles. They tested reason the way storerooms, flea markets and dusty old museums challenge cultural categories and generate questions today. This must sound light years away from when we spoke of documentary earlier, but somehow it's related. If an exhibition is a challenge, it is both educational and entertaining.

Kwon How do you provoke a sense of the marvellous or generate curiosity in our day and age?

Dion One thing is to tell the truth, which is by far more astounding than any fiction. (I cringe as the word 'truth' passes my lips, but I always mean it with a lower case 't'.) For example, one of the biggest problems I have with the environmental movement *and* the museum is that they intentionally mislead people for the benefit of their own pocketbooks, which is unforgivable considering they are organizations devoted to the production of knowledge.

The problem of charismatic megafauna, for instance, which Bill Schefferine and I tried to deal with in *The Survival of the Cutest* (1990) is a case in point. Generally, in order to raise money for the protection of endangered ecosystems, conservation organizations draw isolated attention to extremely attractive and photogenic animals – tigers, whales, pandas. These are not keystone species so the system won't collapse if they are taken out. Of course, all members of an ecosystem are important, but these animals are often the least critical ones, usually peripheral animals at the top of the food chain. They're not like the beaver or corals which produce systems that support other animals. Now, foregrounding charismatic animals is not so bad if you acknowledge at some point their relationship to other forms of life in the ecosystem. If the conservation effort could highlight the fact that by protecting the jaguar, we can also preserve vast areas of habitat that benefits everything in it, including us, then the focus on the 'cutest' would not be so problematic. But that's not what the conservation groups do. They haven't taken the opportunity to reveal the *real* goals. To me, that shows how much they are working against themselves.

Kwon Which parallels the art museum culture in so far as it continues to highlight the 'charismatic' masters to draw people to the museum, to 'save' the institution, perhaps.

Dion Right. In the case of natural history museums, what you see on display, which represents only 1-10% of the entire collection, is usually remedial pandering equivalent to material in school science textbooks. But there are hundreds of people in the back rooms working with specimens and artefacts, hidden from public view. That's where the museum is really alive and interesting. They directly address questions like: what is the function of a collection? Why is it important to name things in the natural world? The museum needs to be turned inside out – the back rooms put on exhibition and the displays put into storage.

Art museums also act like butterfly collectors, always repressing context and process. We would understand Manet better, for example, if his paintings were exhibited alongside works from the academy he was reacting against,

Marcel Broodthaers
Decor (A Conquest by Marcel Broodthaers) XXth Century
1975
Picnic table, chairs, umbrella, rifles, shelves, light, assorted objects
Dimensions variable
Installation, Institute of Contemporary Arts, London

Joseph Cornell
Eclipse Series
c. 1960
Wood, metal, glass, ball, starfish, nails, paper, mixed media construction
23 × 36 × 11 cm

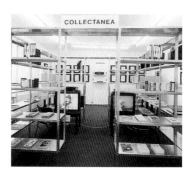

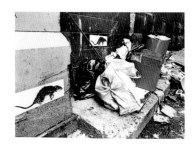

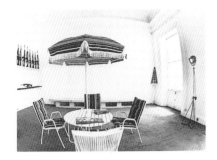

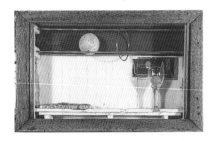

Christian-Philipp Müller
Green Border
1993
Installation, Austrian Pavilion,
Venice Biennale

Stephan Dillemuth
Untitled
1994
Installation, Christian Nagel,
Cologne

Renée Green
Import/Export Funk Office
1992
Installation, Christian Nagel,
Cologne

Christy Rupp
Rat Posters
1979
Project for Lower Manhattan

rather than impressionist paintings from thirty years later. So I say freeze the museum's front rooms as a time capsule and open up the laboratories and storerooms to reveal art and science as the dynamic processes that they are.

Kwon My impression is that you're drawn more to natural history museums than art museums. Why is that?

Dion Natural history museums ask bigger questions about life and history. That's why I'm interested in artists who have expanded the definition of art and enriched the field by looking outside of it. Marcel Broodthaers, Robert Smithson, Joseph Beuys, Joseph Cornell, Gordon Matta-Clark … the dead guys. That's my pantheon. Smithson is of particular interest because he forged a convergence between geology, the science of time, and critical art discourse. There is a side to Smithson that is a bit too Jungian for me, but his practice made art very expansive.

Kwon Who else were you looking at as a young artist?

Dion There were so many: Jack Goldstein, Lothar Baumgarten, Group Material, Hans Haacke, Louise Lawler, Ashley Bickerton, Vito Acconci, Ericson and Ziegler, Yvonne Rainer, Mierle Laderman Ukeles, Chris Burden … I could go on. But my peers were even more influential, like Christian-Philipp Müller, Tom Burr, Claire Pentecost, Gregg Bordowitz, Stephan Dillemuth, Art Oriente Objet, Jason Simon, Fareed Armaly, Andrea Fraser and Renée Green. Fred Wilson and David Wilson, too, although I don't know them as well personally. I share a lot with all of these artists methodologically. Then there is another group of artists who deal with representations of nature – Bob Braine, Alexis Rockman, Christy Rupp, Rachel Berwick, David Nyzio, Greg Crewdson and Michael Paha – whose methods are far from my own but with whom I feel a strong kinship. Bob, Alexis and I get together and talk like nature nerds about birds and insects. I guess in some ways the division that existed before in my life still exists, although Renée, Claire and Art Oriente Objet overlap into both worlds.

right, top, **Lothar Baumgarten**
Installation in the Jardin
Botanico, Caracas
1986
Green plaques suspended from
perches bearing the names of 'Los
Bucadores de El Dorado'

right, bottom, **Ashley Bickerton**
Seascape: Transporter for the
Waste of Its Own Construction #3
1990
Wood, aluminium, glass,
fibreglass, plastic, leather, rope
57 × 210 × 79 cm

far right, **Mierle Laderman Ukeles**
Hartford Wash: Washing, Tracks,
Maintenance: Outside, from
'Maintenance Art' series
1973
Performance at Wadsworth
Atheneum, Hartford, Conncticut

Kwon When I interviewed you few years ago during your preparation for *On Tropical Nature* (1991) in Venezuela, we spoke at length about the mythic figure of the naturalist both in history and in popular culture (exemplified by Indiana Jones at the time). I implied then that rather than being critical of the colonialist underpinnings of such a figure, you were playing out the role as a masculinist fantasy.

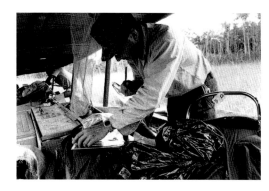

The second of four weeks of travel in the Orinoco River basin, Venezuela, collecting materials for
On Tropical Nature
1991

Dion **I remember. But adopting that position for a while was perhaps the most efficient way to be critical. Distanced critique is a useful but boring tool. I like the idea of throwing myself into the fray. My role in *On Tropical Nature* was to become a magnet for critical questioning. I wasn't too interested in indicting people who lived more than a hundred years ago for being bad colonialists. There were other things relevant to the work, too, like the quincentennial celebration of Columbus' 'discovery' of America. It was important for me to distinguish between someone who ran a slave plantation and someone who spent years of their lives in extremely dangerous and tedious conditions in pursuit of knowledge. They may both be colonialists but these are hugely different endeavours.**

this page and opposite,
On Tropical Nature
1991
Collector's equipment, rope, string, field glasses, clothes, plant press, killing jars, spreading boards, fish spear, insect pins, chemicals, animal traps, fishing tackle, butterfly collection, specimens, gas lamp, shoes, table, crate, shovel, gloves, plastic cups, cassette tapes, adhesive tape, camera, tupperware containers, scissors set
Dimensions variable

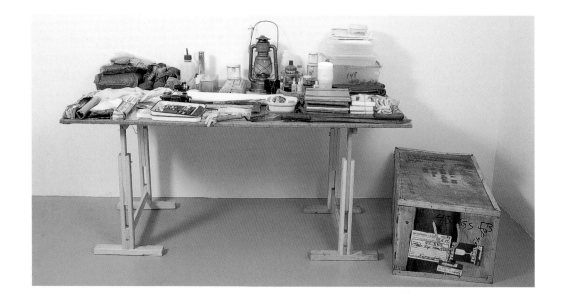

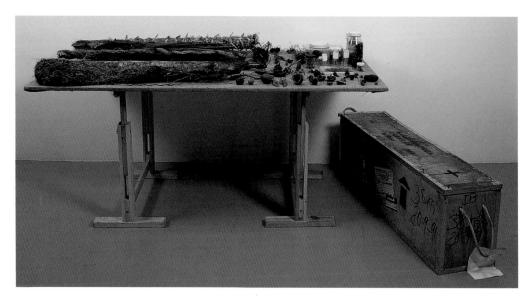

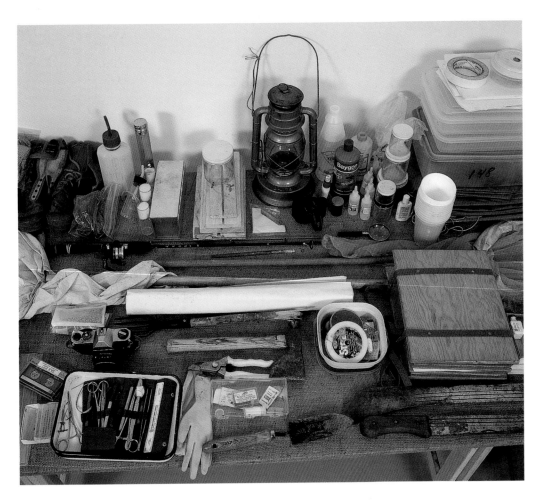

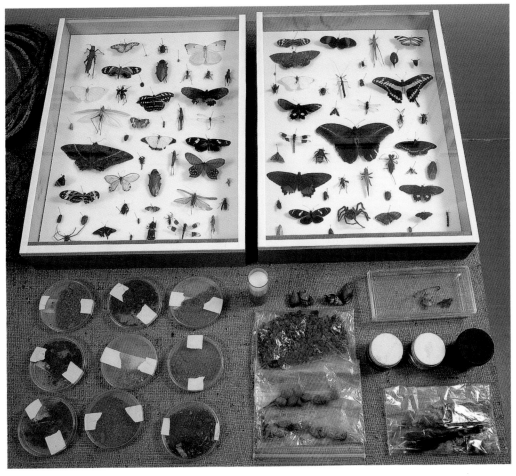

Kwon I think the tendency to collapse the two is due to our tendency to describe knowledge in spatial terms, as territories.

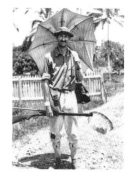

Dion That's why it is doubly important to mark the differences among various types of interactions. Even among a small group of Victorian naturalists, you find vastly disparate attitudes. For example, the English mining engineer Thomas Belt (1832-73) wrote *The Naturalist in Nicaragua* (1874), which is filled with astute field observations but also interventionist logic and horrendous human prejudices. It represents the worst tendencies in the field. But his world-view is very unlike those of eccentric Charles Waterton (1782-1865) or Henry Walter Bates (1825-95) or Alfred Russel Wallace (1823-1913), all of whom spent long periods in the tropical jungles. They were not innocent of the prejudices of their time, but they had robust respect and appreciation for the cultures and individuals who hosted them. Bates spent eleven years in the Amazon Basin and depended greatly on the people of the interior. He owed them his life. And Wallace despised the social Darwinists who judged indigenous peoples as savages, although they had no firsthand knowledge of them.

Kwon In projects of the past few years, you've referenced several of these naturalists – Bates, Wallace and William Beebe. Why the focus on such figures?

Dion My interest lies in trying to understand their motivations. I want to understand this thing called curiosity – a desire for knowledge that is so strong that it leads one to make incredibly irrational decisions. What is it that leads someone to leave the comforts of home, family, friends and career to go live in an unfamiliar, unpredictable and physically dangerous environment that can threaten your health and sanity, if not your life? Why choose to be culturally isolated for years in a foreign country surrounded by people from a different world? Why choose years of solitude with guarantees of nothing except maybe estrangement when you return home? These people were not eco-tourists on vacation – they literally risked their lives.

Kwon Do you think the motivations and desires that drive the naturalist are analogous to those of the artist?

Dion Somewhat. Historically, the pursuit of nature started in the laboratory, the home, the collection. Things that live at a distance were brought into one's own environment to be studied as specimens. Which is to say, what was thought to be observation of life was actually the study of death. Then came the breakthrough when naturalists became field scientists, not only observing nature's operations in its own context, but discovering nature as a system of relationships, an ecology.

Similarly, making art is no longer confined to the institutional spaces that we've created for such activity. It's more in the 'field' now. The focus is on relations and processes – an ecology of art if you will – and not solely on decontextualized objects that are like natural specimens.

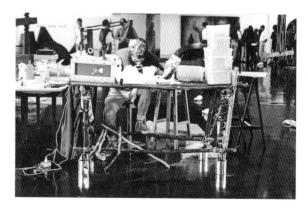

Kwon How has your working method changed with projects like *On Tropical Nature* (1991), *A Meter of Jungle* (1992), *The Great Munich Bug Hunt* (1993) and *A Meter of Meadow* (1995), which involve 'fieldwork'?

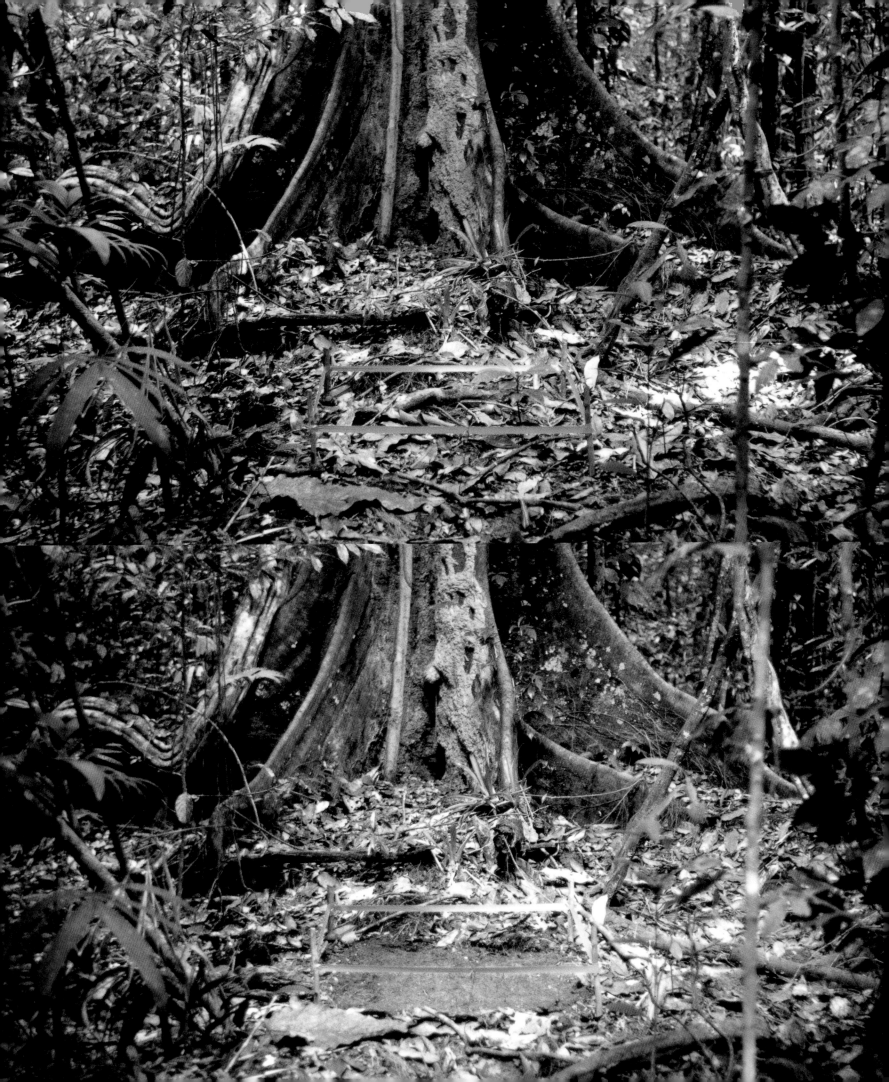

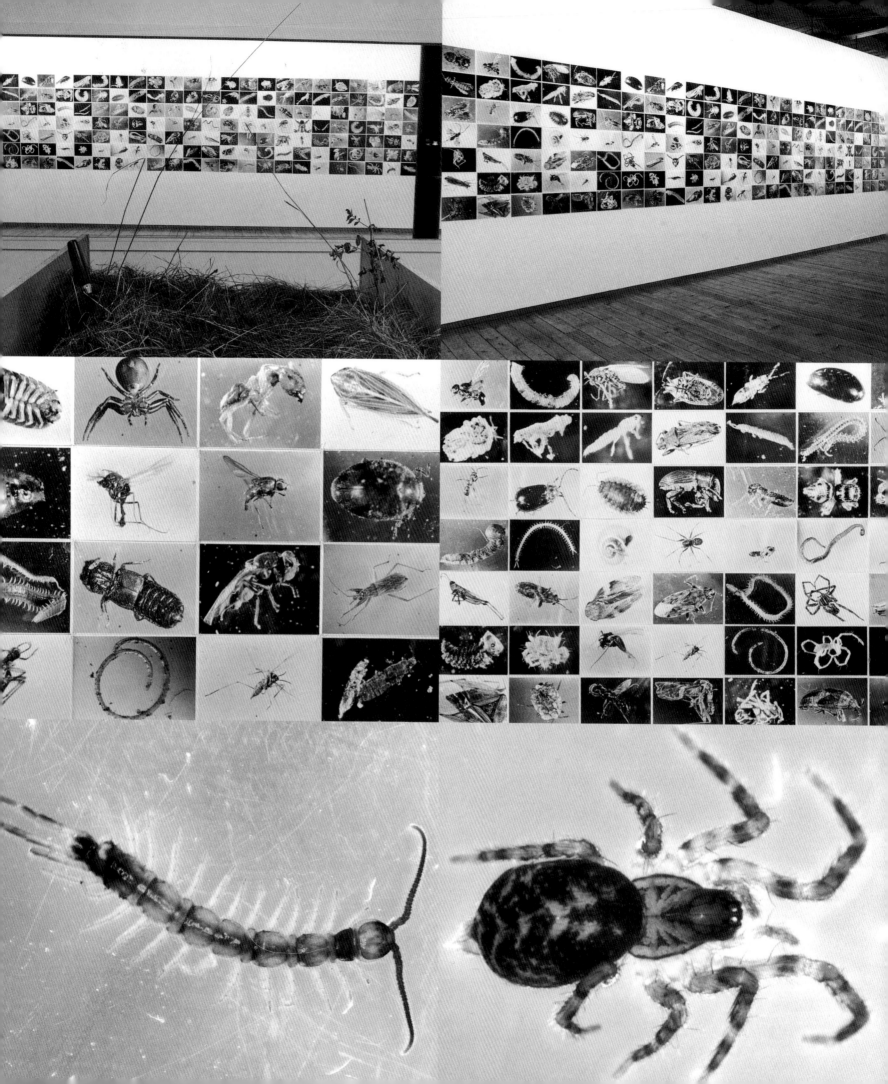

A Meter of Meadow, from
'Unseen Fribourg'
1995
289 black and white photographs
of invertebrate samples, steel pins
21.5 × 30.5 cm each
Installation, FRI-ART Centre d'Art
Contemporain, Fribourg
(Switzerland)

Dion To me, seeing a painting is not as rewarding as seeing a painting in production. So I want to build the process into the work, to have the work exist in several stages, and to have the metamorphosis available to the viewers so that they can engage it in different ways. I'm greedy about not wasting any productive moments. That's why I will not abandon the 'fieldwork' model. In works like *A Meter of Jungle, History Trash Dig* or *A Meter of Meadow*, there is a performative aspect. I take raw materials out of the world and then act upon them in the space of the gallery. This process is visible to visitors during the first ten days or so of the exhibition. I may be going through a pile of leaf litter to sort out the invertebrae, or I may be trying to preserve or identify material. The process is hard to get a grip on because I'm not acting, I'm not a character, I'm not pretending to be someone else. When the collection is complete, when I've run out of space or raw material or time, the work is finished. Later a collection might be re-opened.

For instance, *On Tropical Nature* opened with empty tables, signalling to the viewers that I was working somewhere but not in the exhibition space. I was in the jungle, sending specimens back to the gallery on a weekly basis, with the expectation that, based on my prior instructions, the tables would gradually become filled with the contents of my crates. Essentially, the piece changed with the arrival of each box, which were events in themselves. With works like this and *History Trash Dig* (1995), there are multiple publics that include not only the usual art audience but the people I work with in the field and the partners who put the work together in the institution. In the project for Sculpture Chicago (1992-93), there was an interesting reversal of the role of the audience. The collaborators who helped shape the work were the principal public. In this project, a group of sixteen high school students formed two clubs: *The Chicago Tropical Rainforest Study Group* and *The Chicago Urban Ecology Action Group*. For the first few months we looked into the problems of rainforest conservation, culminating with a visit to the Cockscomb Basin Wildlife Sanctuary in Belize. Later we turned our attention to Chicago's ecology. Over the summer Sculpture Chicago convinced the city to give us a clubhouse in Lincoln Park. There we had a sort of resource centre where people could come to discuss ideas about art and ecology but they could also use *us* as a resource: sixteen strong energetic people available to pick up trash, plant trees, turn vacant lots into gardens … Like all methods, though, this one has its benefits and compromises.

Kwon I think the kind of 'field' practice which you, along with other artists you've mentioned, have forged, constitutes an area of artistic activity that is posing the most challenging questions right now. But what are some of its problems?

Dion One of the biggest problems with this kind of practice, which some call *contexte-kunst*, is that it is virtually impossible to track the conceptual development of an artist. Normally, each show *is* a work rather than an exhibition of several works, which makes it difficult to compare and contrast one project to the next. All of us work in relationship to a site, but we don't necessarily work site-specifically. Someone like myself or Renée Green, we try to use each exhibition opportunity to engage our previous projects and to address past mistakes or problems. I like to have a dialogue with other things that I've done. But this kind of conceptual layering is not visible to most

people because they encounter isolated events or installations that are in fact part of a continuous development.

The Great Munich Bug Hunt
1993
Tree, collecting cabinet,
specimens, lab equipment
Dimensions variable

Kwon How much of that is the structural condition of this type of practice and how much of it is the laziness of the critical community to inform the art audience?

Dion **Let's face it, no one can be expected to see an exhibition in Rome one week, another in Glasgow three weeks later, and then attend a lecture in Los Angeles five days after that. Part of the problem is definitely the condition of the practice. But because of the problem of distance, there is also very little press attention on this kind of site-oriented art.**

Kwon Obviously, this kind of practice demands a huge amount of time and commitment from the artist – preparation and execution of the 'fieldwork', production of objects or installations, then dissemination of information about the work. But it is very demanding on the critics, too, because we have patiently to piece together fragments of information from elsewhere, usually, and follow the project over a relatively long period of time – days, months, maybe even years – as it goes through complicated transformations, generating multiple narratives.

Dion **Information about a project is definitely not available all at once. If there has been a reluctance to address this kind of practice seriously, that's one of the reasons. And I concede it is a lot of work to try to examine or interpret such work critically. But remember, the experience I'm most interested in is not the written appraisal but the actual viewing of the work itself. How could words or photographs ever adequately describe *The Library for the Birds of Antwerp* (1993)?**

Kwon What did you mean earlier when you said you work in relation to the site but not site-specifically?

Dion **Site-specificity today is not that of Bochner, LeWitt, Serra or Buren, defined by the formal constraints of a location. Nor is it that of Asher and Haacke, defined as a social space enmeshed in the art-culture. It can be these things plus historical issues, contemporary political debates, the popular culture climate, developments in technology, the artist's experience of being mistreated by the hosting institution, even the seasonal migration of birds. There are different ways to define a site. And with it comes a newer under- standing and appreciation of the audience. Much of today's art recognizes multiple viewer positions as it attempts to meet the non-art-world viewers halfway. When I make a work, for instance, I don't expect everyone to get everything. People versed in art history will walk away with a different set of references than someone who studied zoology. And I also don't expect everyone to work so hard at analyzing the work.**

It is also important to understand the flexible way in which my peers and I think of our practice. We hold dear the belief that our production can have many different forms of expression – making a film, teaching, writing, producing a public project, doing something for a newspaper, curating or presenting a discrete work in a gallery. The differences are noted, but we see

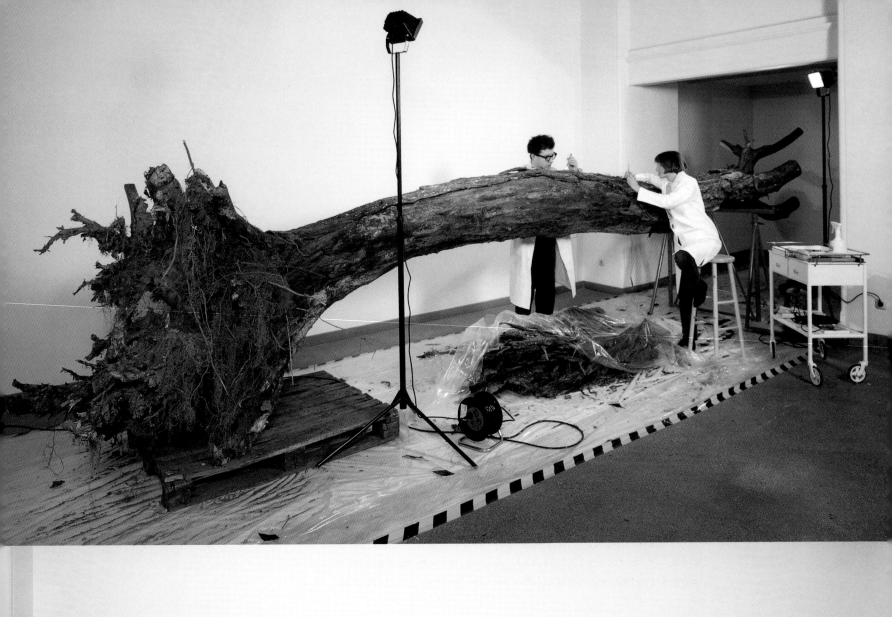
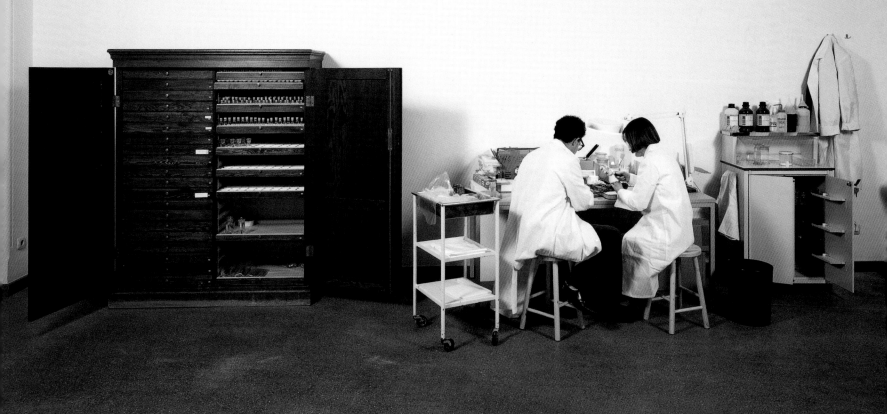

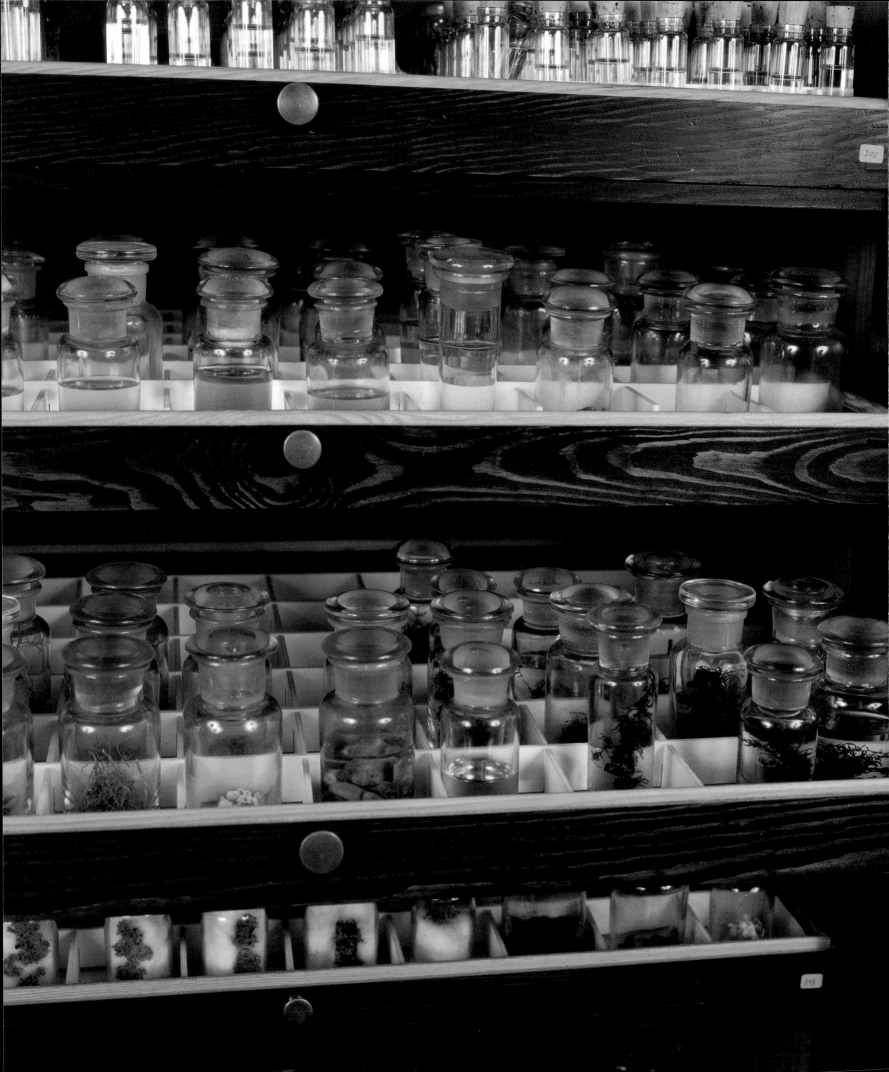

The Great Munich Bug Hunt
(detail)
1993
Tree, collecting cabinet,
specimens, lab equipment
Dimensions variable

each site as one among many at our disposal in terms of cultural work. For me, producing something with a natural history museum, a zoo or a historical society are all viable options. Of course, there is a flip side to this in that it may lead to a kind of dilettantism. And that may be a fair criticism. But for me, the dilettante is a much more interesting character historically than the expert. Some of the greatest contributions in art and science have come from dilettantes rather than professionals.

Kwon Has there ever been a problem of being typecast as the artist who does nature pieces? And if so, how do you respond to such prescriptive attitudes?

Dion On one hand, there is always a desire in the art world to see something familiar – to recognize signature styles. There is a demand that you don't be a dilettante, that you stick with one area and develop it over a long period of time. On the other hand, there is a desire for novelty. So every project has to be new and different. You're accused of being repetitive and boring if you do the same project twice.

Imagine for instance *The Great Munich Bug Hunt* in which I took a tree from the Black Forest, and, with a group of entomologists, examined the tree to remove the invertebrae. Now the same procedure could be followed in California and it would become an entirely different project, because it would involve an entirely different tree and reveal an entirely different set of insects, spiders and worms. But if I pursued a California version, someone will inevitably say that I did the project already, that they had seen it before. People's tendency to disregard differences is so automatic that it's exhausting to resist it.

Anyway, I do tend to get pigeonholed as the artist who works on themes of zoology. That's one of the reasons I made *History Trash Dig* and *History Trash Scan (Civitella Ranieri)*, which are works that superficially borrow the methodology of archaeology in order to reframe the fascination that many

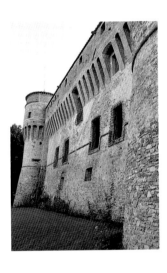

Civitella Ranieri, Italy, view of the castle

History Trash Scan (Civitella Ranieri)
1996
Found artefacts

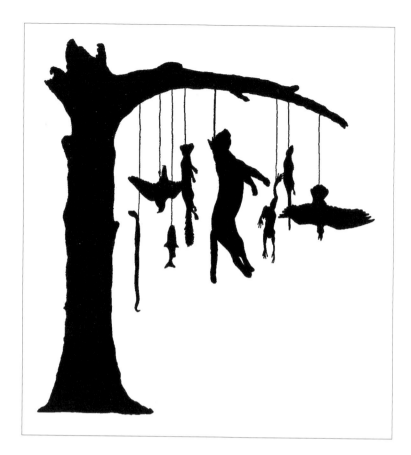

Americans have with the simultaneity of history that one encounters in older European cities. During my digs into trash dumps of previous centuries I'm not interested in one moment or type of object, but each artefact – be it yesterday's Juicy Fruit wrapper or a sixteenth-century porcelain fragment – is treated the same. Other works, like the *Bureau of Censorship*, *When Dinosaurs Ruled the Earth* or *Hate Box* (a time capsule of Desert Storm propaganda produced by the private sector), also depart from the focus on issues of ecology. These works are produced out of anger and disgust, they are sort of throwbacks to my earliest projects.

Part of the reason I continue to focus on nature, though, besides the fact that it is a subject I'm most interested in, is because my work involves intensive research and I find that I can build on the things I already know. I've done enough reading now about problems of taxonomy and the history of natural sciences and ecology that my knowledge can function as a resource pool. I also enjoy trying to interpret my own obsessive relationship to nature. My mania for birds, for example – what is that about?

Kwon Whereas your earlier work registered a spirited energy about the possibilities of change, your most recent work seems reflective. In *Tar and Feathers* (1996), things feel downright dark and macabre.

Dion **That's an aspect of my work that has become increasingly more defined, perhaps, but not new. If you look at my work through the lens of the grotesque and morbid, you will find them in a lot of the early projects too. *Black Rhino, with Head*, which includes a huge severed head of a rhinoceros, *Frankenstein in the Age of Biotechnology* (1991), or the first *Hallway of Extinction*, which I did in collaboration with Bob Braine, are exceedingly dark works. I guess**

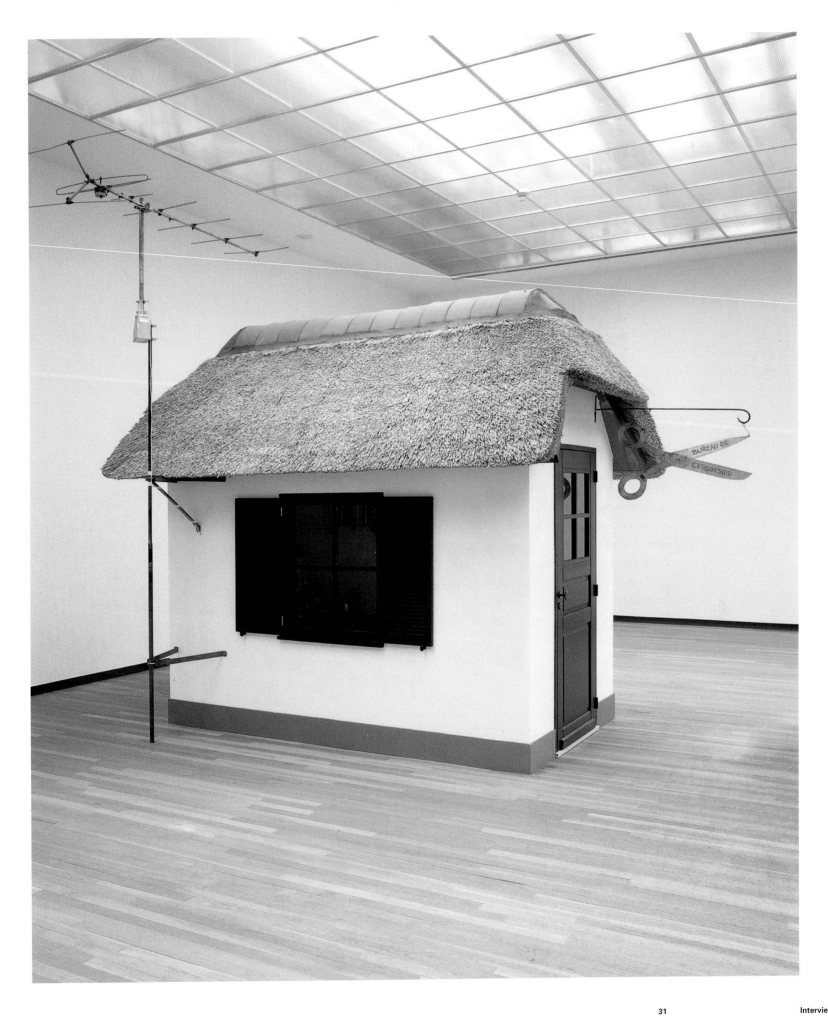

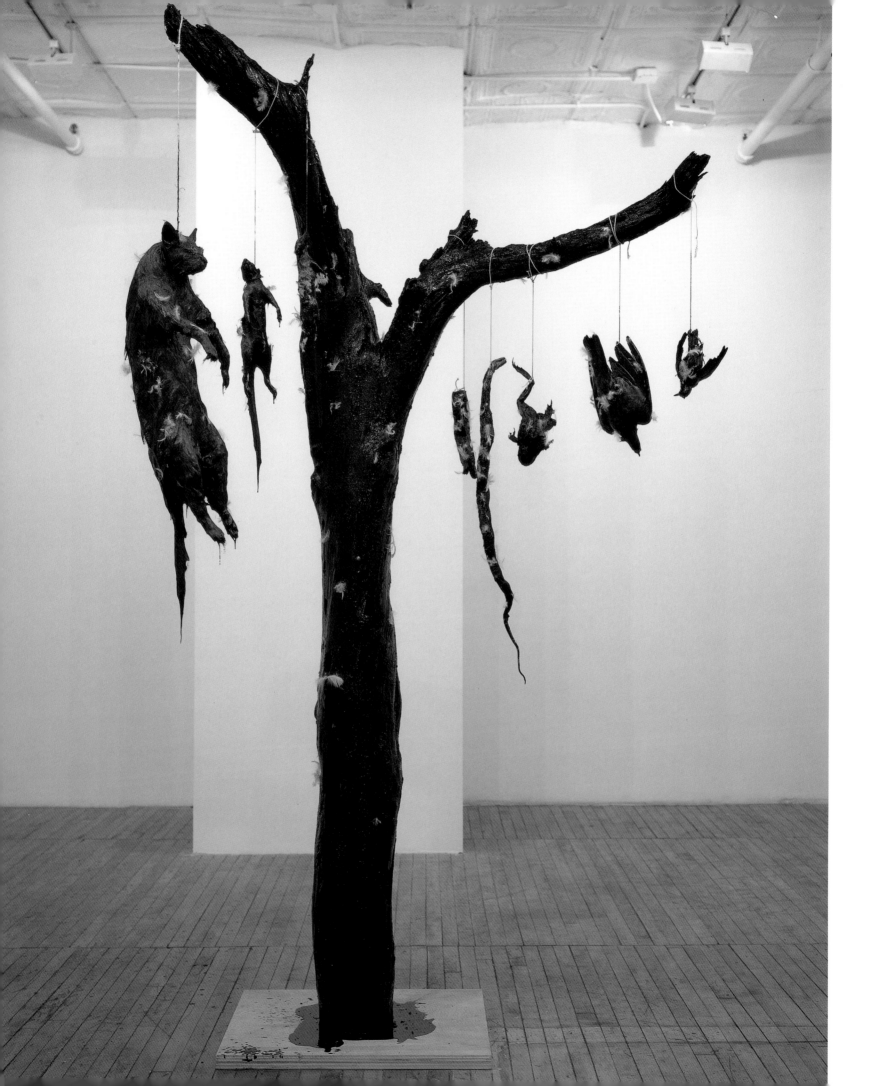

Tar and Feathers
1996
Tree, wooden base, tar, feathers,
various taxidermic animals
259 × ø101.6 cm

when you dwell a lot on issues like extinction, it's hard not to become a bit macabre. In truth, I'm far more interested in Poe than in Thoreau.

The more optimistic projects like *Project for the Belize Zoo* or *The Chicago Urban Ecology Action Group* tend to have a 'real world' practicality, emphasizing productive or generative models of our relationship to nature. But more often than not, the work has tended towards the adverse aspects of our interaction with nature. In fact, I am generally pessimistic about the fact that the environmental movement has shied away from providing a more systematic critique of capitalism. It has become more corporate, divisive and collusive, missing an important opportunity to present a really meaningful challenge to the juggernaut of world market economy. Environmentalism has become eco-chic, another gizmo, another category of commodities. That has led me to a kind of disillusionment.

Flotsam and Jetsam is perhaps the keystone work for this sense of gloom. It expresses a kind of disbelief in the unwillingness of people to act in their own long-term interest, and was triggered by the collapse of the Atlantic fisheries. For decades biologists told fisherman that they were overharvesting and that this would cause the population to collapse, but there was an outright refusal to control their greed. *Flotsam and Jetsam* articulates a sort of sublime wonderment at the extent of our destruction. The stage is a device to coalesce the tragic and public aspects. I don't anticipate much good news on the environmental front, although it has perhaps the greatest potential to build bridges between progressive social movements.

Kwon Do you think your practice has become more private and subjective as a result?

overleaf, **Flotsam and Jetsam**
(The End of the Game)
1994
Boat, sand, wooden platform,
chair, electric fan, net, assorted
beach debris
Installation, De Vleeshal,
Middelburg, The Netherlands

Dion I think I've been consistent in pursuing my interest in the history of the representations of nature and exploring how concepts like chains of being, evolution, the 'wilderness' and fantasies of growth and utopia have shaped our thinking about nature. These days, the dominant idea guiding what we think of as nature is influenced by environmentalism, especially in relation to conservation, so my work has tried to challenge its effects.

You may be right, though, in that my work has become more hermetic in recent years, or at least more esoteric. In the past couple of years, I've been studying pre-Enlightenment traditions of organizing nature such as curiosity cabinets, which were in many ways the nursery of modern science and certainly the forerunner of the museum. In going back to the seventeenth century, I'm trying to imagine how things could have been different, to follow branches on the tree of knowledge that died of dry rot.

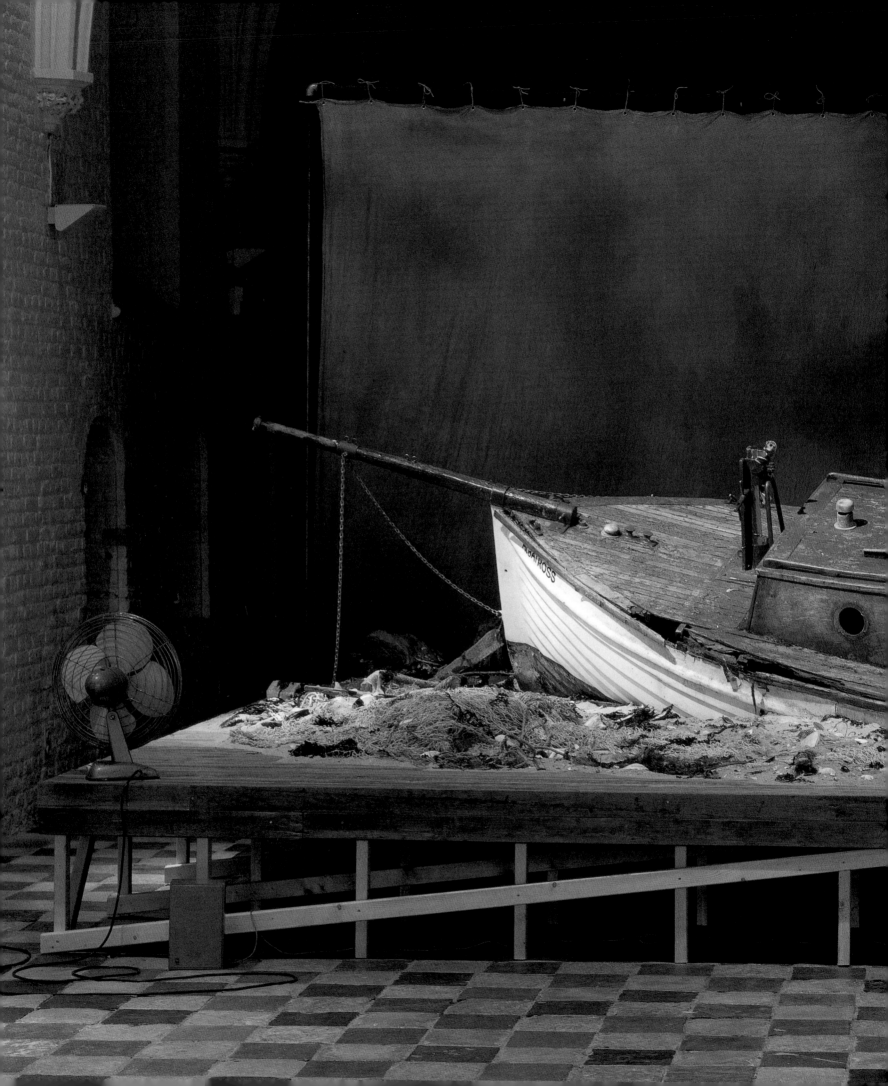

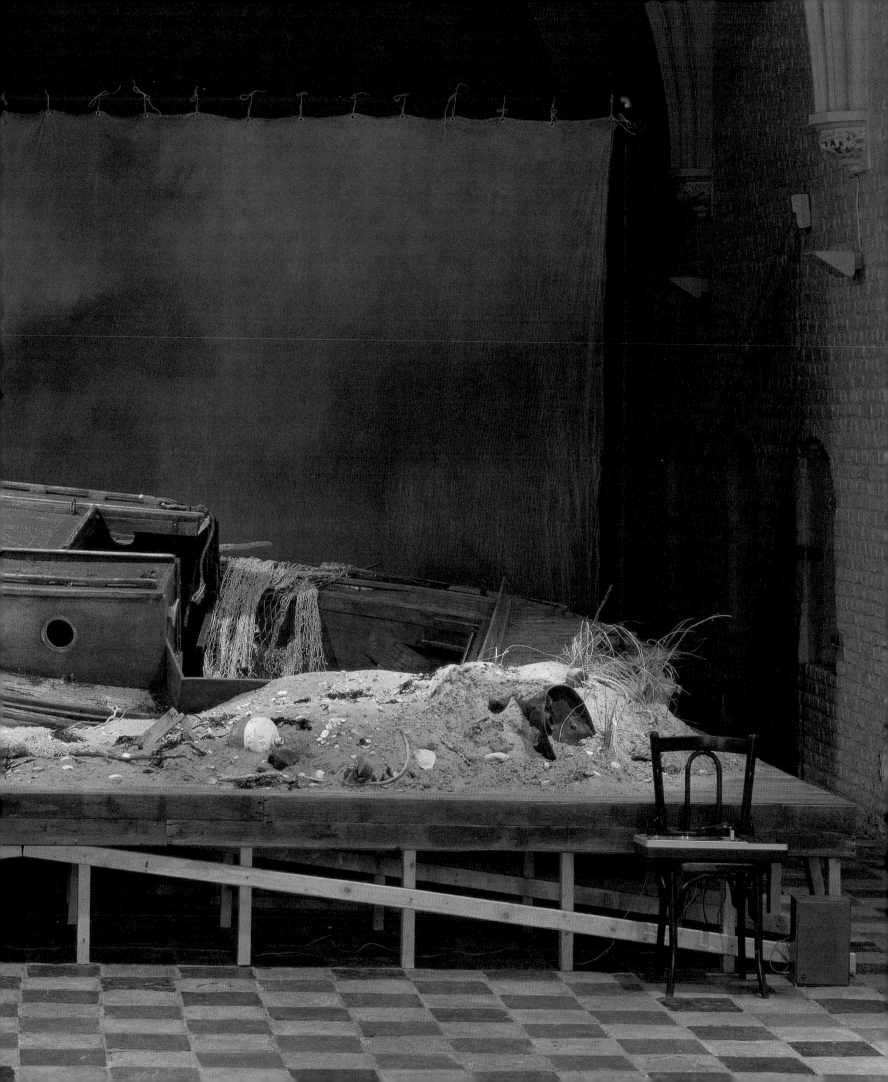

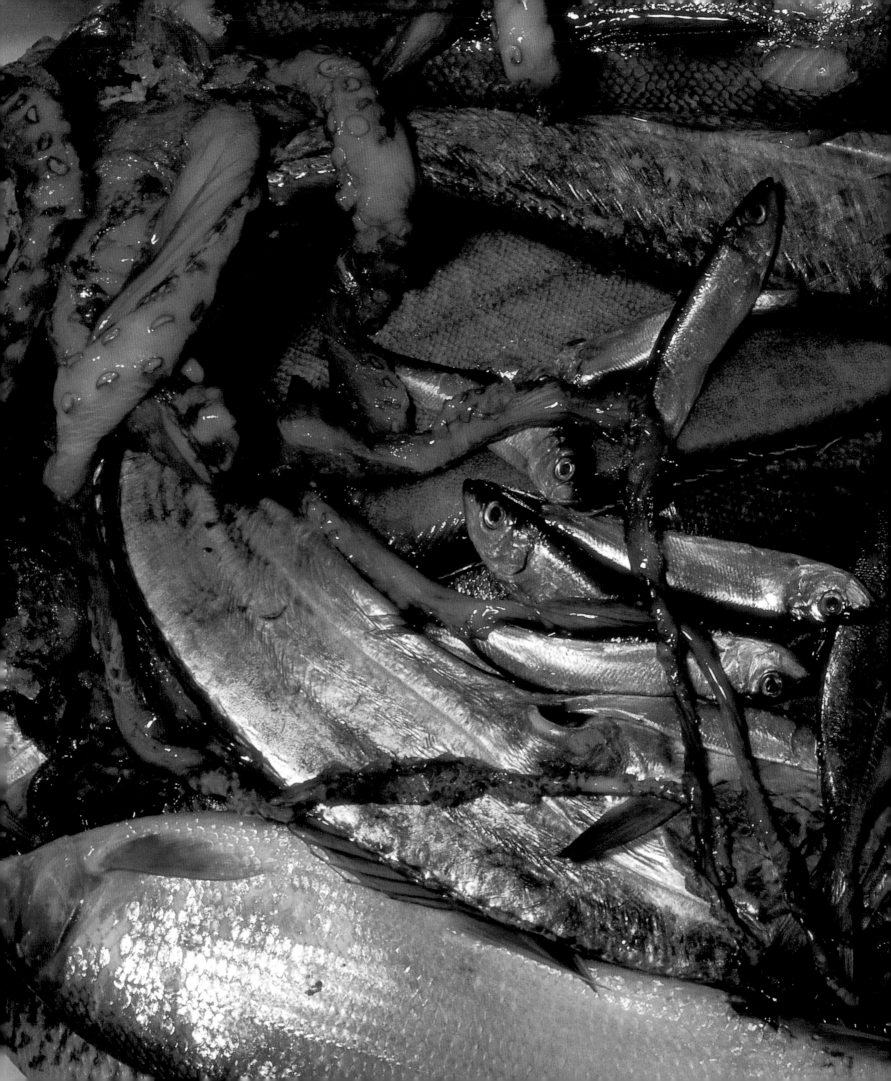

Contents

Most days, Mark Dion wakes up, hangs his binoculars around his neck and heads towards Battery Park with his dog Sister for some birdwatching. Along with a surplus of European starlings, he might be fortunate to spot a mockingbird, a rare but not wholly impossible sight, even in downtown Manhattan. When he arrives home to his living/studio space, he notes his sitings in a small, dated notebook. He then settles down to work at a long refectory table perched on a raised platform, surrounded on either side with curtains hung by hooks on thick hemp rope, like the rigging on a traditional Clipper ship. The table is flanked by glass-fronted cabinets holding stuffed birds, specimen jars and dusty wildlife dioramas. Verdigris walls are hung salon style with engravings of famous naturalists and charts comparing examples of bird, insect, plant and animal species.

The dimly lit scene resembles both the makeshift cabin of an eighteenth- or nineteenth-century explorer categorizing his discoveries; or a princely cabinet of seventeenth-century curiosities in which the intellectually curious pursued the limits of knowledge through displays of natural and man-made wonders. That the space should evoke these two distinct historic periods is not coincidental. For over a decade Dion has immersed himself in the transitional cultural moment during which the menagerie became the zoo, and the *wunderkammer* was dispersed into specialized museums of discrete disciplines, an academic (some say artificial) separation of art and science that has remained virtually intact. His conceptual installations, activist public art projects and sculptures often take as their form the collecting

and exhibiting of structures he has studied. They illustrate how the movement from encyclopedic, idiosyncratic displays of objects to a hierarchical model has helped to construct our notions of knowledge, exploration and nature, and mediated our relationship to the world of living things.

It is tempting to view Dion's environments and his aesthetic preoccupations as a nostalgic, even naive predilection for the arcane. However, Dion's arrangements are never mere simulacra. Although the objects he amasses or fabricates form a fascinating compendium of flotsam and jetsam, what is on display are the processes of naming and sorting and the political and ideological conditions framing them. His research is supported by an impressive personal library containing an eclectic range of historical and critical texts reflecting on the converging evolution of museums and the natural sciences as they are embodied in the acquisition, arrangement and interpretation of objects over the past four hundred years.

In his essay, 'The Oyster Club', Dion 'romantically mourn[s]' the disappearance of 'the polymath', the truly interdisciplinary intellectual.[1] Dion's early training in the Whitney Independent Study Program at the Whitney Museum of American Art in New York (1985) demanded just such a turn of mind. His teachers encouraged rigorous debate around issues centred on two specific areas: the *critique of representation* (how images, whether functioning within the arenas of mass media or 'high art', construct cultural concepts such as identity); and the *institutional critique* (how the ideological structures underpinning systems of

power such as the academy, the museum and the marketplace construct cultural values). Influenced by readings of postmodern theorists and philosophers, in particular Michel Foucault, Dion like many of his contemporaries in the Whitney program was challenged by the possibility of using a three-dimensional form didactically to stir critical awareness in the viewer. From their discussions emerged an 'anti-aesthetic', post-Conceptual Art that redefined the role of the artist as a 'cultural producer' – at different times social gadfly, researcher, performer, writer, filmmaker, curator, collaborator and *occasional* fabricator of objects – and an increased emphasis on the *process* as opposed to the *product* of artmaking. When an object was chosen as the communication medium, these artists avoided high production values and exhibited 'context' – the site of display – as an intrinsic component of the work. Moreover, their productions relentlessly questioned how we approach and understand 'truth'. Dion has characterized his aesthetic position as a response to three trends in the New York art scene of the 1980s: the clean detached styles of Minimalism and early theoretical Conceptual Art that dominated gallery and museum exhibitions; an antagonism and distrust of neo-expressionist figurative painting; and the 'polished, plexi-formica smart art' repetitions of the 1980s with its emphasis on commodification.[2]

Overtly political, oppositional, interventionist and didactic, Dion's early works are full of art-world allusions without being burdened by the art-historical canon or its expectations. Moreover, they show evident delight in the visual and verbal puns that characterize appropriation, and a sensitivity to site-specificity both of which had become the calling card of his content-focused mentors. These works also demonstrate Dion's compulsion for assembling high-impact arrangements of dozens of identical, mass-produced objects in ways that reveal how their familiarity hides a complex network of questionable agendas. From the outset, Dion showed a preference for finding his content-matter in the social sphere, and offering low-tech, humourous commentary on issues ranging from censorship, U.S. foreign policy and the presidential elections to consumerism and the environment.

In *I'd Like to Give the World a Coke* (1986), Dion visually blurs the distinctions between the insider languages of the art and corporate worlds, drawing attention to their incestuous and symbiotic relationship. Created for the Arts Festival of Atlanta, the work was ideally sited in this city dominated by the head offices of Coca-Cola, a company whose products are sold in 250 of 255 nations in the world. Dion researched and obtained the specifications of the table and carpeting in the company's boardroom, so that the installation replicated it exactly. The glossy red-striped walls quote both Daniel Buren's conceptual striped paintings, and ironically, the lurid hue favoured by Barbara Kruger as the voice of authority in the pithy tag-lines of her mass media critiques. The precise progression of homogeneous boxes and bottles containing samples of Coke in every one of its numerous available forms recalls Donald Judd's widely collected ziggurats. The world map, with nations 'colonized' by Coke painted red, refer to

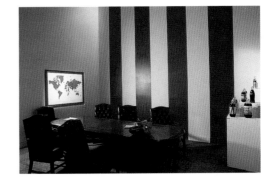

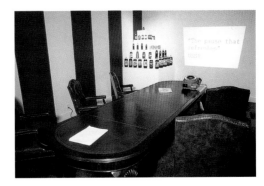

I'd Like to Give the World a Coke
1986
Coca-Cola bottles, slide projector, boardroom table and chairs, world map, stepped plinth, paint, carpeting
Dimensions variable

**Relevant Foreign Policy
Spectrum (From Farthest Right
to Center Right)**
1987
Clothes line, pulley, clothes pins,
T-shirts, stool, basket, text
Dimensions variable

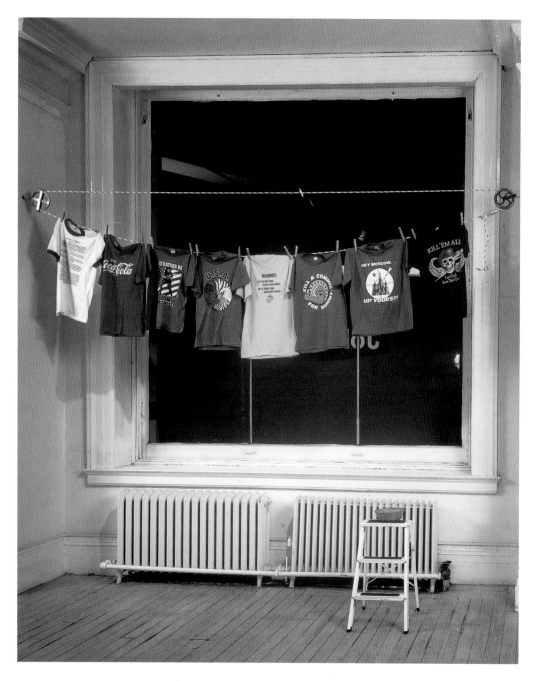

conceptual artist Conrad Atkinson's maps and charts. However, the work is not merely an art-world send-up. Shortly before the project, Dion had made a trip to Nicaragua and Mexico City as a 'tourist' of the revolution. He returned from his journey more attuned to the consequences of capitalism, and how decisions made in the United States affect the lives of people elsewhere. This experience is reflected in the slide projectors continuously flashing quotations and slogans from the history of Coke, the names of Coke-colonized countries, images of Coke being consumed in those countries, and terse critiques of multinational capitalist behaviour abroad.

In response to a cultural and political system that was far from inclusive, Dion created *Relevant Foreign Policy Spectrum (From Farthest Right to Center Right)* (1987). He installed the work during the Iran/Contra hearings, as a visual protest against both the limited range of aesthetic positions available to artists in the 1980s and the analogous range of political positions available to citizens during the Reagan presidency. A series of coloured T-shirts printed with reactionary slogans ('Kill a Commie for Mommy') were hung on a clothesline strung between a shiny new pulley and a very rusty one, each painted with the title of the installation. From the back, the shirts appear like square Minimalist canvases stripped from their taut stretchers. Below the clothesline a basket of clothes pegs sits on a stepladder, a symbol of the old system about to be dismantled. Each step carries a quote from U.S. foreign policy intellectuals reflecting their disregard (and sometimes outright contempt) for the rights of

people outside the United States. Made of cheap materials, with the impoverished look of a back alley tenement washline, the work resists the 'finish' associated with slick gallery art. As in the Coca-Cola installation, the near fascism of the political sentiments is coupled with an allusion to the dictatorial constraints imposed by art-world officialdom.

In *Vocabulary Lesson for an Election Year* (1988) and *Toys 'R' U.S.*(1986), Dion recreates 'innocent' childhood spaces as a foil for the calculating behaviour of adults in control of their worlds. *Vocabulary Lesson for an Election Year* simulates a classroom where the textbook 'blacklist' controversy surrounding the removal of 345 books from U.S. public school curricula (from Shakespeare to the *American Heritage Dictionary*) and the use of Orwellian 'doublespeak' during the presidential elections are examined. *Toys 'R' U.S.* is framed by contemporary analyses of fairy-tales and fables by Bruno Bettelheim, Jack Zipes and Angela Carter that consider the way amusing tales for children convey serious messages about human actions while simultaneously reinforcing normative cultural behaviours, desires and values.[3] In Dion's installation, a child's bedroom is filled with smurfs – the elfin, blue cartoon character that became a global rage in the 1980s. The smurf fad epitomized the licensing explosion of toys in the international market. What began as a cartoon character in Europe soon became one of the most extraordinary phenomena in the billion-dollar toy industry. Dominating a ruckus 'pandemonium' of smurf products was the audio track of a televised smurf video.[4] Dion replaced the original smurf audio with

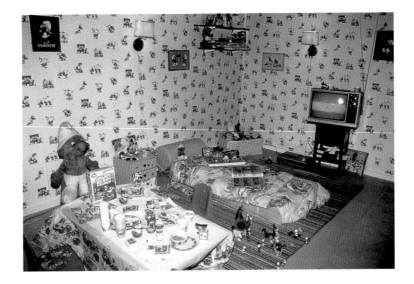

Toys 'R' U.S.
1986
Children's bed, table, chairs, bedside tables, television, audiotape, Smurf toys, cereal, wallpaper, wall pictures, party plates, paper table cloth and cups, bedspread, figurines, magazines, books, games, videos
Dimensions variable
Installation, Artists Space, New York

his own revisionist version, in which economic and feminist analyses of the smurf hysteria is narrated by the smurfs themselves, identifying their story as a modern fairy tale. In *When Dinosaurs Ruled the Earth* (1994), a second version of *Toys 'R' U.S.*, Dion interrogates the perilous connection between the popularization of scientific theories and commodification. As in his *Wheelbarrows of Progress* (with William Schefferine, 1990) Dion suggests that only the 'cutest' and most charismatic animals survive and find a place on the Ark. Mass-consumption of assembly-line products – lunchboxes, clothing, toys and books – bearing dinosaur images enable the public to indulge a fetish for the one creature which unquestionably perished without human intervention.

Fascinated with nursery tales, toys and the cultural stories they can help to tell, Dion continued to enlist Aesop, La Fontaine and his own cuddly, stuffed armies in the struggle for environ-

overleaf, **Toys 'R' U.S. (When Dinosaurs Ruled the Earth)**
1994
Children's bed, desk, chair, bedside table, television, audiotape, dinosaur bedside lamp, toys, cereal, wallpaper, posters, stencils, inflatable Tyrannosaurus Rex, calendar, penant, bedspread, pillow, slippers, clothing, wastepaper basket, umbrellas, games, plastic figurines, books, games, framed picture, videos, baseball cap, fan, bulletin board, postcards, pencils and pens, pencil holder, bookbag, rug, stuffed animals, cup and straw, assorted other dino memorabilia
Dimensions variable
Installation, American Fine Arts, Co., New York

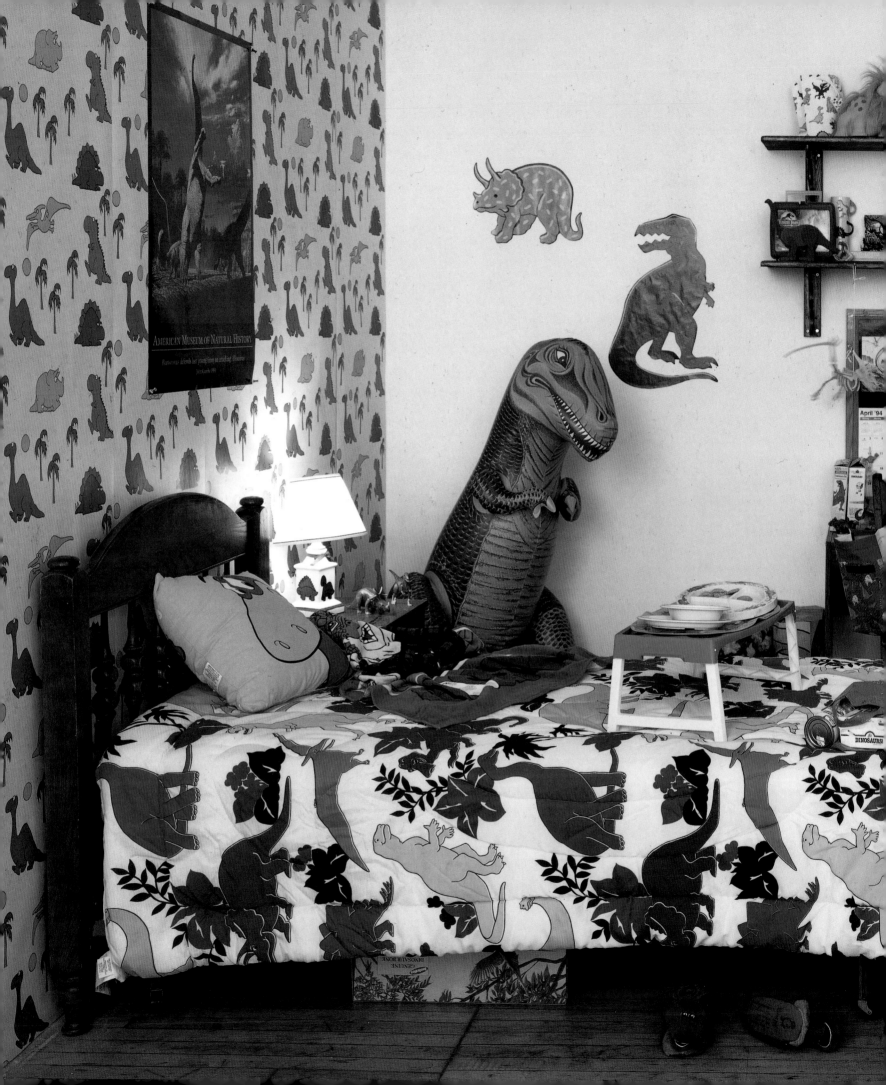

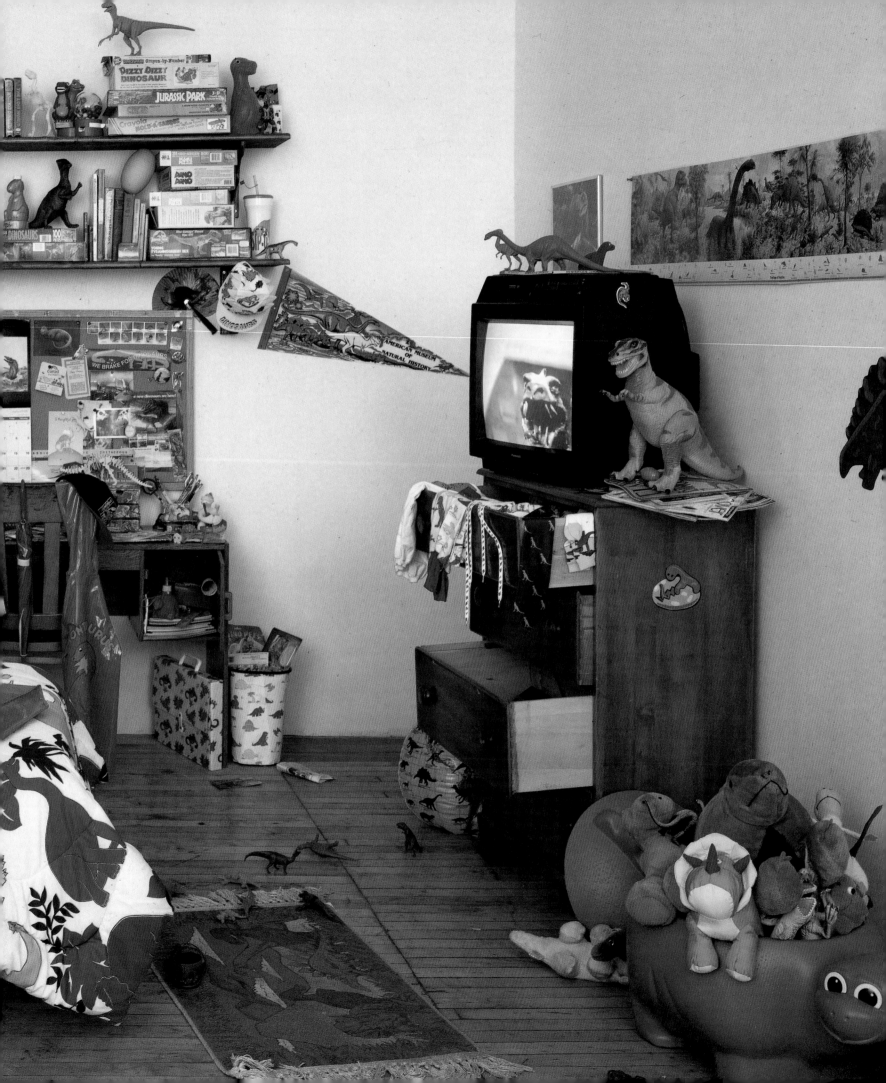

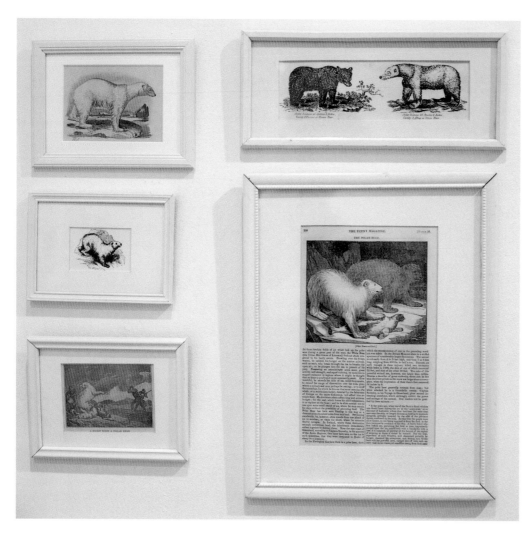

White Out (detail)
1994
100 framed illustrations
Dimensions variable

mental protection. *Extinction Series: Concentration* (1989) brings to mind 'The House that Jack Built', and 'The Old Lady Who Swallowed the Fly' to document the catastrophic results of the 1968 initiative by the World Health Organization to eradicate malaria-carrying mosquitoes from Borneo using DDT. On the wall, silhouettes cut to scale of a mosquito, a caterpillar, a wasp, a lizard, a cat and a rat are lined up following a miniature silhouette map of Borneo. Each image is accompanied by a handwritten report of the absurd and tragic chain of events that followed the chemical spraying. Along with the mosquitoes, the spraying also wiped out predatory wasps. Within two months, thatched roofs began to cave in and houses collapse, when thatch-eating caterpillars usually consumed by wasps experienced a sudden

population explosion. An indoor spray to alleviate the caterpillar problem was introduced, but a chain reaction had already been set in motion. Geko lizards, used to a steady diet of caterpillars, ate the writhing insects in their death throes and were soon writhing themselves as the caterpillar poison continued to do its work. The final, near-comic gesture occurred when non-native cats, to replace those which had died eating the poisoned geko lizards, were parachuted into the jungle to 'restore the balance' since, when the native cats died out, the rat population had boomed. Suddenly, rodents were eating human food and threatening to spread bubonic plague.

With great economy of means, *Concentration* demonstrates the monumental folly behind such misguided attempts to solve a human problem by meddling with the equilibrium of nature. *Black Rhino with Head* (1989), a second piece in the *Extinction* group, draws attention to the plight of the world's fastest disappearing animal, the black rhinoceros of southern Africa. The installation consists of stacked packing crates stencilled with handling symbols ('fragile'), charts and maps of the past and present distribution of the rhino population, photographs of poached rhinos and texts about poaching, and a well-known image of Theodore Roosevelt hunting the once numerous animals. One crate is left open to expose a massive, real rhino head. This piece retained strong overtones of Hans Haacke's *U.S. Isolation Box, Grenada* (1983-84). Dion's piece is similarly preoccupied with the long-term consequences of colonization, particularly on the natural world.

A related series of works about environ-

**Polar Bears and Toucans
(from Amazonas to Svalbard)**
1991
Stuffed toy polar bear, Sony
Sports cassette player, cassette
recorded in Venezuela-Amazonas
territory, wash tub, tar, crate,
orange electrical cord
231 × 112 × 75 cm

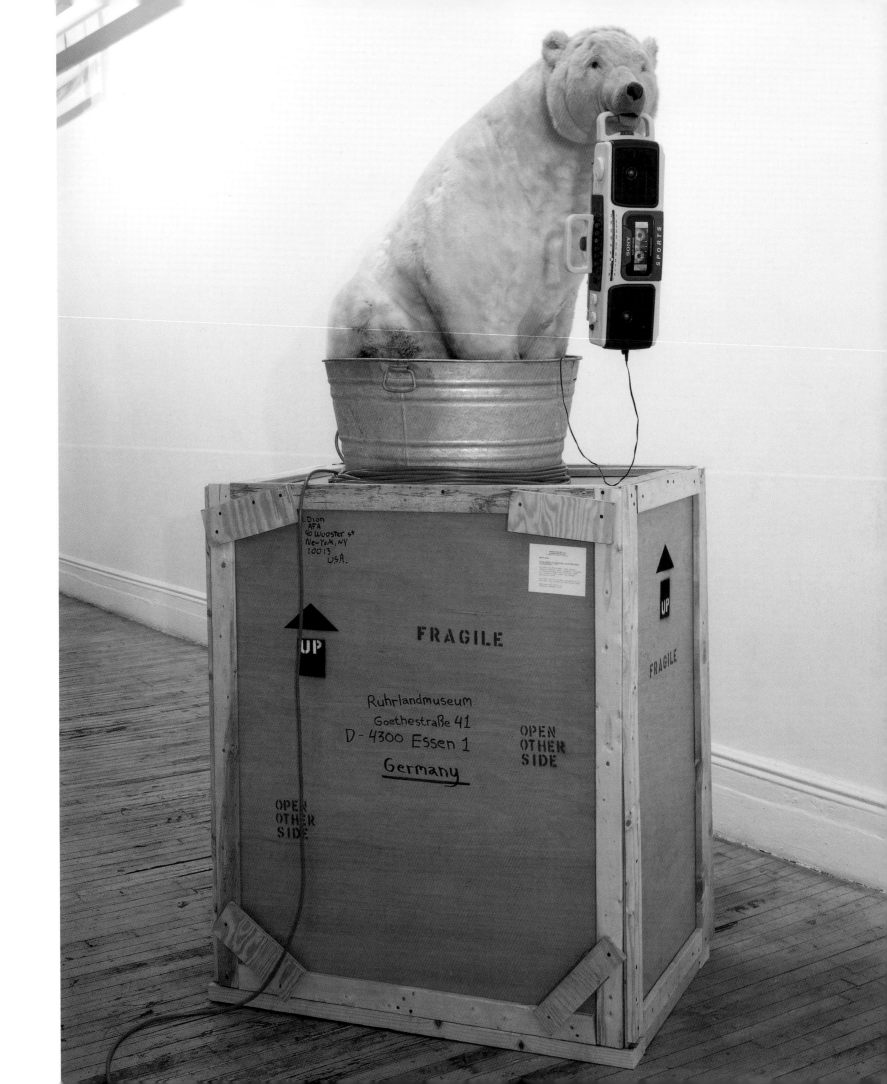

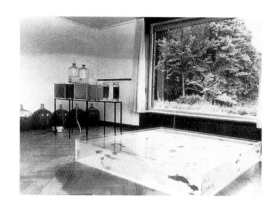

Hans Haacke
Rhinewater Purification Plant
1972
Installation, Museum Haus Lange,
Krefeld

mental problems focuses on the earth's most contested habitats: the Arctic, the tropical rainforest and the city. The first two places have captured the imaginations of explorers for several centuries, and, until recently, have escaped human intervention. Yet, our relationship to them has undergone a drastic conceptual shift almost overnight, from landscapes viewed as dangerous and savage to fragile ecologies requiring our protection. In *Polar Bears and Toucans* (1989 and 1991) and *Ursus Maritimus* (1991), the white body of the polar bear is likened to a screen for projecting human fears and fantasies about the wilderness. The polar bear remains one of the few wild animals that are routinely a problem for people. The bear is also a reminder that despite the illusion that we have mastered nature, it can still threaten us. *White Out* (begun in 1994, and ongoing), is a collection of over one hundred, identically framed pre-twentieth-century illustrations of polar bears. Viewed as a group, they resemble both a stark, white installation reminiscent of Robert Ryman's subtly variegated paintings, and a comprehensive archive documenting the evolutionary development

of the bear's physiognomy. The majority of the images portray the animal as demonic and fierce, in contrast to more current images of the animal as a tragic victim in need of human aid.

Tropical Rainforest Preserves (1989, with William Schefferine) critiques the attempt to import the U.S. model of park conservation into a non-Western culture. A later mobile version is outfitted like a museum diorama on wheels, with sound effects of bird recordings, texts describing sustainable products, maps and charts. The mobile unit raises consciousness of the jungle as a laboratory of evolution, the richest and oldest expression of life on the planet.

Two publications and an exhibition entitled *Concrete Jungle* (1992-96, collaborations with Alexis Rockman and Bob Braine), and the foreboding *Tar and Feathers* (1996) consider the urban habitat and how our behaviours set in motion chain reactions of incalculable consequence in the natural world. Dion's environmental-art-as-activism closely follows the aesthetic politics of his former teacher Hans Haacke. Haacke's *Rhinewater Purification Plant* (1972) had a particular

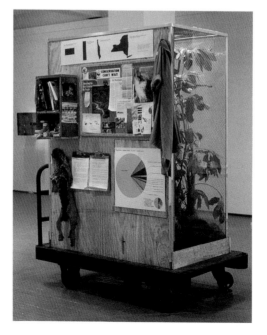

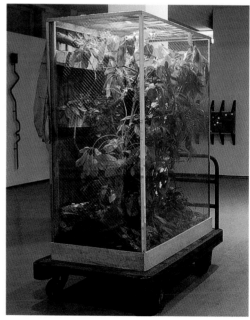

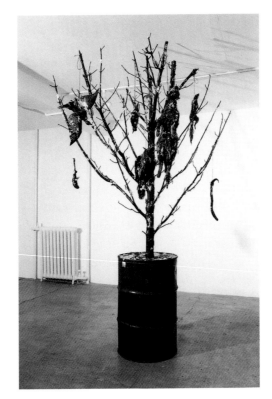

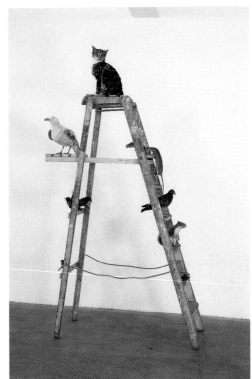

resonance for Dion. Created for the Museum Haus Lange in Krefeld, Germany, Haacke created his own ecosystem using samples of raw sewage and industrial run-off collected from the city's plants. Haacke's installation mimicks a laboratory with filled bottles of polluted water, a pumping system and a larger basin with goldfish in which cleaned water samples flowed. While the large basin resembles Minimalist sculpture, what was on 'exhibition' was really the state of Krefeld's water supply.[5]

With this group of politically and didactically based works, Dion began to consider how the problems of representation were applicable to other worlds. In particular, he was interested in 'nature' as a constantly reinvented rhetorical construction, and how these constructions articulated cultural anxieties about difference that separated *Homo sapiens* from other living creatures. In the early 1970s, Norwegian philosopher Arne Naess made a distinction between 'shallow ecology' – a human-centred view of the world in which nature is believed to exist solely for the use of humans – and 'deep ecology', in which the world is viewed as a network or web, with humans being only one of its many strands. Most important, 'the essence of deep ecology is to ask deeper questions, of all paradigms, structures and assumptions about the human-centred view of the world'.[6] In so doing, its advocates believe, humans will become sufficiently aware of the symbiotic connection between all things to make ethical decisions about the future. This advocacy of strenuous self-reflexivity and criticality in all areas of culture in order to salvage our ecosystem is central to Dion's later works. He cites the writings of paleontologist

Stephen Jay Gould, eco-critic Alexander Wilson and eco-feminist Donna Haraway as crucially significant influences. All three writers share a view of the environmental crisis as fundamentally a crisis of culture.

With irony and humour, Stephen Jay Gould's essays illustrate how often nature mocks the attempts of scientists to impose static form and order on evolving living systems. Despite such orderly structures as taxonomy and its embodiment, the museum, Gould's work demonstrates how the efforts of science to use formulae to explain the natural world is always defeated, since 'messy and multifarious' nature will never conform to its laws.[7] Alexander Wilson has analysed how theme parks like Disney World, museums, fairs, nature films and even state parks have become synonymous with 'The Environment', concealing value-laden perspectives about the natural world that are dangerous to our survival. His dismantling of these constructed environments reveals that '...

Killers Killed, from 'Concrete Jungle'
1994
55-gallon drum, 1 sycamore tree, prepared animal skins, tar, feathers, cord
280 × 225 cm
Installation, Marc Jancou Gallery, London

Back Alley Pyramid, from 'Concrete Jungle'
1994
Wooden ladder, prepared animal skins, cord
222 × 133 × 63 cm
Installation, Marc Jancou Gallery, London

Tropical Rainforest Preserves
(with William Schefferine)
1989
Wheeled terrarium, plants, Gro-lights, plywood, bulletin board, iguana, photographs, clipboards, clippings, drawings, books, specimens, animal skin
Installation, Clocktower, New York

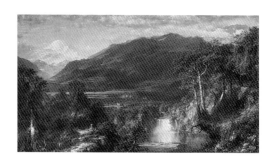

Frederick Edwin Church
The Heart of the Andes
1859
Oil on canvas
168 × 303 cm

the whole idea of nature as something separate from human experience is a lie. Humans and nature construct one another'.[8] Donna Haraway, like Wilson, agrees that nature is constantly reinvented by humans as a series of artificial constructs. Her primary interest is in how social relations – gender, race and class – shape scientific inquiry, make science anything but a neutral, objective method of understanding phenomena.[9] The positions of Gould, Wilson and Haraway are united in their insistence on the importance of taking a broad social and historical view questioning how our cultural assumptions shape and reshape 'nature'. Dion's own position insists on translating these insights into artistic practice. He remains convinced that the representational act is an ethically responsible contribution to furthering both theoretical discourse and environmental activism.

In a sense, the history of New Bedford, Massachusetts, the New England town where Dion spent his childhood, is a case study in changing attitudes towards nature. For over a century, the town has been one of the world's most important fishing ports. Once home to the world's largest whaling fleet, the town inspired Melville's *Moby Dick*. The whale eventually became a rare sight off New Bedford until its plight was recently taken up by the environmental movement. Today, the whale is protected and tourists line up in Provincetown, the tip of nearby Cape Cod, for places on whale-watching charters. Indeed, the New Bedford fishing industry is fighting for its life because of commercial overfishing.[10] Dion's interest in the natural world developed during his childhood in

New Bedford. He hiked, fished and studied specimens found near the salt marshes, bird sanctuaries and eroding, dune-swept beaches of Buzzard's Bay. He later discovered the art of three painters who had made their homes in or near the town – William Bradford, Albert Bierstadt and Albert Pinkham Ryder. In this place, Dion became absorbed with how the local cultural community represented its interaction with the natural world.

The nineteenth century saw a dramatic rise in the popularity of landscape as a subject of artists and writers in the United States. The doctrine of Manifest Destiny encouraged the charting of 'new' territories in North and South America and the polar regions. The young republic saw the signing of a bill that created the world's first wilderness park at Yosemite, California, a sort of 'botanical Parthenon',[11] which symbolized the nation's desire for validation through its natural monuments. William Bradford (1823-92), like Frederick Church (1826-1900) and Martin J. Heade (1819-1904), was one of a group of landscape artists who 'experienced', and painted, the frontier. Bradford, Heade and Church, excited perhaps by the explorations of Charles Darwin and other naturalists, made sojourns to obscure places in the tropics, the Arctic, and the Near East, in search of 'raw material' for their moody, reverential paintings. For these artists, 'virgin nature' could be dominated by aesthetic force and possessed through creations that rivalled her beauty. However, by mid century, much of the American landscape had, like the Hudson River, been tamed to ensure the prosperous development of commercial enterprises. One was as likely, perhaps

more likely, to find coal burning barges and grim warehouses gathering along the banks of the Hudson as a flock of wild birds. Such development made the painter's view of contemporary reality highly selective, their compositions requiring many adjustments to turn these evocative vistas back into a Garden of Eden.[12] Dion was impressed with the passionate responses of these artists to the natural world. He was also attracted to the idea of the travelling artist-explorer with paintbox in hand, using experiences of foreign environments as the source of an art which self-consciously constructs a luminous representation of nature before human intervention.

By contrast to their grandiose images, Albert Pinkham Ryder's (1847-1917) modest-sized paintings capture a distinctly private and independent view of sea and landscapes. *The Dead Bird* (late 1870s) is a particularly affecting example of how the intimacy of Ryder's compositions and his expressive use of thickly applied paint can evoke a highly emotional response. This sensitive depiction of a dead songbird is a marked contrast to the more common *trompe l'oeil* compositions of dead game birds as hunting trophies popularized by Ryder's contemporary, William Harnett. The work encourages the viewer to empathize with the tragic plight of the bird, a point of view that appealed to Dion's own disposition towards a decentring of human experience.

As an art student, Dion was challenged by the prospect of bringing together his commitment to ecological awareness and the process of art-making. He found in the writings and activities of Joseph Beuys and Robert Smithson two perspec-

tives that became formative models. Beuys, with novelist Heinrich Böll, founded the Free International University for Creativity and Interdisciplinary Research in order to promote an understanding of art as connected to all other activities, a view that did not restrict its practice to trained arts professionals. To Beuys, 'Social Sculpture' based upon interactive dialogue had the potential to be transformative and healing. In the action *Coyote, I Like America and America Likes Me* (1974), Beuys shared living quarters with a live coyote in the René Block Gallery in New York.[13] Beuys often used animals to teach the lessons of social ecology – 'the cultural characteristics and patterns of social organization that have brought about the current ecological crisis' – and ecofeminism – how the domination of man over the natural world reproduces his domination in society, leading to mutually catastrophic destruction.[14] Dion's use of blackboards, sleds, animal toy surrogates, specimen jars and symbols of healing are among the numerous visual quotations that express his indebtedness to Beuys.[15]

Dion decided that, like Beuys, he too would create works that were uncategorizable by medium, would blur the lines between art and pedagogy, and invite participation by the viewer. Dion often works cooperatively with individuals of many backgrounds, intentionally disrupting the notion of an originating author. In this way, his works attempt to undermine the authoritative voice of the artist, honouring and encouraging the audience's capacity to make associations and form independent meanings that are not merely an extension of his own.

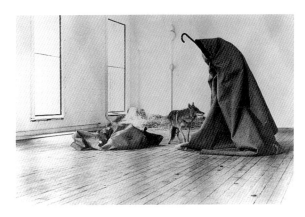

Albert Pynkham Ryder
Dead Bird
1890s
Oil on wood
11 × 25 cm

Joseph Beuys
I Like America and America Likes Me
1974
Week-long action with coyote at
René Block Gallery, New York

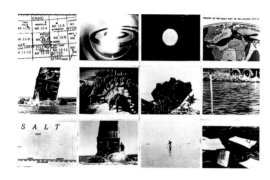

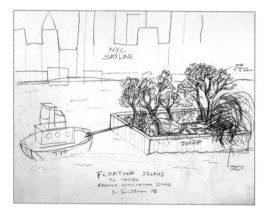

Robert Smithson
The Spiral Jetty
1970
35 mins.
16 mm film on 1500-long
sculpture in the Great Salt Lake,
Utah, co-editors Bob Fiore and
Barbara Jarvis
Filmstills

Robert Smithson
Floating Island to Travel Around
Manhattan Island
1970
Pencil on paper
48 × 61 cm

This aesthetic position by its very nature puts into question the ideological structures of institutions and the cultural assumptions they embody. Excavating 'established attitudes about art, knowledge and culture' was also the primary activity of Robert Smithson.[16] Smithson's interest in 'examining the apparatus I am being threaded through' – the art world system – led him to create works such as *Spiral Jetty* (1970), 1500-foot long and 15-foot wide earthwork of black rock, salt crystals, earth and red water algae in the Great Salt Lake, Utah.[17] Behind such works was a self-conscious resistance to the institutionalized mechanisms that usually determine the making and exhibiting of art. Using organic, 'non-art' materials in monumental works that accept the flux and decay of natural processes as part of their meaning, Smithson's use of time disrupted conventional expectations of art's permanence. Smithson's view of the museum included a pointed critique of its arbitrary categorization of fragments and artistic media. 'The categorizing of art into painting, architecture and sculpture seems to be one of the most unfortunate things that took place. Now all these categories are splintering into more and more categories, and it's like an interminable avalanche of categories ... '[18] This futile and self-defeating activity amused Smithson, who liked museums precisely because of their 'uselessness'.[19] Smithson argued that Art, Time, Nature, Truth – the authoritative language used by museums to validate their categories – merely fills the voids of what they cannot account for. This is as true for museums of natural history as for art museums, 'there is nothing "natural" about the Museum of Natural History. "Nature" is simply another eighteenth- and nineteenth-century fiction'.[20] According to this view, museums are not their collections, but a collection of historic perspectives on what constitutes knowledge. From Smithson, Dion developed an ongoing fascination with the museum as an artefact of its own past.

Smithson's observations about the museum were not the only ones to influence Dion. During the mid 1980s, the view of these institutions as embodiments of value systems that enable one group to dominate or impose its views on another was a prevalent topic of discussion that became central to the work of many critics and artists, some of whom were Dion's contemporaries.[21] Marcel Broodthaers' *Musée d'Art Moderne, Département des Aigles*, in particular, would provide Dion with the basis of his own, later 'museums'. Through Broodthaers' fictional museum, Dion also absorbed Duchamp's legacy – the displacement of the authority of the museum, the artist and the definition of art.

Related projects by Dion and his peers included creating museums or assuming the behaviours of curators and academics engaged in museum activities. Examples include Andrea Fraser's 'backstage' performances as the museum docent 'Jane Castleton' at the New Museum for Contemporary Art in New York and the Philadelphia Museum of Art; Renée Green's *Mise-en-Scène*, a fictional museum of decorative arts displaying aspects of the slave trade in eighteenth-century France; *Mining the Museum* (1992-93) at the Maryland Historical Society, Fred Wilson's critique of the racially-biased acquisition and exhibit

policies of museums with permanent collections; and David Wilson's still evolving *Museum of Jurassic Technology*, a postmodern *wunderkammer* that is equally convincing as a Conceptual Art project and as an odd simulacra of an early science museum.

Dion's first 'museumist' project was *Artful History: A Restoration Comedy* with Jason Simon (1988), a film based upon a series of installations, performances and magazine articles. The series drew heavily on Dion's four-year stint in an art conservation studio specializing in Hudson River School painting and American 'primitives'. The film is a wry, controlled parody made credible through near-perfect simulation of the clichés associated with the documentary format: voice-overs of experts, slow and sentimental panning over the scarred and pitted surfaces of the damaged goods, and elaborate rationalizations of intentions that nearly validate the capital-driven actions. However, the film goes off-kilter at unexpected moments; one-too-many genre scenes are denuded of their complexity and selectively reduced to a series of quaint still lifes. These subtle visual incongruities expose the profiteering and historical revisioning of collectors and museum curators hidden behind the decision-making processes in the restoration field.

By 1989, Dion was fully immersed in creating historically-based tableaux: four types of libraries and desks of museum directors and explorers; bureaucracies and laboratories engaged in collecting and categorizing; *wunderkammer* and natural history museums; and 'practicum' – projects that intervened in museum activities, becoming a seamless part of their daily life with Dion emulat-

ing the roles of curators and museum educators. Dion's museum environments assimilate all the presentation vehicles employed by these institutions over the past four hundred years: the plethora of orderly vitrines and over-stuffed shelves, peculiar combinations of diverse specimens, informational texts, dioramas, simulated mises-en-scène, Disney-style special effects, theatrical lighting and even their overpowering and unforgettable perfume 'odours ... known to museum professionals throughout the world – dust, mothballs and formaldehyde'.[22] These works undermine the perception of certainty and inscrutability of the scientific system by illustrating the internal ironies lodged in the practices of natural scientists and the museums. While artists like Smithson deconstructed and then turned away from the museum, Dion, a self-described 'museum conservative', has returned to it again and again as an inexhaustible source of visual and intellectual pleasure. He relishes the opportunity to visit places like the Teyler Museum (Haarlem, The Netherlands) or the Hessisches Landesmuseum (Darmstadt, Germany), institutions that remain nearly intact examples of the earliest manifestations of the museum. This 'undeniable admiration for the institutional venues in which he works', distances Dion's position from the critiques of the colonialist agendas of museums put forth by Fraser, Green and Wilson.[23] As Stephen Jay Gould and many others have observed, the history of elitism coexists in the 'cabinet style' museum *along with* their breathtaking variety and extraordinary quantity of things.[24] While far from naive regarding their

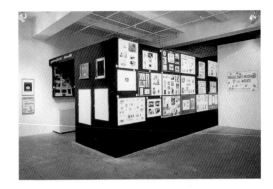

Marcel Broodthaers
Section Publicité Musée d'Art Moderne Département dea Aigles
1968-72
Installation, Marian Goodman Gallery, New York

Fred Wilson
Mining the Museum (detail, 'Metalwork')
1992
Metal objects, labels
Installation, the Contemporary, Baltimore

pasts, Dion's affection for the locus of his imaginative speculations is intimately connected to his unflinching conviction that *visuality* can trigger powerful associations that defy categorization, offering insights into culture that transform that 'odour' of mould and mothballs into a heady perfume.

Dion's 'model' for these arrangements begins with the *wunderkammer,* an encyclopedic, albeit idiosyncratic collection of rare objects, natural wonders and curiosities amassed by aristocracy and wealthy bourgeoisie from the sixteenth through eighteenth centuries.[25] The inventory of a typical *wunderkammer* included examples of *naturalia* (specimens created by God: animals, vegetables and minerals and unique examples of nature's oddities and deformities); *artificialia* (things made by man such as paintings, sculpture, musical instruments and scientific inventions and hybrid combinations of elements made by nature but 'perfected' by man, perhaps a nautilus set in an ornate gilt mount and transformed into a vessel; *antiquitates* (objects of historical significance such as medals of rulers); and *ethnographica* ('exotica' associated with Native peoples from the New World). In 1673, Edward Brown inventoried the bizarre and varied contents of a 'Chamber of Rarities' owned by Herr von Adlershelme, Burgomeister of Leipzig, in his *A Brief Account of Some Travels in divers Parts of Europe* ...

'An Elephant's Head with the dentes molares in it. An Animal like an Armadillo, but the scales are much larger and the Tail broader. Very large flying Fishes. A Sea horse. Bread of Mount Libaus. A Cedarbranch with the Fruit upon it. Large Granates as they grow in the Mine. A Siren's hand. A Chameleon. A piece of Iron, which seems to be the head of a Spear, found in the Tooth of an Elephant, the Tooth being grown about it. The Isle of Jersey drawn by our King Charles the Second [...] A picture of our Saviour [upon] the Hatches [of] which are ... written ... the story of his Passion. Bevers taken in the River Elbe. A Picture of the murther of the Innocents, done by Albrecht Durer. Pictures of divers strange Fowls. A Greenland Boat. The skins of white Bears, Tigers, Wolves and other Beasts. And I must not omit the Garter of an English Bride, with the story of it; of the Fashion in England for the Bridemen to take it off and wear it in their Hat, which seemed so strange to the Germans, that I was obliged to confirm it to them, by assuring them that I had divers times wore such a Garter my self'.[26]*

Displayed in glass cabinets, on shelves, set in niches and hanging from ceilings, the assorted contents of a *wunderkammer* were seen in one contiguous space as a holistic group of objects that could be touched and rearranged poetically to produce a kind of awe that could enlighten the mind, delight the senses and encourage conversation. Objects might be divided in any number of ways, for example, by the type of material they were made of, or according to a philosophical statement, such as that depicted in a painting of the Archdukes Albert and Isabella in their collector's cabinet (1626).[27] More usually, the objects were organized according to what was visually pleasing to the owner generally without

Linnaeus
1992
Key cabinet, photograph, dead
leaf, botanical print, specimen
pins
26.5 × 20 × 6 cm

regard for function, origin, historic continuity, artistic style or school. Comparisons might suggest similarities between cultures by juxtaposing a multitude of objects from different cultural groups, or the endless artistry in nature as embodied in a bountiful array of objects of a particular shape or design. Ancient inscriptions on antique architectural fragments awaited the collector's eye to rearrange them by ornamentation without heed to their meanings.[28] Moreover, these collections were neither completed nor systematized because God had made nature infinite and the 'order of nature was not shackled to coherent sets of laws, but was subject to unlimited variability and novelty'.[29] These arbitrary *visual* arrangements therefore seemed 'natural', and capable of revealing knowledge that was at once empirical and metaphorical without need of explanatory texts. They were ripe for projecting an endless, fluid play of subjective and visually generated meanings for the conversation and entertainment of the restless, spirited collectors and their friends.

With the development of Linnaean taxonomy – a universal system of classification formulated by Carl Linnaeus in the first half of the eighteenth century – the endless play of meaning possible in the *wunderkammer* was superseded by the rational structures governing the display practices of the modern museum. At institutions such as the Zwinger Palace Royal Collections (Dresden), the Habsburg Collections (Vienna), or, one of Dion's favourites, the Teyler Museum, founded by Pieter Teyler van der Hulst (1702-78) in Haarlem, we no longer find paintings, inventions, navigational tools and fossils in

a single room.[30] While Teyler conceived of a museum of art and natural history under one roof, the collections were divided into separate galleries for each. Museums like the Teyler signal the advent of the process of forever severing these two experiences of the world from one another. Soon, each gallery had its separate display language. Paintings were framed and hung on satin walls; minerals arranged by type in endless flat vitrines; and the library became a separate entity of its own, removing the object studied from the site of scholarly publication. Most important, specimens are labelled, catalogued, named and explained. Knowledge is elucidated now through the verbal rather than the visual.

Within each 'field' of study, levels of specialization increased at an exponential rate. Collectors and the museums they created required their own keepers and librarians, experts in art history, geology, physics, numismatics and paleontology. The birth of the museum was simultaneous with the birth of academic departments – a 'disciplining' of knowledge that soon required that the museum of art and the museum of natural

history become architecturally distinct. Thus one finds the American Museum of Natural History and the Metropolitan Museum of Art in New York, for example, located on two sides of the same park. The splitting of the disciplines in the New York museums, as in many other cities, resulted in ongoing 'problems' of classification; how to classify objects of indigenous African cultures called 'anthropology' in the former and 'art' in the latter.

This amputation of the limbs of inquiry from the body of knowledge and experience marks a decisive rupture in the concept of nature as infinitely variable and uncontainable. Now, nature could be contained within the finite constructions of *genus* (the family name) and species (the individual name). 'Sets' of objects could be made complete with dedication and, over time, through gruelling field work in the most inhospitable conditions. Behind the field work of explorers and scientists sponsored by museums was an insatiable demand for closure, to find examples of all living creatures, to number, label and enter each one in its proper vitrine for posterity. Exploration of unknown places led to 'discoveries'. The students of Linnaeus, with his *Systema Natura* (1735) under their arms, travelled with explorers like Captain Cook to the Dutch East Indies and South Pacific in search of new fruits, insects, and animals to name and collect. For the early naturalists, the orderly act of naming was a way of gaining control over the foreign 'chaos' found in the jungles and forests of new lands. Bringing their booty back to the west for display was the final act of taming the vast unknown they had encountered. What they could not foresee was the irony of their own enterprise. While collecting specimens to complete their categorizing, scientists, amateurs, and those obsessed with the mere act of collecting, destroyed numerous groups of living things, and sometimes, as in Nabakov's short story 'Terra Incognita', themselves. Today, the act of listing is more likely to include the names of examples of extinct or about-to-become-extinct species.

In Dion's *Selections from the Endangered Species List (the Vertebrata) or Commander McBrag, Taxonomist* (with William Schefferine, 1989), the first in a series of installations about 'Great Naturalists', contradictory but comparable activities of the Enlightenment taxonomist are merged with those of the contemporary environmentalist. Taking the tone of a *vanitas* still life, the fictional desk arranged with the 'tools of the trade' allegorizes extinction using emblematic texts and props. These include index cards with the names of endangered vertebrates and books describing the process of naming that was in part responsible for their disappearance; quotations from John James Audubon, the Catskills naturalist John Burroughs and Daniel Boone, bemoaning how much wild life has disappeared as early as 1803; and mnemonic objects: an extinguished candle, a dinosaur model, a picture of 'Martha', the last of the passenger pigeons, which became extinct in 1914.

Later great naturalists' 'portraits', real and fictional, are also set in their personal libraries. These installations examine the destructive conjunction of empirical acumen and willfully

selective vision in those who dedicated their lives to observing and classifying the natural world. These works rely heavily on historical data and literary allusions, and associations from the past are used to shed light on the present. *Extinction, Dinosaurs and Disney: The Desks of Mickey Cuvier*, (1990) portray Baron Georges Cuvier, the early nineteenth-century zoologist and founder of comparative anatomy, who built upon Linnaeus' taxonomy and demonstrated the phenomenon of extinction. Cuvier was a driven man with great discipline and an inexhaustible desire for learning. His eccentric daily habits consisted of moving hourly between his seven libraries and workrooms, each of which was devoted to a separate area of study ranging from ichthyology to law. He was also extraordinarily competitive and fervently Christian, a combination that motivated his crushing attacks on Lemarck and the supporters of evolution. Ironically, it was Cuvier's expanded notion of geological time that led to the theories of evolution and natural selection that he fought vociferously against; Cuvier's research supported what his faith would not allow. Throughout this and other thematically linked installations, Dion exploits these twists of fate that seem to characterize the scientific world.

Cuvier is symbolized by four costumed Mickey Mouse characters each working at four desks overflowing with objects associated with the naturalist's seven daily disciplines. Each desk represents one of Cuvier's contributions to the history of natural science: *M. Cuvier 'Discovers' Extinction, Deep Time/Disney Time, Taxonomy of Non-endangered Species*, and *The Fixity of a Rodent*

Species (based upon Cuvier's mistaken theory of the fixity of species – the belief that one species cannot become another). The animated tableaux are activated by floor buttons that trigger a lecture by Mickey, appropriating Cuvier's theories to expose the authoritarian world of Disney.[31] The tableaux imitate those found in Disneyland, where animal characters proselytize about 'truths', or the 'official' version of world history or natural science constructed by the entertainment conglomerate. Created for Galerie Sylvana Lorenz in Paris, the

Deep Time/Disney Time
1990
Antique writing table, chair, cushion, animated Mickey Mouse figurine, feathered hat, globe, bust, hourglass, books, 2 candles, 2 candlesticks, magnifying glass, specimens, hammer, file, arrow, fossils, maps, audiotape
110 × 120 × 130 cm

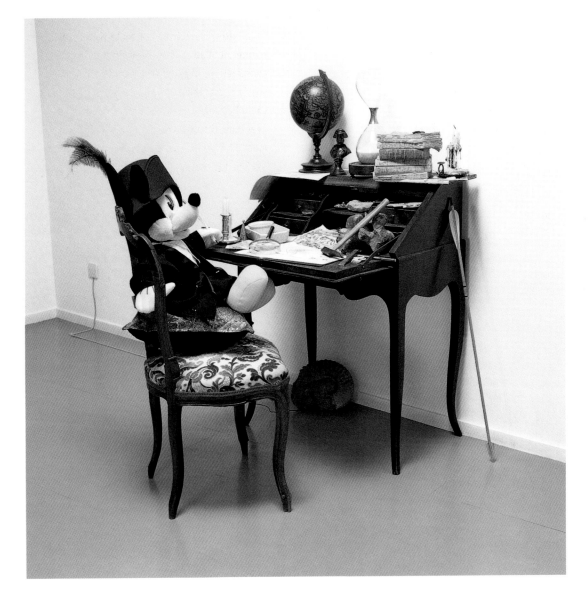

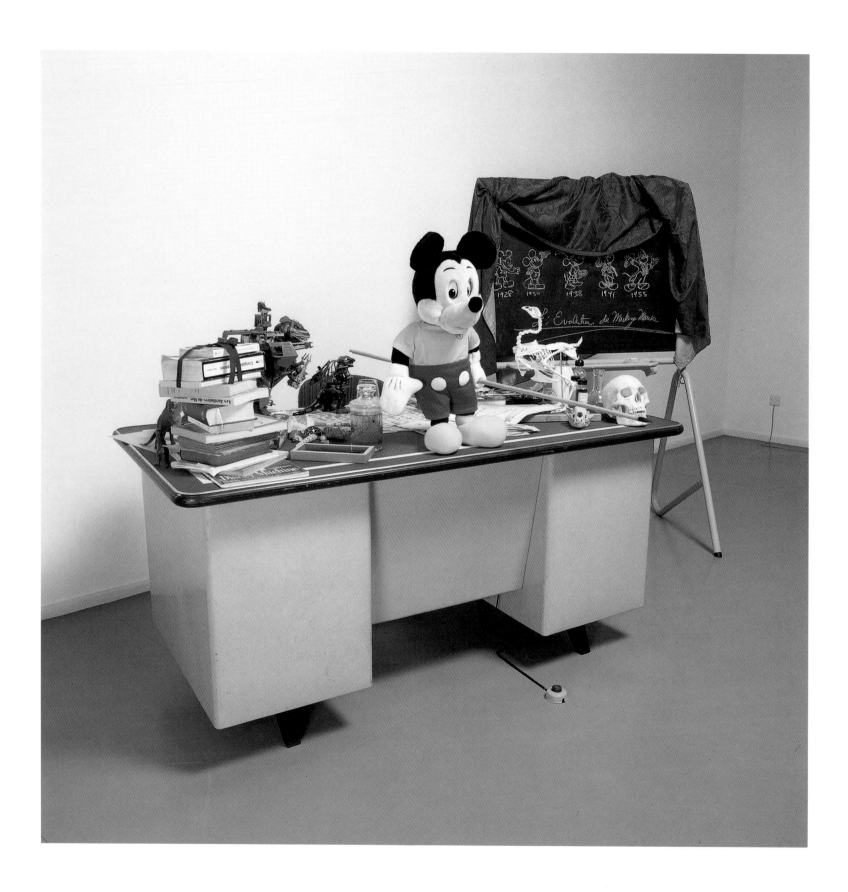

The Fixity of a Rodent Species
1990
Desk, animated Mickey Mouse
figurine, blackboard, curtain,
animal skull, nineteenth-century
etchings, bird skeleton, books,
toys, pointer stick, specimens,
eggs, tea cup, Tyrannosaurus Rex
models, dissecting kit, audiotape
150 × 300 × 150 cm

work was exhibited to coincide with the opening
of EuroDisney in a Paris suburb that fed into the
French fear of this 'American Versailles' colonizing
their local countryside.

Continuing to overlap the fictional and the
factual, *Frankenstein in the Age of Biotechnology*
(1991) depicts the workspace of Dr. Frankenstein,
the main character of Mary Shelley's gothic novel.
The installation is currently on view in a vaulted
basement gallery in the atmospheric Frankenberg
Castle in Aachen, Germany (coincidental pun
intended!). It provides a compressed history of
the arrogant attempts to recreate nature in our
own image and according to our own desires, from
Pinocchio the artificial wooden boy, to the hybrid
animal-human smurf, to genetically altered fish.
Strong and unanticipated visual juxtapositions
encourage the viewer to consider how to intervene
in the invisible decisions that biotechnology
corporations are making about our relationship
to the natural world. The sights and smells of
the dark, subterranean installation intensify
the catalytic possibilities of intense visceral
experience. The entryway is overpowered by smells
of mildew, rot and formaldehyde (traces of the
early natural history museum *and* the laboratory),
emanating from the rusting farm implements,
fermentation equipment, bloodsoaked cotton balls
and specimen jars full of neon liquids and floating
faux body parts. Once adjusted to the cavernous
space, the eyes perceive a disjunction between
the antique, primitive tools used in early attempts
at biotechnology – farming, brewing, gardening
and animal husbandry – and the reflected, techno-
logical light bouncing off the tiled, modern work

table, the stainless steel surgical tools, the glass
vials, the plant growing equipment, the metal-
tipped syringes and the day-glow hazardous waste
bags. The incongruous spaces are 'bridged'
thematically by a field of amusing visual-verbal
associations created by Dion's use of existing signs
painted on the stone walls – 'Rauchen verboten!'
(Smoking forbidden!), – on the found objects
('Atlas' skies) and the spines of related books.

The installation was originally accompanied
by an issue of *The Daily Planet* newspaper, a parody
of the comic strip Superman, perhaps the most
famous artificially 'enhanced' hero in pop culture.[32]
In a mock interview between Superman, in the
guise of reporter Clark Kent, and Dr. Frankenstein,
Dion allows the scientist to redeem himself after
abdicating responsibility for the monster he
created and abandoned. Frankenstein disavows
biotechnology as 'a series of novel techniques'
in the service of industry, not a 'real' science,
and one with unforeseeable consequences for
ecosystems. He prevails upon humans to absorb
the lesson he has learned the hard way, to face the
monstrous conditions we, too, may be creating as

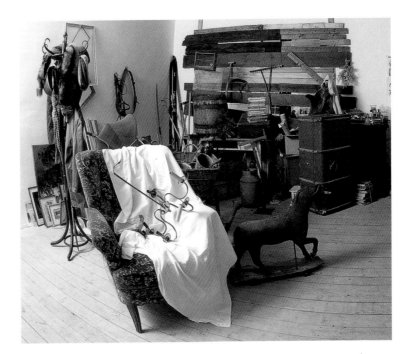

left and overleaf, **Frankenstein in
the Age of Biotechnology**
1991
Laboratory equipment, boar's
head, frames, old photographs,
paintings, tools, pram with toys,
sleigh, beer barrel, cow skin,
taxidermic pigeon, various
liquids, books, glassware, fishes
in alcohol, medical charts,
sporting equipment, milk can,
model human skull, model giant
fruit, dead plants, model human
body parts, surgical tools, stool,
scale, blankets, bow and arrow,
gun, cobwebs, hobby horse,
cuckoo clock, furniture, trunks,
coat stand, fur stole, clothing,
chandelier, gardening tools
Installation, Galerie Christian
Nagel, Cologne

Survey

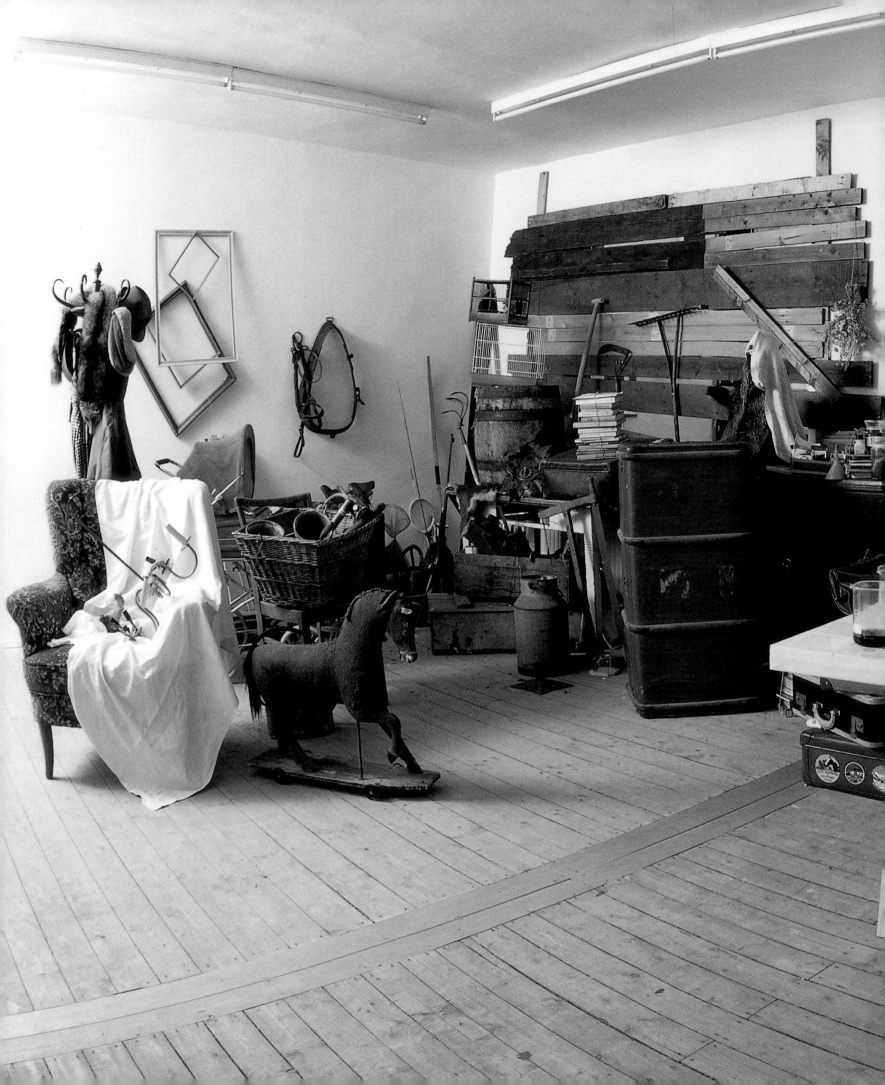

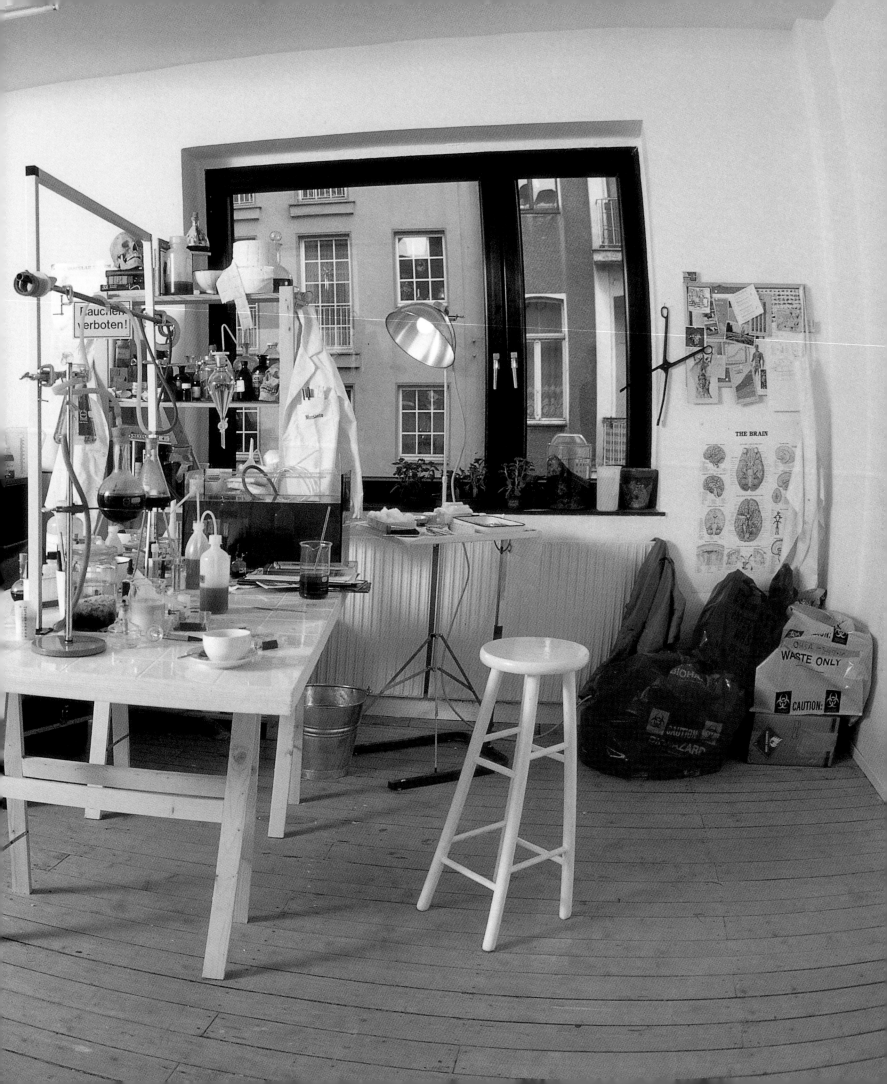

Daily Planet, from 'Frankenstein in the Age of Biotechnology'
1991
Printed 4-page newspaper
55.5 × 35 cm

we 'make' something that we are calling 'nature'. Stacks of empty picture frames near old still life paintings ask what it means to make an art work about nature, and remind us that nature, whether on the canvas, in the museum or in the laboratory, is always being framed.

The nineteenth-century scientist, as Dion has pointed out, 'embodies a whole bunch of dichotomies, intentions and relations ... The character who is logical, rational and systematic also does not have common sense and completely disregards personal safety and comfort'.[33] These naturalists combined the machismo of the obsessive collector of delicate things with the 'psychotic' drive of the effete classifier; the violent colonial in the guise of the explorer with the pacific countenance of the conservation-minded professor. *The Delirium of Alfred Russel Wallace* (1994), one of the more recent additions to Dion's series, considers the contradictory nature of Alfred Russel Wallace (1823-1913) who shares with Charles Darwin the distinction of founding the theory of evolution by natural selection.[34] Constrained educationally and by his social class, his contribution to 'Darwinism' has been occluded by his wealthier and more widely recognized contemporary. A devoted natural historian, Wallace travelled to Para, Brazil, on to the forests of the Amazon Basin and later to Rio Negro, in search of proof that new species originate through sexual reproduction rather than from a 'divine' source. To support his activities, he and his colleague Henry Walter Bates supplied specimens of insects and birds to British natural history collectors. Returning to England during

a bout of malaria, his boat sank, and with it, his own extensive collection, notebooks and drawings chronicling the expeditions. Undeterred by his misfortune, Wallace used the insurance money from the accident to travel to the Malay Archipelago (modern Indonesia) where, observing the Orangutan in its habitat, he identified the 'Wallace Line', the boundary in Malaysia at the junction of tectonic plates separating Asian-derived animals from those from Australia. He later developed a theory of natural selection.

Wallace was without the benefit of the academic system or the scientific methods that contributed to Darwin's immortalization and was, thus, never legitimized by the 'establishment'. His reputation as an eccentric liberated his ability to act as an outspoken advocate for conservation, social justice and spiritualism. In Dion's installation, an electronically activated fox lying in a canopied hammock and surrounded by traps, trunks and collectibles, symbolizes Wallace. Contemplating the trajectory of his life aloud in a feverish state, his semi-conscious free associations wander from the danger of Eurocentrism to the mysterious individual soul that set *Homo sapiens* apart from animals, to his thwarted search for the truth. Rocking beneath the live palms in the torpor of Dion's mock-jungle, Wallace recognizes the internal contradiction of his own enterprise as a specimen hunter. 'Even in taking its [the specimen's] life, there was the thrill that in death this creature's beauty would last forever'.[35] Of the works in this series, *The Delirium of Alfred Russel Wallace* feels the most personal, as though Dion experienced a profound identification between

DAILY PLANET.

APRIL 5, 1991

Science of the Planet

B1

The Clark Kent Interviews:
Discussions in Science and Technology
Today: Dr. Victor Frankenstein
Visionary Microbiologist

Kent: Your presentation last week at the Hammer Conference on Biotechnology in London sparked an enormous controversy. In fact, it caused what can only be described as a riot. What did you say?

Frankenstein: I told the truth. The Hammer Conference is one of the few forums in which the popular press and the public directly interface with the bio-technocrats who control the genetic engineering industry. I merely presented a paper expressing concern over the direction the industry I helped to develop was going in, and answered some questions about ethics, safety and the scope of the biotechnology revolution.

I said that biotechnology leads us to reinvent ourselves to assume a more planetary role, that this entrancement allows us to recreate the natural world in our own image, to serve our needs of productivity and efficiency. What I did not do, is give the usual noble speech about the race to feed the planet and eliminate disease, because that is not necessarily what the companies which drive the bio-tech-revolution are interested in. Unless these pursuits translate into substantial profits.

Stating that this new technology was not a neutral tool in itself upset many people. Advanced science is something frightening to the public because it is a powerful and potentially destructive force with a history of abuse, because its goals and values are those of corporate or state leadership and because to many people, the idea of „progress" translates into something which endangers our lives and futures.

When a participant in the conference asked me why the public has so little say in the debate over biotechnology, I had to answer that it is because they have not challenged the shibboleth of progress. This is the ruling paradigm for science and technology. It dictates that once a technology is developed it will be used. What can be done must be done. The problem is that progress is essentially a matter of trial and error. Therefore, unlike my colleagues, I believe that the public's concern over the potential hazards of biotechnology are not out of anti-intellectualism but out of legitimate concern. After all, commercialized genetics has proceeded with such haste - with little or no scrutiny or commentary from the outside - that the public remains largely uninformed about its dimensions and implications.

What caused the most reaction was when I claimed that the official assurances of safety, in light of the past record of industrial mishaps,

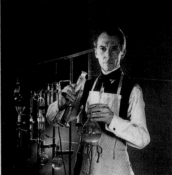

Dr. Frankenstein in the Age of Biotechnology
Photo: Jimmy Olsen

in the chemical, nuclear and waste disposal industries, will no doubt prove false. This statement caused me to lose my positions on the advisory boards of both Monsanto and Hoechst.

Kent: Can you explain to me what biotechnology is?

Frankenstein: When I say, „biotech", I'm speaking narrowly, about genetic engineering. Over the past twenty years, researchers have made unprecedented developments in the direct manipulation of the genetic makeup of living things. This means the manipulation of genetic material through intervention at cellular and molecular levels rather than at the level of fully developed plants and animals. It is now possible to ship, insert, recombine, rearrange, edit, program and produce genetic material at the smallest possible scale -individual genes. This means that we can alter the very blueprint of life. We can give organisms traits from other organisms or we can produce novel organisms. At this point we are in the infancy of this technology. Genetic engineering is not so much a science yet, but rather a series of novel techniques, the effects of which are being investigated through the traditional scientific methods.

As a new technology, it promises many benefits and will have its most immediate impact on the commercial sectors of pharmaceuticals and agriculture. The products being developed fall into two broad categories: the chemical substances that can be synthesized from biologically engineered organisms (for

example, hormones produced from engineered microbes) and genetically altered organisms themselves.

Kent: It does not seem, to me, that biotechnology is different from what breeders have been doing to improve agriculture for millennia.

Frankenstein: Selective breeding is to genetic engineering what the abacus is to the super computer. Make no mistake about this -

Continued on Page 2

Frankenstein Abandons Creation

Proposals On Genetic Technology

U.S. Panel Urges Easing of Regulation

By Edmund L. Andrews

Special from The New York Times
WASHINGTON, Feb.18 - A White House task force on biotechnology policy has recommended that the Government develop regulations that simplify the approval of genetically engineered crops, pesticides and animals.

In a report to be released Tuesday by the White House Council on Competitiveness, headed by Vice President Dan Quayle, the panel urges regulators to evaluate products made through gene splicing just as they would treat comparable products made through traditional methods.

If adopted by Government agencies, the recommendation could make it much easier for biotechnology companies to win approval for things like genetically engineered crops that resist pests or frost; "transgenic" hogs and cows that grow faster and microbes that break down sewage and toxic waste. But environmental groups, among others, warn of risks.

Seeks to Ignore Process

In essence, the report urges regulators to ignore the fact that such products are created through genetic engineering and to focus on a product's inherent characteristics. For example, regulators looking at a new breed of pest-resistant tomato would look at the plant's likelihood of becoming an out-of-control weed and at any risk posed by a toxin the plant may give off in fighting insects. The fact that the tomato was produced through ge-

Continued on Page 2

A Genetically altered Catfish, grow bigger and faster than natural relatives.
Photo: Bob Brame

New Prospects for Gene-Altered Fish Raise Hope and Alarm

WITH quickening speed, scientists are genetically engineering new strains of fish, producing faster-growing, larger strains but raising concerns about whether Government regulation will move fast enough to head off potential environmental problems.

„On one side of me I see people saying, 'Oh, my God! We're going to have Frankenstein fish," said Dr. Eric M. Hallerman, a geneticist at Virginia Polytechnic Institute and State University. „On the other side I see people saying, 'We're going to feed the world."

Scientists have modified the genetic structure of goldfish, carp and channel catfish to make them grow bigger faster. Soon, they say, they will be able to create fish that withstand heat, cold, disease and toxins that pollute waterways, as well as sport and aquarium fish that are bigger, prettier and more feisty.

Though it will be some time before such fish appear on the nation's dinner tables, scientists say genetic engineering will transform commercial aquaculture, or fish farming.

Alarm Over Impact

In the five years since Chinese scientists first transferred a human growth hormone gene into goldfish, researchers have successfully transferred a foreign gene into fish at least 27 times. They have put genes from people, cattle, chickens, mice and other fish into a number of species from Atlantic salmon and rainbow trout to wall-

eye and northern pike.

The proliferation of experiments has alarmed environmentalists and many scientists, who say these new transgenic strains could profoundly disrupt fragile aquatic ecosystems.

„We have created new organisms," said David P. Philipp of the Illinois Natural History Survey, a state research center. „Without safeguards the release of these fish - whether intentional or inadvertent - has the potential of impact the environment."

Since the 1970's, when scientists learned how to isolate and splice genes, researchers have mixed genes from other species into scores of microbes, plants and mammals, including laboratory mice and farm animals such as cattle.

In 1985, researchers at the Institute of Hydrobiology at the Academy of Sciences in Wuhan, China, reported the first successful gene transfer in fish. The researchers, led by Dr. Zuoyan Zhu, injected a gene that regulates human growth into the eggs of 3,000 goldfish. As the eggs developed, the gene was integrated into the chromosomes of more than half the fish. Some of those grew to two or four times their normal size.

„It still needs some time," said Dr. Zhu, who is working at the Center for Marine Biotechnology at the University of Maryland. „But I think there is potential."

In many ways fish are proving easy to manipulate compared with mammals, since the female lays many large eggs that develop outside her body. Once scientists have isolated a gene they want to trans-

plant, they inject it into fish eggs using a microscopic needle. Then, by means they do not yet fully understand, the foreign gene is spliced into the chromosomes of some of the eggs.

Offspring Grew Faster

The first gene transfer in the United States was reported three years after Dr. Zhu's. Using a similar technique, a team of scientists from the University of Maryland, Johns Hopkins University and Auburn University transferred the gene that regulates growth in the rainbow trout into common carp.

The carp, which are kept in ponds on the Auburn campus in Alabama, have grown 20 to 40 percent larger than their natural relatives.

„Not only did they grow bigger and faster, but their offspring grew faster too," said Dr. Dennis A. Powers, a leader of the team.

Dr. Powers, now director of the Stanford University Hopkins Marine Station in Pacific Grove, Calif., and his colleagues, Dr. Thomas T. Chen at Maryland and Dr. Rex A. Dunham at Auburn, have also transferred the gene into channel catfish.

In Newfoundland, a research team has isolated the gene that allows the winter flounder to live in sub-zero temperatures through the winter and introduced it into Atlantic salmon.

The frigid waters of Newfoundland, where temperatures fall to about 28 degrees, are an inhospitable winter home for Atlantic

salmon, which cannot survive below about 30 degrees. Anti-freeze proteins in the winter flounder and other fish lower the freezing level of their blood.

Dr. Garth L. Fletcher of Memorial University of Newfoundland in St. John's said he has successfully integrated the gene that produces this protein into the salmon, though not yet at levels high enough to prevent the salmon's blood from freezing.

„It's a far-out experiment," said Eugene B. Henderson, director of the New Brunswick Salmon Growers Association. „But if in fact it worked, it would have a tremendous impact on the potential to grow salmon."

A 'Blue Revolution'

While it will be at least a few years before stable strains of genetically altered fish are ready for commercial use, scientists like Dr. Fletcher say their experiments will revolutionize fish farming, a $900 million industry in the United States.

Strains of fish that grow bigger faster and are resitant to diseases could spark a „blue revolution" in aquaculture in the way fertilizers, herbicides and pesticides sparked a „green revolution" in agriculture.

While the experiments have expanded scientists' understanding of genetics, many environmentalists and scientists say genetically altered fish could have an adverse impact on fragile aquatic ecosystems if ever released into the wild.

„Scientists ring up, 'Feed the world,' and all objections are sup-

posed to fall away." said Dr. Jane F. Rissler of the National Wildlife Federation. „The question we have to ask is are the risks worth the benefits. Why are we exploiting the benefits of these organisms to satisfy our interests?"

For their part, scientists say they do not intend to release genetically altered fish into the wild but rather confine them to aquaculture farms or laboratory tanks.

Regulations Are Criticized

But environmentalists and scientists say that regulations in the United States controlling the research and release of genetically engineered fish are vague, allowing the opportunity for mistakes or abuse.

Since the early 1970's the National Institutes of Health in Bethesda, Md., has issued guidelines controlling recombinant DNA research in laboratories receiving Federal money and recommended that private institutions comply. The Department of Agriculture is in the process of setting its own guidelines over experiments conducted outdoors.

So far, only Dr. Zhu's fish in China and the carp and catfish in Alabama are being held outdoors, and in both cases the fish are confined in ponds covered in netting with drains wrapped in wire mesh to prevent escapes.

In the case of the Auburn carp, Dr. Rex Dunham requested permission from the National Institutes of Health and the Department of Agriculture to hold the fish in

outdoor ponds, though he said he was „technically and legally not required" to do so.

In Nov. 14, the Department of Agriculture approved a new request by Dr. Dunham to put into similar ponds hundreds of fry, the offspring of the roughly 50 transgenic carp and catfish in the ponds now.

Recognizing loopholes in regulations, the American Fisheries Society, an organization of fisheries scientists, has recommended that the Federal Government closely monitor experiments and tighten control over the release of altered fish into the environment.

In a report in a recent issue of its journal, Fisheries, the society recommended that genetically altered fish be sterilized before being released into the environment, perhaps by exposing them to chemicals in water while they are in the larval stage; whether in fish farms or in natural waterways.

Congressional efforts to impose regulations for the release of modified organisms have so far failed to gain momentum.

„Where it will eventually be decided is economics," said Perry B. Hackett Jr., a geneticist at the University of Minnesota, where scientists have genetically engineered rainbow trout, walleye and northern pike. „When the economics in the United States push for genetically altered fish, we're going to see genetically altered fish in one environment or another."

DO NOT FORGET THE NEEDIEST!

Survey

himself and the isolated, rugged individualist.
Within Wallace, Dion charts his own obsess-
ive impulse to chase and ensnare the 'most magnif-
icent butterfly', to arrest the fragile creature on
a canvas mount for his personal delectation.

Not content merely to live vicariously
through their biographies, Dion developed a series
of 'bureaucracies' in which he would actually don
the expedition gear and laboratory coats of these
naturalists and assume their activities. These
performance/installations leave behind Dion's
reliance on text to illuminate the historical and
political thrust of his work, providing occasion for
viewers to 'talk back' to the artist-cum-amateur-
scientist who passes on information that they, in
turn, process. By motivating viewers to share in his
compulsions by engaging in critical debate about
the naturalist's activities, Dion's later installations
no longer function as 'a vehicle transmission of
facts' but transform viewers into deep ecologists
who, like Wallace, are capable of acknowledging
and questioning from within their own activites
the inescapable, underlying ideological codes
directing them'.[36]

In 1991, Dion spent three weeks in remote
jungles in the Orinoco Basin, Venezuela as part of
his project *On Tropical Nature* commissioned for the
exhibition 'Arte Joven en Nueva York'. Isolating
himself in the interior, with the occasional visit of
photographer Bob Braine, a boat would travel to
rendez-vous points during his 'expedition' and pick
up a box from the artist that would eventually be
delivered to the Sala Mendoza in Caracas. Museum
staff, never certain if anything would arrive,
opened the boxes and decided how to display the

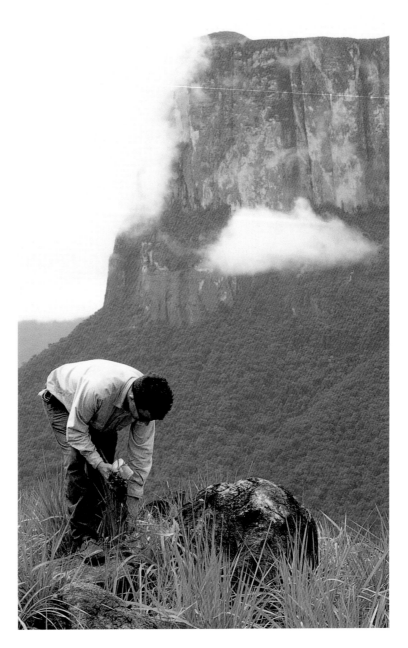

Mark Dion collecting for **On
Tropical Nature**
1991
Atunua Mountain, Amazonas,
Venezuela

On Tropical Nature

1991
Containers, preserved insects, soil
samples, leaf litter, birds' nests,
nuts, seeds, vegetation specimens
Dimensions variable

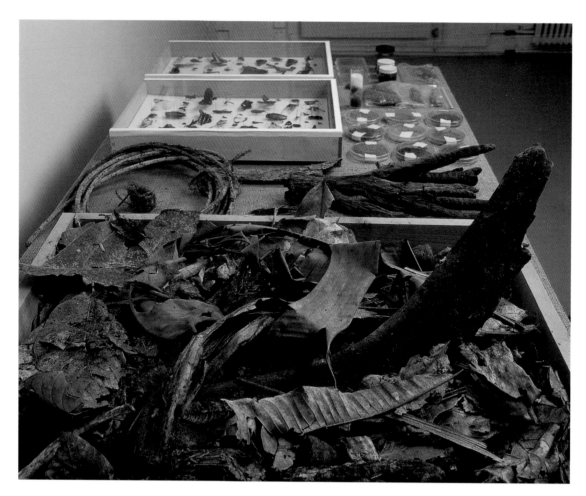

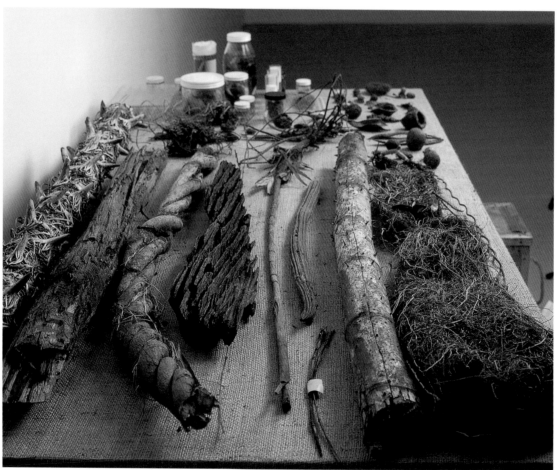

contents – dirt, insects, plants and reptiles – without instructions from Dion. Exhibited on three tables with his journals, tools and maps, the objects form an evocative, sensual and 'exotic' display for gallery visitors. The arrangements for the project were extremely delicate and expensive, requiring Dion to negotiate a series of South American bureaucracies, each protecting their own interests. This organizational experience would prove useful in later projects that demanded access to the administrative structures of museums, zoos, universities and corporations, a process that, while not always evident in the final presentation of a work, remains inseparable from its meaning.

Recycling plays a role in Dion's environmental politics and his art. In 1992, the specimens collected from his jungle expedition reappeared in an exhibition at American Fine Arts, Co., (New York). While the gallery was open, Dion worked for several hours daily in each of three offices he had created (following Cuvier) and visitors could observe and interact with him. In *The N.Y. State Bureau of Tropical Conservation*, Dion continued to organize and preserve crates of his 'finds' into 157 labelled and numbered items. Next door, *The Upper West Side Plant Project* conserved fruits, vegetables and plants purchased at markets on Broadway between 110th and 111th Streets by drying them under infra-red lamps and then labelling them in plastic containers for internment in a cupboard. With identification manuals in hand, Dion searched for the names of marine life purchased near the gallery and preserved in alcohol for *The Department of Marine Animal Identification of the City of New York (Chinatown Division)*. Gathered

during self-imposed time, under demographic and geographic constraints, and organized within circumscribed conditions, these bureaucracies mock the arbitrary construction of natural history museums with their ingrained biases reflecting the individual and shared neuroses of the collectors. Dion's actions blur the boundary between role-playing for performance and actual identification with the scientific establishment. Dion has admitted that the pleasure he takes in his methods, while partly motivated by a lack of interest in making objects, comes dangerously close to absorbing him into the rubric he wishes to expose.[37] This insistence on displaying his own problematic and fetishizing relationship to objects produces carefully staged events that become an unpredictable theatre of restrained chaos, undermining the notion of scientific objectivity.

Dion's early bureaucracies have been compared to Smithson's incongruous 'displacements' of natural resources in the creation of his *Site/Nonsite* projects, but with an important distinction. Whereas Smithson was primarily interested in 'highlighting the gap between the life of the "site"

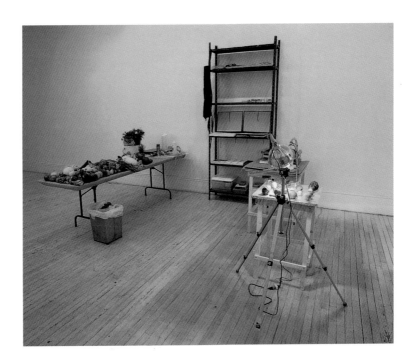

left and overleaf, **Upper West Side Plant Project** (in progress)
1992
Collection of vegetation from the Upper West Side (Broadway between 110th and 111th Street), metal shelf, portfolios, containers, door, apron
Dimensions variable

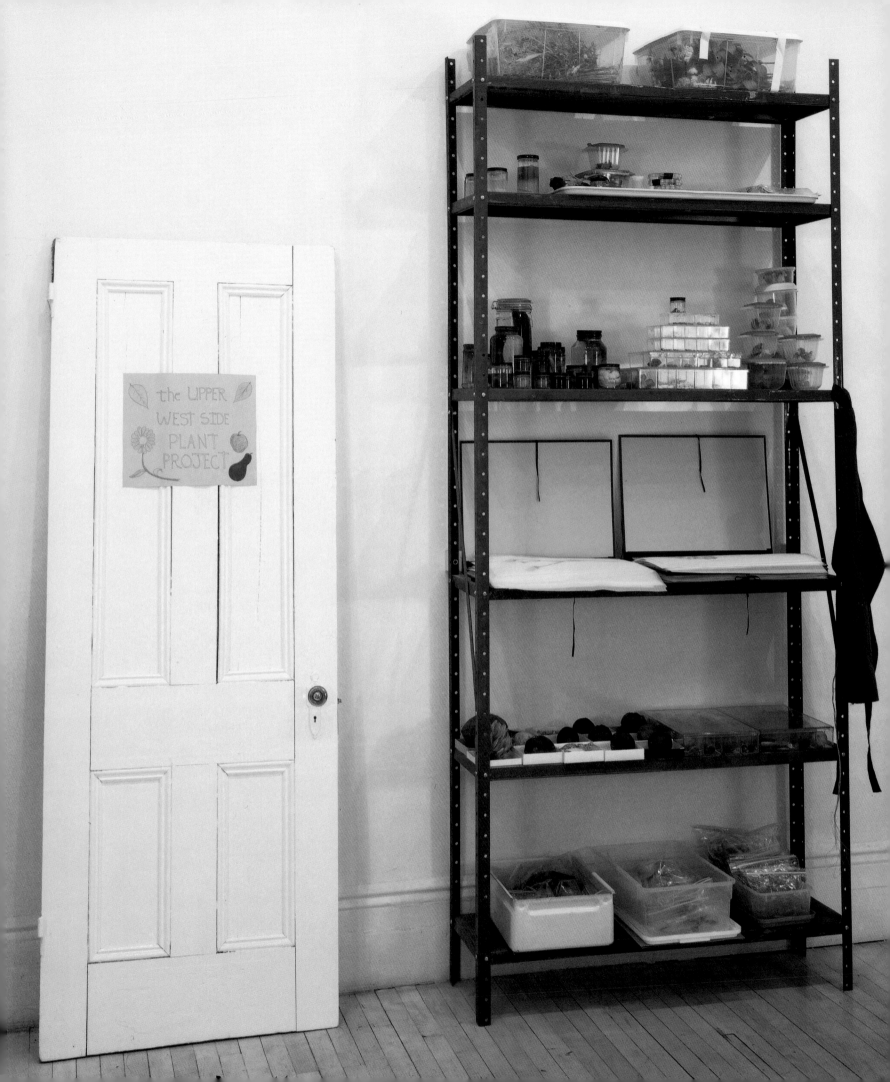

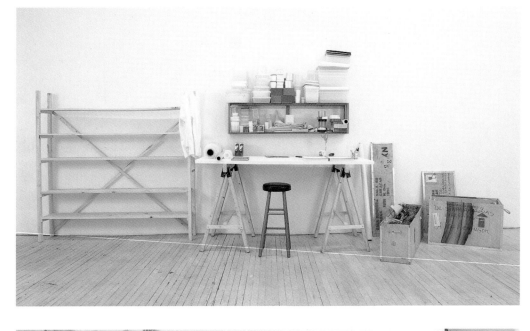

The N.Y. State Bureau of Tropical Conservation (initial stage)
1992
Laboratory equipment, furniture and containers, lab coat, crates from Orinoco Basin, Venezuela
Dimensions variable

The N.Y. State Bureau of Tropical Conservation (in progress)
1992

The N.Y State Bureau of Tropical Conservation (final stage with stencilled door)
1992

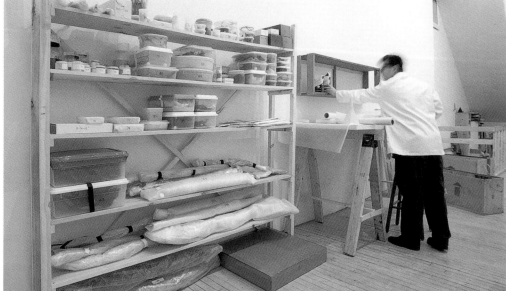

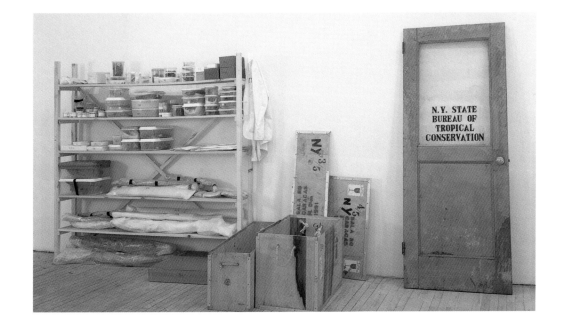

The Department of Marine Animal Identification of the City of New York (Chinatown Division) (*top,* in progress; *bottom,* final stage)
1992
Marine animals collected in Chinatown, door, metal cabinet, blue lab coat
Dimensions variable

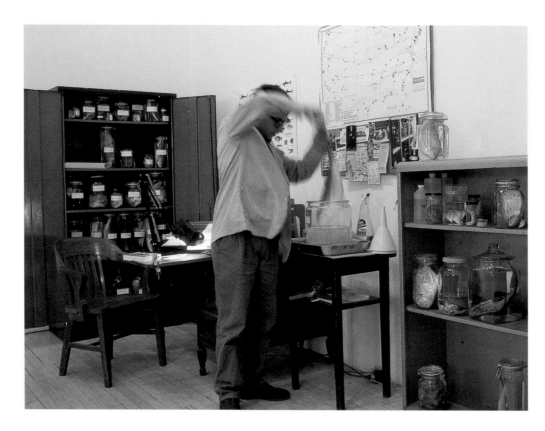

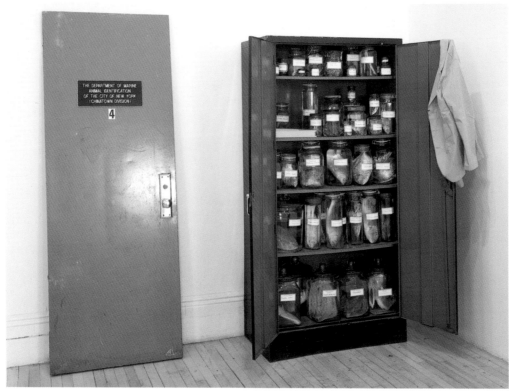

opposite, **The Department of Marine Animal Identification of the City of New York (Chinatown Division)** (*top,* initial stage; *bottom,* final stage)
1992

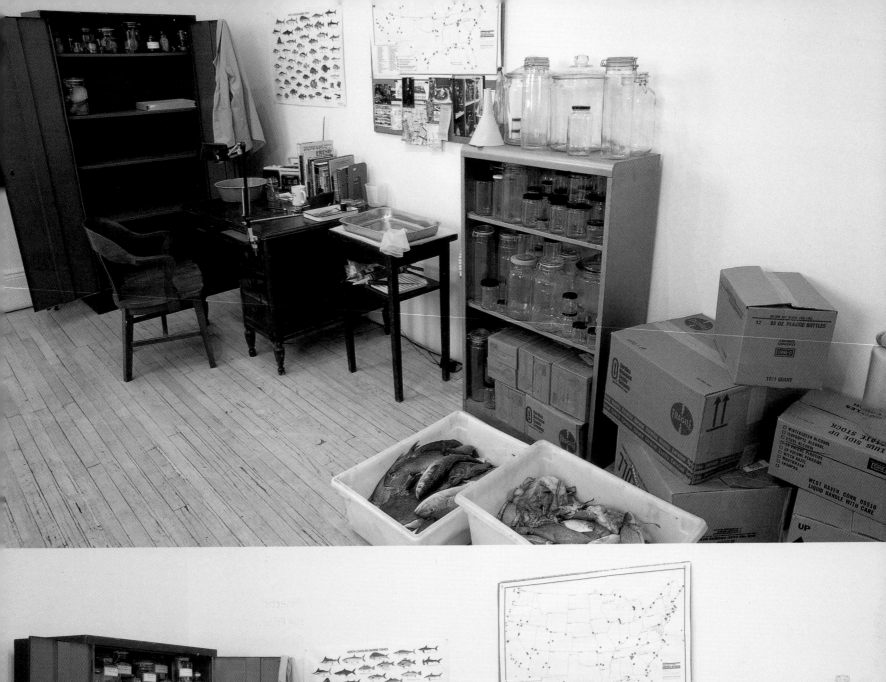
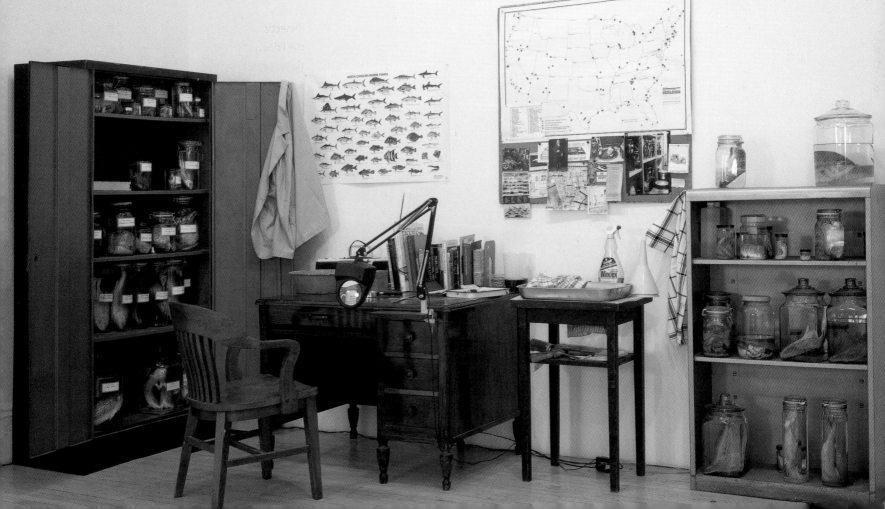

Rearview of 16th-century residences which face the main square, Fribourg, Switzerland

History Trash Dig, from 'Unseen Fribourg'
1995
Table, chair, ledger, cleaning materials, containers, artefacts, pail, specimen boxes, dirt, shovel, shelf
Installation, FRI-ART Centre d'Art Contemporain, Fribourg, Switzerland

History Trash Dig, from 'Unseen Fribourg' (detail)
1995

and the atemporal stasis of the exhibition (art) space', Dion 'highlight[s] the very processes of such displacements and their role in scientific knowledge'.[38] *A Meter of Jungle* (1992), *The Great Munich Bug Hunt* (1993), *Angelica Point* (1994), as well as *History Trash Dig* and *A Meter of Meadow*, from 'Unseen Fribourg' (1995), all involved the artist collecting and removing natural elements from one context to another in order to underscore the absurdity of a method that, as the antithesis of the ecosystems under observation, invalidates the data which emerges from the process of study. This practice formed the basis of the work of early naturalists such as William Beebe (1877-1962), the American biologist who removed a square metre of soil from Belém in the Amazonian rainforest to New York City for investigation. In *A Meter of Jungle, History Trash Dig* and *A Meter of*

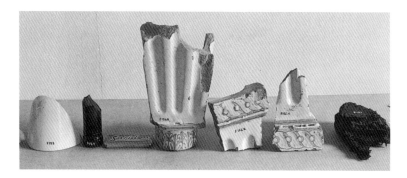

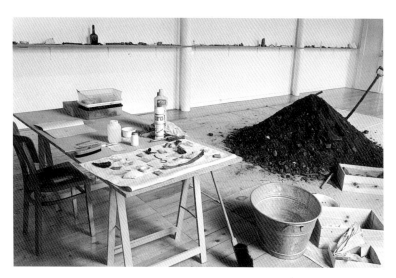

Meadow, Dion removed soil from Belém and Fribourg, Switzerland respectively, setting up laboratories in which he continued to perform the function of biologist, geologist and archaeologist. At the Center for Contemporary Art in Fribourg, Dion exhibited himself neatly sifting a metre of meadow and four metres of soil. As the process continued, an evolving wall was hung with 289 photographs by Eliane Laubscher of invertebrates removed during Dion's study. In Munich, Dion created a similar *mise-en-scène*, this time coordinating cranes and trucks to transport an enormous felled tree from a woodland to the gallery at K-Raum Daxer. Dion, with local scientists, earnestly drilled into the dead trunk removing an entire unseen world for classification and organization. The identical vials and glass jars were placed in a wooden cabinet resembling those found in early natural history museums. The cabinet door was left ajar, giving visitors the chance to watch the dissection and evolving taxonomic activity. Both the Fribourg and Munich projects sullied conventional expectations of the hygienic art gallery even while the artist slavishly imitated museum behaviours. The projects also 'exoticized' the local landscape by presenting the study of indigenous specimens under the most 'advanced' conditions using high-tech microscopes and cameras. Together, they created a perception that the contents of the immediate natural environment were regarded as seriously as those culled from distant, romantic settings like the jungle.

Angelica Point (1994), at the Galleria Emi Fontana in Milan, added an new dimension to the 'bureaucracy' series. Three disciplines of

Scala Naturae
1994
Stepped plinth, artefacts,
specimens, taxidermic animals,
bust
238 × 100 × 297 cm

organization – botany, anthropology and zoology
– were brought to bear on materials shipped to
Italy from Angelica Point, a small peninsula and
salt marsh in Massachusetts. To Dion, Italy was
the most threatening of the European countries
because he could not speak the language and was
unfamiliar with its culture.[39] While he could have
collected objects from the Italian coast, the arti-
facts from his natural habitat bridged the alien
surroundings. For Dion, the hours spent sorting
these 'transitional objects' comforted him, becom-
ing mnemonic devices triggering a combination
of personal associations and generalized insights
about his complex identification with things
destined for museums. To the Italians, the com-
monplaces of Dion's native home – lobster pots,
archaic crab and eel traps, algae, seaweed, starfish
and sea urchins – were transformed into rarities
deemed worthy of their attention as Dion performed
his cataloguing duties religiously each afternoon.

Whereas works like the 'great naturalists'
and 'bureaucracies' are entrenched in the
nineteenth century, Dion developed a separate
group of projects concurrently which took the
form of exploring the quirky private collections
that preceded the public museum. The wonder-
struck Italian audience in Milan experienced a
glimmer of the serendipity that would have
titillated the seventeenth-century visitor. Dion's
wunderkammern are no less idiosyncratic than
their historical models, in fact, they flaunt and
exaggerate their self-referential, eccentric orga-
nization. *Scala Naturae* (1994), was a straightfaced
subversion of Aristotle's attempt to classify life
according to a hierarchical system. The archi-

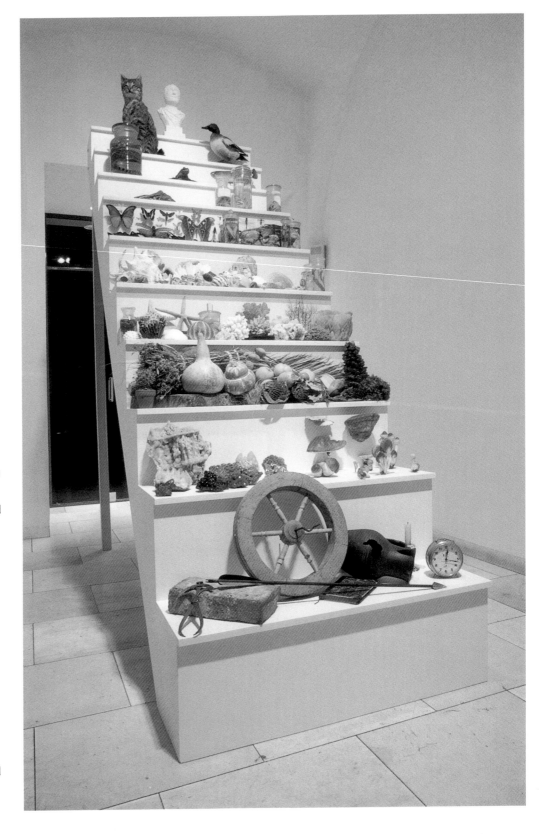

Center for the Preservation of Coastal Marsh Zoology, from 'Angelica Point'
1994
Metal shelving, specimens in containers, door, sign
Installation, Galleria Emi Fontana, Milan

Anthropology Department, from 'Angelica Point'
1994
Stencilled metal shelving, specimens in containers, nets, specimen collecting baskets, debris, files, door, sign, floats, markers, traps and other fishing equipment
Installation, Galleria Emi Fontana, Milan

Massachusetts Botanical Survey, from 'Angelica Point'
1994
Wooden shelving, specimens in containers, files, door, sign, plant presses
Installation, Galleria Emi Fontana, Milan

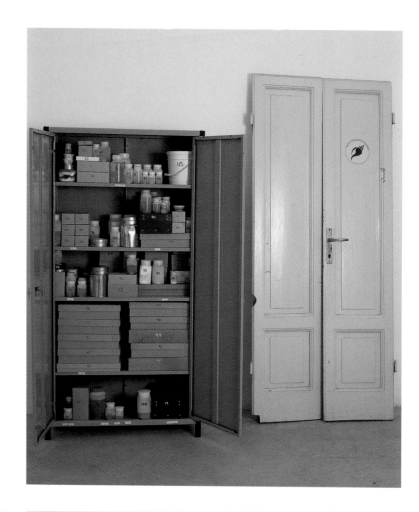

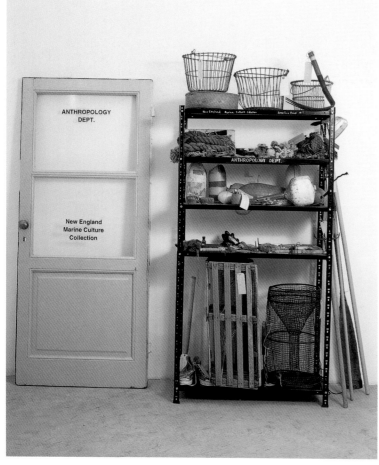

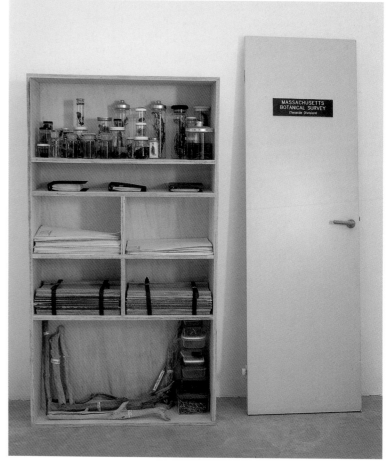

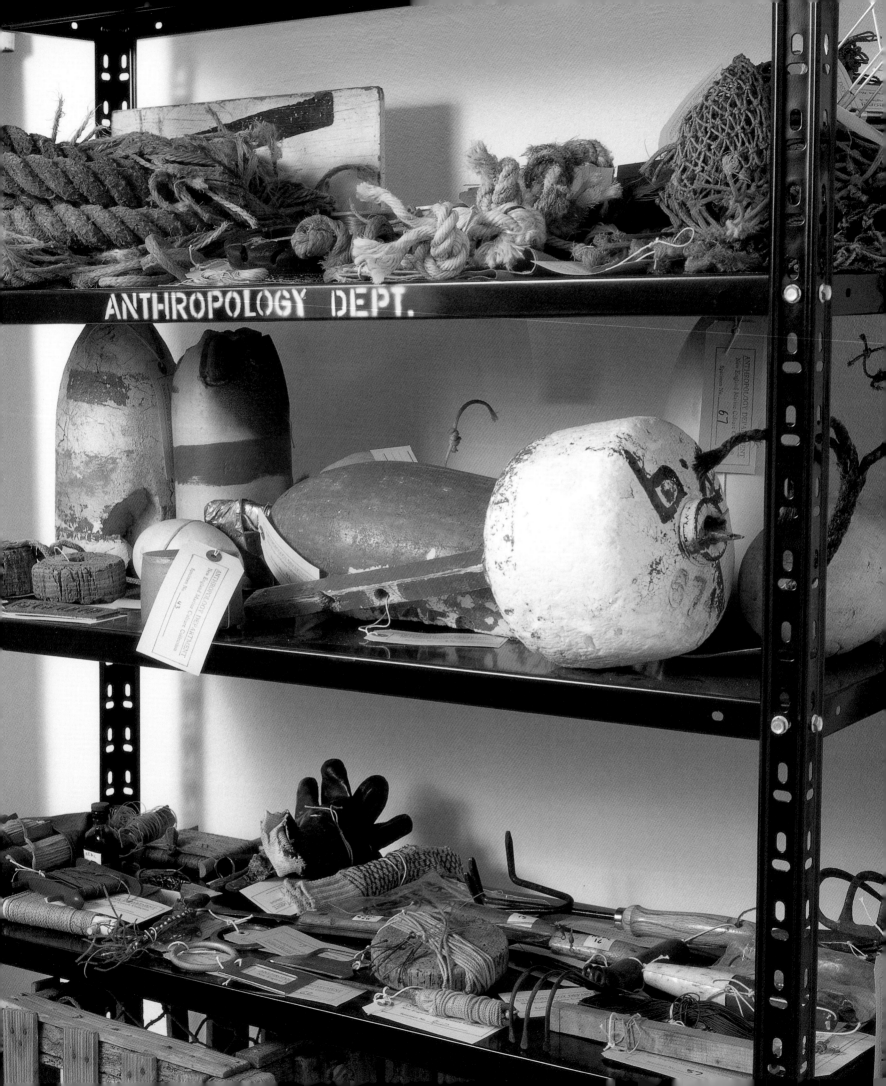

ANTHROPOLOGY DEPT.

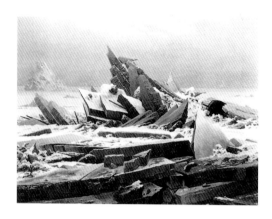

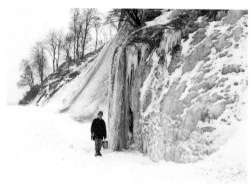

Caspar David Friedrich
The Wreck of the Hope
1824
Oil on canvas
97 × 127 cm

A cold February on the Island of
Rügen while collecting for **A Tale
of Two Seas: An Account of
Stephan Dillemuth's and Mark
Dion's Journey Along the Shore
of the North Sea and Baltic Sea,
and What They Found There**
1996

tectural construction of Dion's *scala*, a dense,
floor-to-ceiling incline of shelves, is adapted from
earlier prototypes. The receding steps begin with
man's creations (some like the spinning wheel,
the arrow and the clock representing the concept
of time), climbing past fungi, fruits and vegeta-
bles, corals, butterflies, a stuffed cat and duck and
concluding with a bust of the classical scholar. As
in the case of its ancestors, Dion's *wunderkammer*
stirs the senses with its enticingly colourful
offerings. But just as viewers believe they had
discovered a unifying 'structure', that sense of
predictable order is shattered. On Dion's hierar-
chical ladder, the stunning physicality of the
natural objects contrasts sharply with the
metaphysical realm of ideas implied by the
blank space left above the philosopher's head.

*A Tale of Two Seas: An Account of Stephan
Dillemuth's and Mark Dion's Journey Along the
Shores of the North Sea and Baltic Sea and What
They Found There* (1996), exhibited at the Galerie
Christian Nagel in Cologne, is perhaps the most
complete statement to date of Dion's aesthetic
and thematic concerns as they have developed
over the past decade. A collaboration with Stephan
Dillemuth, a German artist, writer, media activist
and curator, the project includes an expedition
in near-Arctic weather to the frozen shores of
two seas, and the creation of a display cabinet.
Traversing a route between Germany and the
Netherlands (Baltic Sea) and Germany and Poland
(North Sea) in a donated Renault van during a
frigid February, the artists gathered souvenirs of
their journey from rural and urban sites: tourist
kitsch, water, soil, dead birds, brightly coloured

rope, nets and fishing tackle, worm-eaten drift-
wood, feathers, hardened tar, plastic containers
and other irregularly reshaped refuse. With few
expectations and unprepared for the dramatic
variations in the shoreline, the two photographed
their activities and kept meticulous journals listing
the birds they spotted and the towns they visited.

A Tale of Two Seas ... required Dillemuth
and Dion to perform all the functions of a museum,
collecting, curating, installing and archiving
their random finds; ultimately, compressing their
experiences into their own system of display.
Their *wunderkammer* is installed in a double-sided
cabinet, each half a mirror of the other. Its design
conflates the pre-Enlightenment cupboard with
a nineteenth-century souvenir cabinet. The items
collected are also presented in a way that recalls
both historic periods. A barnacle-encrusted bottle
suggests the kind of *ormolu* and jewelled nautilus
found in most seventeenth-century collections
while glass fragments are labelled with descrip-
tive notes and placed in drawers, the way a
nineteenth-century colonial collector might
display an ancient pottery shard. 'As in any
wunderkammer', stated Dion in an interview about
the project, 'there is an emphasis on anomalies'.[40]
Despite a cabinet design that appears the same on
both sides, the arrangements are not twinned and
the transmuted materials beaten into new forms
by the sea defy existing categories. This creates
a layer of internal dialogue that hints at a subtle
political dimension in the work. While the cabinet
arrangements reveal that the plastic containers
found in the West noticeably exceed the size of
those in the East, in fact, Dion's data can not claim

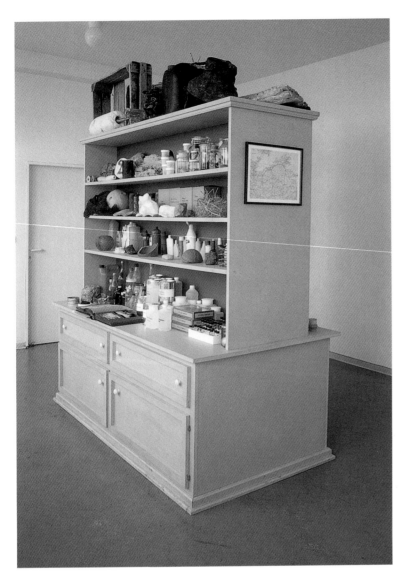

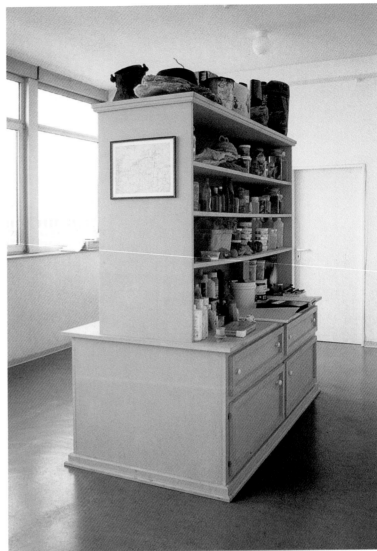

to distinguish between the regions since he has not used standardized, scientific protocols during the collecting process. In this post-Cold War project, the political boundary of East and West becomes merely a geographic division.

As in Dion's earlier works, social and art-historical politics are entwined. During their trip, Dion and Dillemuth made a special stop at the bleak, Baltic coastal villages where the influential German Romantic landscape painter Caspar David Friedrich (1774-1840) had worked. The association with Friedrich immediately introduced into Dion's

piece the questioning of traditional definitions of the landscape artist. *A Tale of Two Seas ...* is unclassifiable as an art work. Dion was struck by the meaning of filling a plastic bag with dead bird's feet and calling it art. 'I always thought about this project as an attempt to produce a sculptural equivalent to the travelogue genre. You know, something not landscape painting, not a road movie, not a photo diary, not a scientific expedition or any other document of a voyage; but something which incorporated aspects of all of those expressions'.[41] The project makes a strong

above and overleaf, **A Tale of Two Seas: An Account of Stephan Dillemuth's and Mark Dion's Journey Along the Shores of the North Sea and Baltic Sea and What They Found There**
1996
Wooden display cabinet, specimens, debris, containers, framed map, photo album
Installation, Galerie Christian Nagel, Cologne
198.5 × 250 × 108 cm

overleaf, **A Tale of Two Seas: An Account of Stephan Dillemuth's and Mark Dion's Journey Along the Shores of the North Sea and Baltic Sea and What They Found There** (detail)
1996

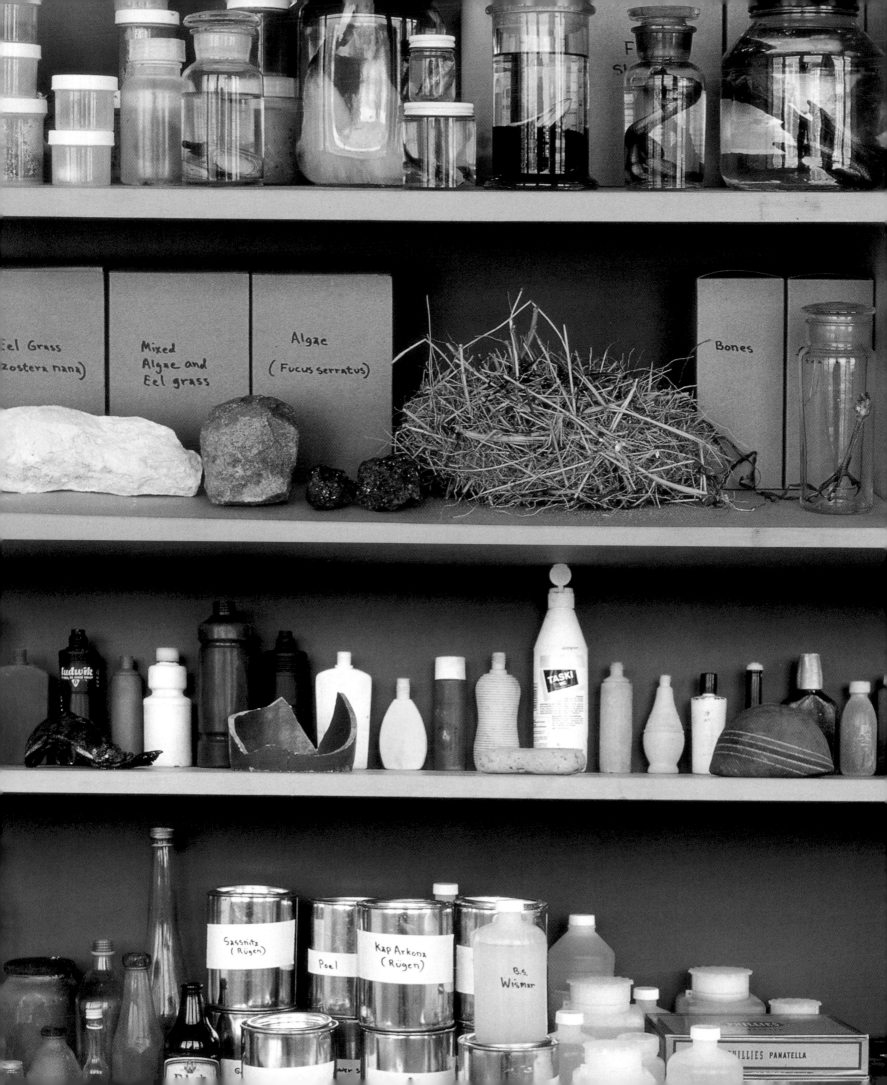

Eel Grass
(zostera nana)

Mixed
Algae and
Eel grass

Algae
(Fucus serratus)

Bones

Sassnitz
(Rügen)

Poel

Kap Arkona
(Rügen)

B.s.
Wismar

TASKI

ludwik

HILLIES PANATELLA

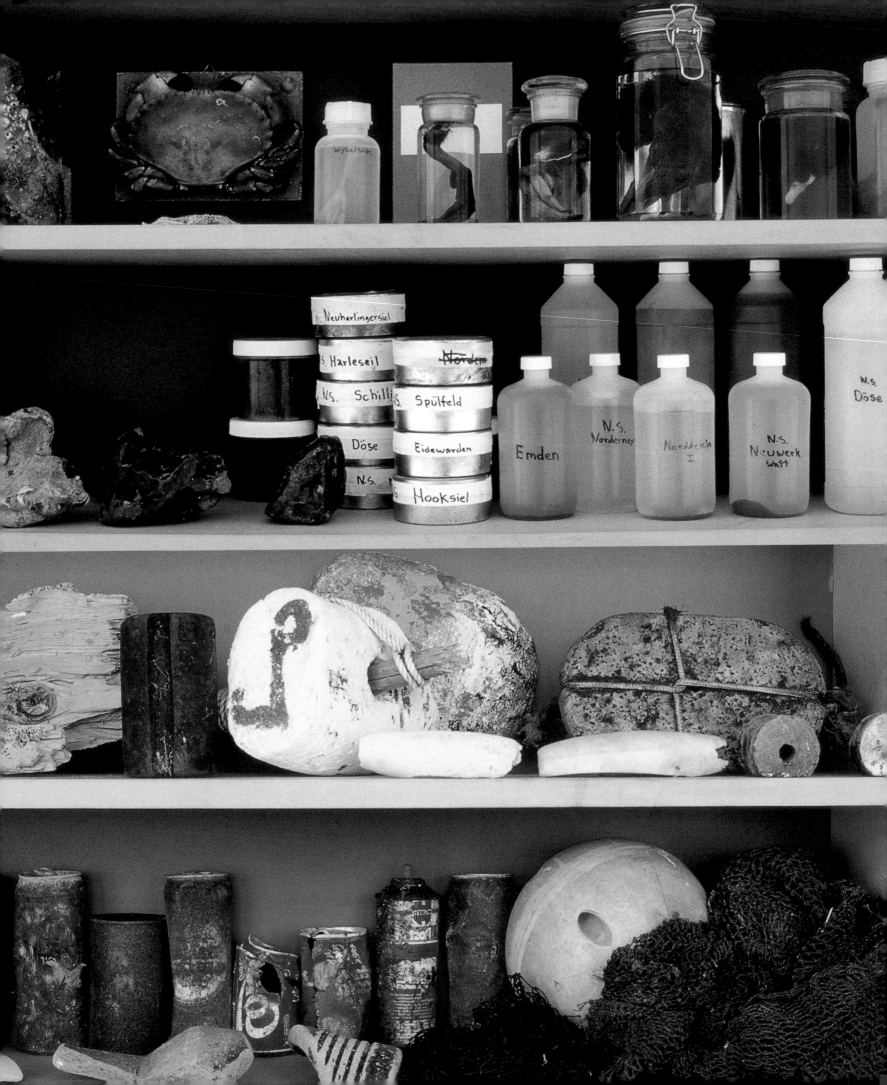

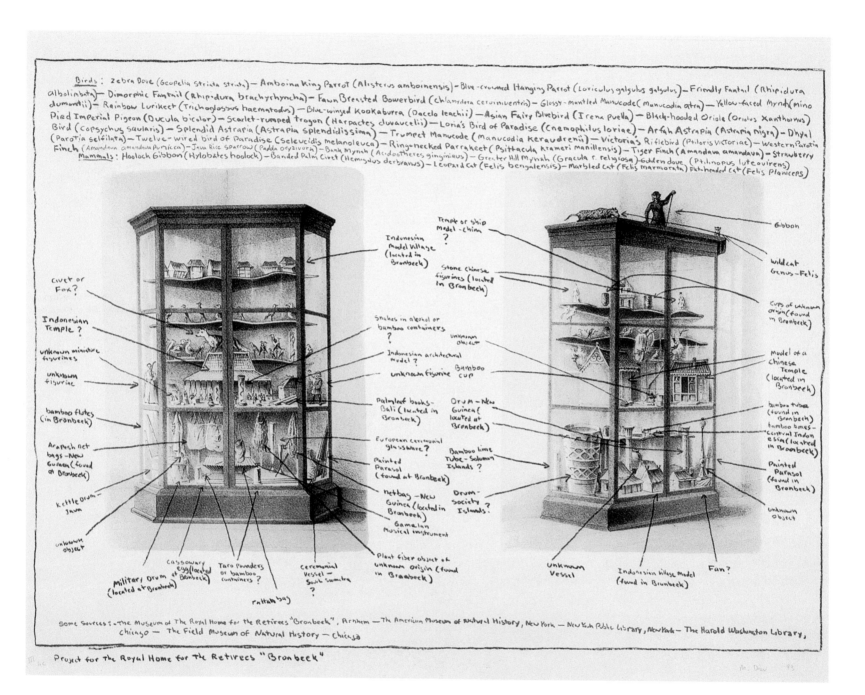

**Study for Project for the Royal
Home of Retirees, Bronbeek**

1993

Silkscreen

50 × 70 cm

case for the *wunderkammer* as a 'discursive space' where dialogue prompts an infinite series of discoveries and the only vehicle required for an adventurous journey is an open cabinet and an open mind. The viewer can make certain choices about the puzzle ...' by opening the drawers, examining the contents and making 'choices outside the narrative structure within the museum'.[42]

Several of Dion's *wunderkammer* required the cooperation of conventional museums, forcing curators and registrars to relinquish their usual working methods and to capitulate to Dion's unorthodox taxonomies. *Nos Sciences Naturelle – Observations of Neotropical Vertebrates* (1992) was created while Dion was in the Brazilian rainforest. Each day, the Museum of Natural History in Fribourg emptied display vitrines in preparation for a series of faxes from the artist listing birds, fish and mammals he observed and could identify. The museum staff would examine the collection for examples of the specimens on Dion's list and exhibit them with his faxes. *Project for the Royal Home for the Retirees, Bronbeek* (1993) was commissioned for Sonsbeek in Arnhem (The Netherlands). The project took place at a facility for military pensioners that included a museum of its own history dating to the mid nineteenth century, complete with old fashioned cabinets full of stuffed animal specimens, trinkets reflecting the history of Dutch colonialism and personal effects of previous retirees. Dion carefully reconstructed the history of the displays in two vitrines, discovering that their organization had little apparent coherence except as incongruous curiosities. During Sonsbeek, Dion arranged for

the present-day inhabitants to have authorization to actively add, remove or rearrange objects as they chose. In *Collectors Collected* (1994), exhibited at the Reina Sofia in Madrid, Dion scavenged in the cellars and libraries of the museums of natural history, anthropology and the botanical gardens to investigate the personalities behind the *Expedicion Al Pacifico* (1862-66) and their impact on the museums' collections of insects, ethnographia and preserved specimens. Unlike the valorizing exhibitions of famous discoverers typical of history museums, Dion proposed to 'collect the collectors' and 'exhibit these figures

 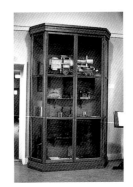

above, **Project for the Royal Home of Retirees, Bronbeek**
1993
Detail of residents' display case with tin-can steam engine and assorted personal artefacts loaned from the residents of Bronbeek, with resident

left, **Project for the Royal Home of Retirees, Bronbeek**
1993
Display cabinets, found artefacts

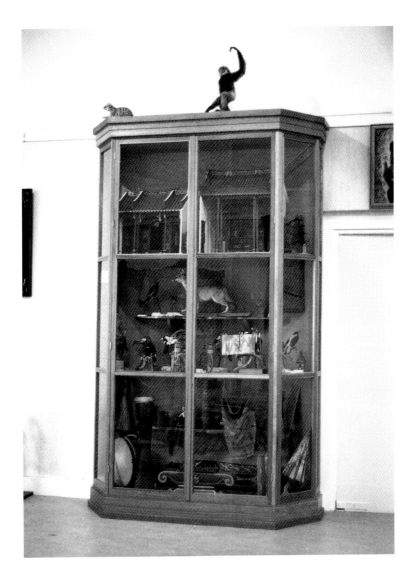

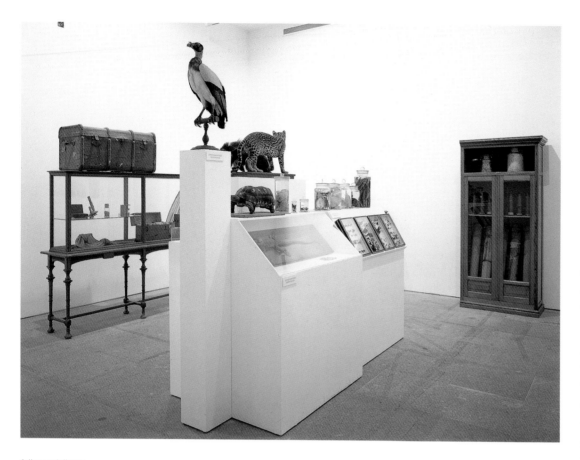

Collectors Collected
1994
Plinth, museum specimens,
taxidermic animals, antique
display cases
Dimensions variable
Installation, Reina Sofia, Madrid

as *they* would have exhibited people of another culture in the ethnographic systems of their time'.[43] A second aspect of the project questioned the ultimate value of the expedition to the museums by asking curators to chose an object that symbolized the 'spirit and goals of the expedition'. The objective of these three projects was to demystify curatorial practice while indicating the arbitrary and crude ways in which collections are formed, and by extension, the limits of the 'knowledge' they proffer.

Dion's current work-in-progress is a *Curiosity Cabinet for the Wexner Center for the Arts* (1996, ongoing), another context-specific *wunderkammer* that functions as a museum within a museum,

interrogating the way in which the Wexner, a university art museum, might function within the rubric of the academy. In preparation for the project, Dion studied paintings by Brueghel, Archimboldo, Rembrandt and Snyders, and from their works decided to maintain the Aristotelian interplay between the natural and artificial. The proposed allegorical *wunderkammer* will use objects culled from the vast collections of each separate academic department. The content of the nine cabinets comprising the project maintains the heady baroque sophistication of seventeenth-century iconography. The display units are designed to sit on a semi-circular platform two feet off the ground with a protective railing. A gulf of five feet separates the exposed and desirable inventory from the viewer, adding a titillating psychological tension to the work. The intraversable physical distance from the objects becomes a barrier to intellectual encounter with their meanings. According to the artist, the rise of disciplines during the Enlightenment meant the demise of the *wunderkammer*, and the present-day isolationism is an extension of this historic phenomenon. Consequently, the lack of crossover between the departments and the art museum, in his opinion, suffocates the possibility of developing a fluid, interconnected concept of knowledge. In this project, the rigidly defined institution of learning, embodied by the objects from the self-contained departmental collections, becomes a microcosm

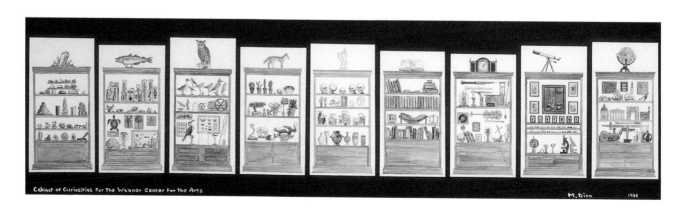

for a stultifying view of the world in which academics in different departments, let alone faculty and curators, rarely share experiences and information.

Dion's coy interventions in the museum intersect with a series of 'practicums' in which the invisible line between museum curator and artist is entirely erased. In projects such as *Project for the Belize Zoo* (1990), *The Chicago Urban Ecology Action Group* (1993) and *Schoharie Creek Field Station* (with J. Morgan Puett and Bob Braine, 1996) Dion's aesthetic activities become virtually indistinguishable from his pedagogical activism. Although these three projects involved Dion in a role that would appear as far from the rarefied world of contemporary art as possible, Dion sees his participation as consistent with his repositioning of 'the artist' as part of an integrated whole that does not separate the gallery or the studio from the world outside.

For *Belize Zoo*, Dion wrote and designed innovative educational texts with multiple levels of information about the native wildlife of the Belize rainforest. Each sign includes basic data about an animal with the following types of information: the animal's name in Spanish and English, the difference between its behaviour in the wild and its cultivated habits in captivity, images juxtaposing representations from European and ancient Mayan cultures, identification of endangered species and commentary about conservation. This approach to the zoo labels parallels insights Dion has brought to his gallery-based projects, where the conjunction of colonialism, the development of zoos and

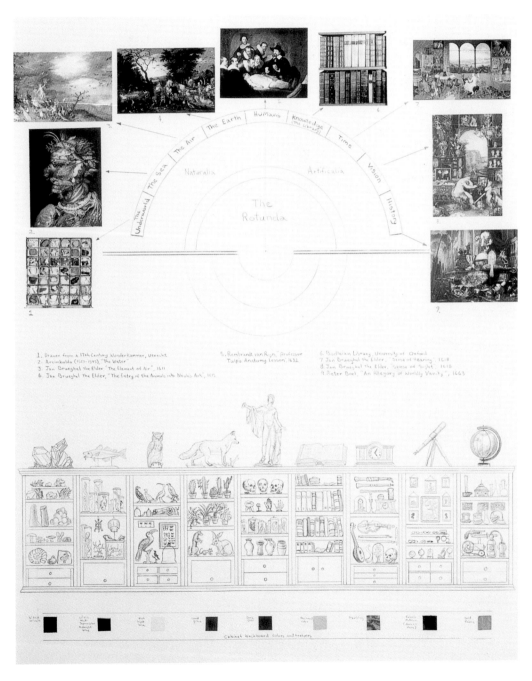

Curiosity Cabinet for the Wexner Center for the Arts
1996
Black ink, watercolour on paper
61 × 48 cm

Curiosity Cabinet for the Wexner Center for the Arts
1996
Collage and coloured pencil on paper
24 × 89 cm

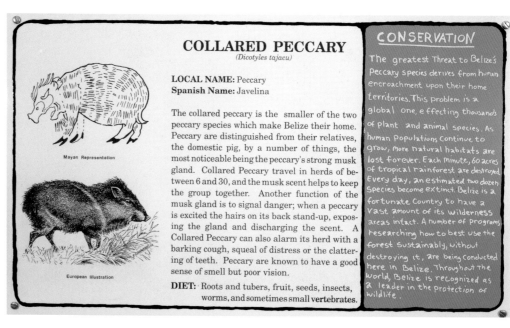

Project for the Belize Zoo
(Collared Peccary)
1990
Silkscreen enamel on aluminum
56 × 51 cm
Belize Zoo, Central America

museums of natural history, and the onset of mass extinction of species are inextricably linked. To Dion, the modest, low-budget Belize Zoo remains an exemplary model, promoting conservation and alternative resource projects and working with its rural populations to increase commitment to preventing deforestation.

Dion continued his work with the Belize Zoo through a commission for 'Culture in Action', a series of community-based public art projects in Chicago.[44] With urban high school students, Dion again visited Belize to install watershed models built by the students for the education centre of the Cockscomb basin wildlife sanctuary and jaguar preserve. When they returned to Chicago, he worked in partnership with the teenagers to form *The Chicago Urban Ecology Action Group*. The Group,

located during 'Culture in Action' in a field station they created in Lincoln Park, studied the relationship between tropical ecosystems and their own environment. A series of lectures by conservationists and environmental activists, of projects and dialogues facilitated by Dion, realigned student ideas about the role of the artist in effecting social change. This project may be as close as Dion has come to positing earthbound alternatives to Beuys' quasi-mystical Social Sculpture.

The Lincoln Park 'eco drop-in center and clubhouse' provided a prototype for the *Schoharie Creek Field Station* a creative and adaptive re-use of vernacular rural architecture.[45] Dion, with his partner, the artist-designer J. Morgan Puett, and photographer Bob Braine, reclaimed a rotting chicken coop, transforming it into a contemporary

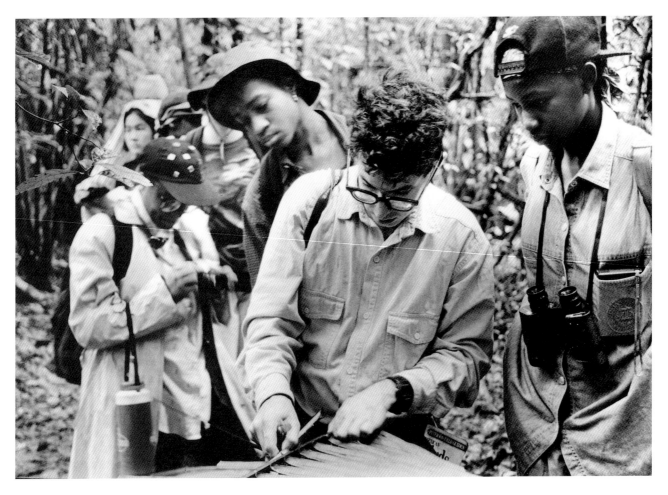

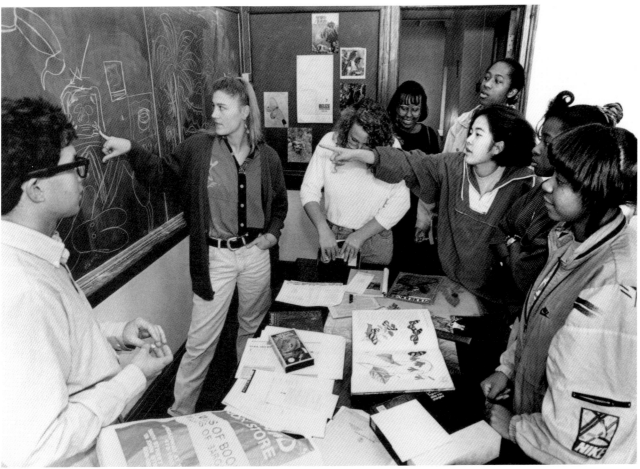

John James Audubon
The Great Auk, from 'The Birds of
America'
1827-38
Engraving
65 × 95 cm

data collection facility in a style evoking the era of local naturalist John Burroughs. Their idea was to construct a rustic but permanent library-meeting space for school and youth groups, local environmentalists and artists. The room is filled with a mixture of contemporary and historical objects, field guides, maps, old photographs, specimens and animal skulls. While redolent of the atmosphere of the by-gone age of the impassioned amateur naturalist, the fully operational field station is inviting without being anachronistic; an unmistakable and delicate balance is struck between past and present.

The Age of Enlightenment signalled the 'eclipse' of visual education, within a culture that increasingly privileged the word.[46] As Barbara Marie Stafford has observed, the resulting 'shift from sensory impact to a rationalizing nomenclature was also a move from the extraordinary to the ordinary.'[47] Within the growth of the museum, this shift transformed newly discovered wonders of nature accessible to the eyes of few into stockpiles of commonplaces on view for the burgeoning middle class. From museum to museum, the ways in which objects were displayed and explained became increasingly standardized, lowering expectations and creating a fertile ground for the spread of an 'if you've seen one Great Auk, you've seen them all' attitude. When the Great Auk ceased to be valued even as a specimen, it ceased also to be valued as a living creature. Soon, the Great Auk was no more. Not even Audubon's lavish and exacting images could preserve interest in the disappearing bird life of North America once orthodox taxonomy had transformed looking

into naming. The question remains whether the activities of an artist can do much to save the Great Auk, the Black Rhino, or *Homo sapiens* in light of the Enlightenment legacy.

The lasting contribution of Dion's *wunderkammern* will not be determined by his ability to save the next Great Auk. His challenge resides in whether he can continue to temper the seductive power of nostalgia with the sobering reality of our ecological predicament without rigidly denying us a wonder-producing, critical visual intercourse with objects. In a sense, Dion's challenge is also that of the contemporary museum. If writers like John Horgan are correct, we are entering a post-scientific, quite possibly post-museum age.[48] The future contribution of these models of the Enlightenment perspective of truth might be whether they can, through the display of fragments of the past, persist in raising awareness of any number of hazardous social behaviours while resisting the tendency to preach. This might be achieved by replacing the ways in which objects have been presented since the eighteenth century with an intertextual model that allows for doubt, contradiction, irony, conflict and constant revision. Could such a borderless postmodern *wunderkammer* ever fail to absorb us? Dion's installations affirm the limitless possibilities awaiting us in such a re-imagined museum.

Schoharie Creek Field Station,
with Bob Braine and J. Morgan
Puett
1995
Furnished cabin in Lexington,
New York
Approx. 200 × 450 × 300 cm

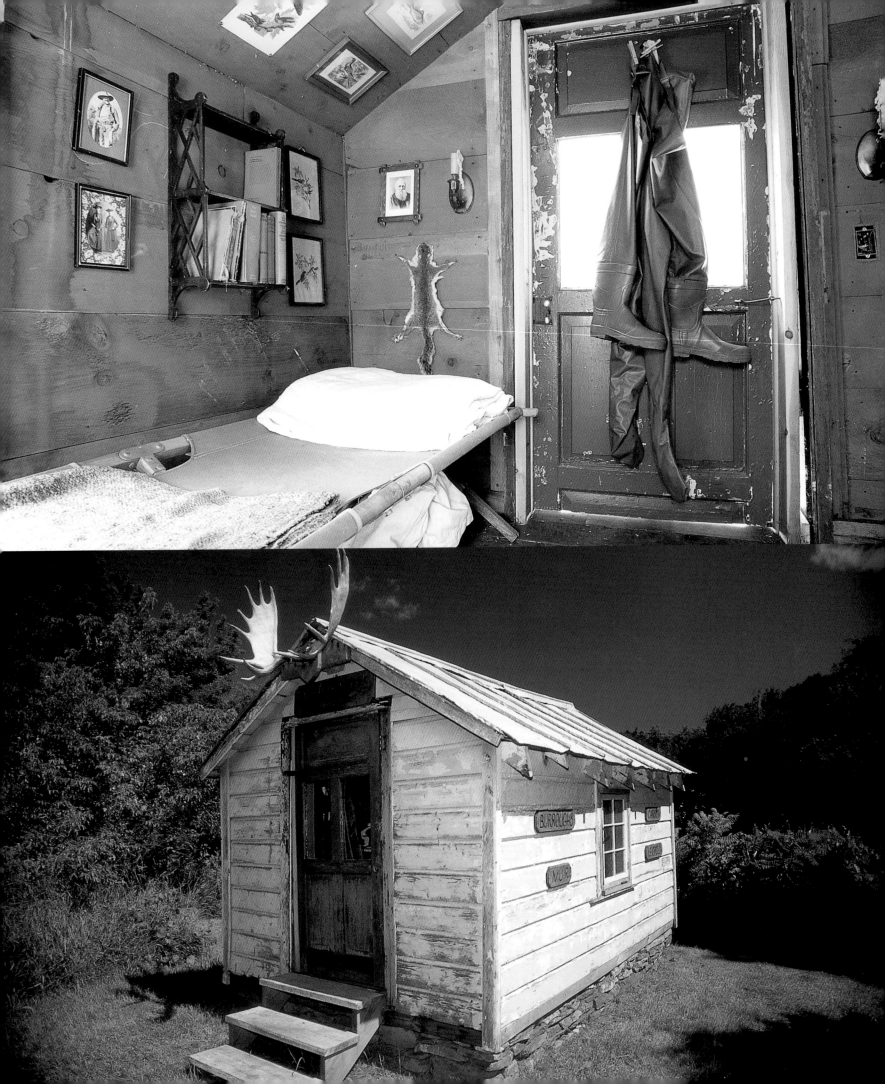

1 Mark Dion, 'The Oyster Club', *Akademie*, eds. Stephan Dillemuth
 Gerhard Theewen, Salon Verlag, Cologne, 1995, p. 225

2 Mark Dion in an interview with the author, July 14, 1996

3 See Bruno Bettelheim, *The Uses of Enchantment*, Knopf, New York,
 1974; Angela Carter, *The Bloody Chamber*, Harper and Row Publishers,
 Inc., New York, 1979; and Jack Zipes, *The Trials and Tribulations of
 Little Red Riding Hood*, South Hadley Massachusetts, 1983

4 'Pandemonium' is the term used by the artist in an unpublished
 transcript describing this work.

5 For a fine, introductory overview of contemporary artists'
 engagement with environmental issues see Barbara C. Matilsky,
 Fragile Ecologies: Contemporary Artists' Interpretations and Solutions
 Rizzoli, New York, 1992.

6 An elaboration of this summary and the quotation from Naess' work
 may be found in Fritjof Capra, *The Web of Life*, Anchor Books,
 Doubleday, New York, 1996, p. 7.

7 Stephen Jay Gould, 'Happy Thoughts on a Sunny Day in New York
 City', *Dinosaur in a Haystack: Reflections in Natural History*, Crown
 Trade Paperbacks, New York, 1995, p. 3. See also, *The Flamingo's
 Smile: Reflections in Natural History*, W.W. Norton and Company, New
 York, 1985, a book that interested Dion early in his career.

8 Alexander Wilson, *The Culture of Nature: North American Landscape
 from Disney to the Exxon Valdez*, Blackwell, 1992, Cambridge, p. 13.

9 See Donna Haraway, *Primate Visions: Gender, Race and Nature in the
 World of Modern Science*, Routledge, New York, 1989.

10 Overfishing alone did not end the whaling industry in New Bedford;
 the Civil War also had a dramatic impact, because it seriously
 disrupted port life. During the Industrial Revolution, the city's
 economy gradually shifted from whaling to cotton weaving and
 factories. See Elizabeth Broun, 'The Ryders of Massachusetts', *Albert
 Pinkham Ryder*, National Museum of American Art, Smithsonian
 Institution, 1989, p. 17.

11 Simon Schama, *Landscape and Memory*, Alfred A. Knopf, New York,
 1995, p. 191

12 Ibid., pp. 364-67

13 For a discussion of this action, see *Energy Plan for the Western Man:
 Joseph Beuys in America, Writings and Interviews with the Artist*, Carin
 Kuoni, ed. , Four Walls Eight Windows, New York, 1993, pp. 141-44.

14 Capra, op. cit., pp. 8-9

15 Dion's openness to Beuys was readied by his contact with Martha
 Rosler and other feminist artists and critics with whom he studied. He
 shared their goal 'to change the character of art', 'reintegrate the
 aesthetic and social self', and to make work that raised political and
 historical consciousness by 'expressing oneself as a member of a
 larger unity or comm/unity'. See Lucy Lippard, 'Sweeping Exchanges,
 The Contribution of Feminism to the Art of the 1970s' in Lucy Lippard,
 The Pink Glass Swan, The New Press, New York, 1995, pp, 171-82.

16 Jack Flam, 'Introduction: Reading Robert Smithson', *Robert Smithson:
 The Collected Writings*, University of California Press, Berkeley, 1996,
 pp. xiii

17 Robert Smithson, 'Conversation with Robert Smithson (1972)',
 Flam, ed., op. cit., pp. 262-269. For Smithson's discussion of *Spiral
 Jetty*, see 'The Spiral Jetty' (1972), 143-53.

18 Ibid., p. 48

19 Ibid., p. 49

20 Ibid., p. 85. Other comments by Smithson about museums may be
 found in, 'Some Void Thoughts on Museums (1967)',
 pp. 41-42; 'What is a Museum? A Dialogue Between Allan Kaprow
 and Robert Smithson' (1967), pp. 43-51; and 'A Museum of
 Language in the Vicinity of Art' (1968), Flam, ed., pp. 78-94, which
 includes his discussion of the American Museum of Natural History.

21 The subject is broad, by no means limited to research I have
 published elsewhere on the institutional critique in contemporary art.
 An overview of some texts in this genre include: 'Artists Look at
 Museums, Museums Look at Themselves,' Lisa G. Corrin, ed., *Mining
 the Museum: An Installation by Fred Wilson*, The New Press, New York,
 1994; 'Installing History,' Patricia M. Burnham and Lucretia Hoover
 Giese, eds., *Redefining American History Painting*, Cambridge
 University Press, 1995, pp. 120-36; and 'The Legacy of Daniel
 Robbins', *Raid the Icebox I, Rhode Island School of Design, Museum of*

Art Journal, Providence, vol. 83, no. 4, 1996, pp. 54-61.

22 Stephen Jay Gould, 'Four Antelopes of the Apocalypse', in Gould, 1995, op. cit., pp. 274

23 See Carolyn Gray Anderson, '*Ignotum per ignotius* or The Wunderkammer-Logic of Natural History', *Die Wunderkammer,* K-raum Daxer, München, 1993.

24 See Gould, 1995, op. cit., pp. 238-47

25 In his *Gesta Grayorum (1594),* Francis Bacon described the *wunderkammer* as 'a small compass a model of the universal made private … a goodly, huge cabinet, wherein whatsoever the hand of man by exquisite art or engine has made rare in stuff, form or motion. Whatsoever singularity, chance and the shuffle of things hath produced; whatsoever Nature has wrought in things that want life and maybe kept; shall be sorted and included.' Quoted in Lawrence Weschler, *Mr. Wilson's Cabinet of Wonders*, Pantheon Books, New York, 1995, pp. 76. Weschler's delightful and concise discussion of curiosity cabinets is indebted to Oliver Impey and Arthur MacGregor, eds., *The Origins of Museums: The Cabinet of Curiosities in Sixteenth and Seventeenth Century Europe*, Clarendon Press, Oxford, 1985.

26 Quoted in Weschler, op. cit. pp. 116-17

27 Mary Smith Podles, 'Virtue and Vice: Paintings and Sculpture in Two Pictures from the Walters Collection', *The Journal of The Walters Art Gallery,* Baltimore, 41, 1983, p. 29

28 Described by Barbara Marie Stafford in *Artful Science: Enlightenment Entertainment and the Eclipse of Visual Education*, M.I.T. Press, Cambridge, Massachusetts, 1994, p. 240.

29 Anthony Alan Shelton, 'Renaissance Collections and the New World', in Elsner and Cardinal, op. cit., p. 184

30 For a history of the Teyler Museum see M.A.M. van Hoorn et al., *Highlights from the Teyler Museum: History, Collections, Buildings*, Teyler Museum, Haarlem, The Netherlands, 1996. The Teyler is a unique example because it has remained virtually intact as the founders conceived it in the late eighteenth century.

31 See in this volume 'M. Cuvier "Discovers" Extinction', p. 114.

32 Dion had already recreated the desk of Clark Kent, the 'mild-mannered reporter' who serves as a foil for Superman's real identity at *The Daily Planet*, in *This is a Job for FEMA or Superman at 50* (1988).

33 From an unpublished interview with Miwon Kwon in 1991.

34 The brief biography of Wallace summarized here is indebted to the didactic handout which Dion developed for visitors to the installation.

35 See in this volume 'The Delirium of Alfred Russel Wallace', p.124.

36 A phrase used by Miwon Kwon in 'Confessions of an Amateur Naturalist', a discussion between Dion, Kwon, James Marcovitz and Helen Molesworth in *Documents*, New York, Fall/Winter 1992, p. 37.

37 Ibid., p. 43

38 See Miwon Kwon, 'Unnatural Tendencies: Scientific Guises of Mark Dion', *Forum International*, New York, May-August 1993.

39 Mark Dion in an interview with the author in July, 1996.

40 From an unpublished interview between Dion and Stephan Dillemuth at the conclusion of the project.

41 Ibid.

42 Ibid.

43 From the first draft of Dion's unpublished proposal for the project.

44 See Michael Brenson, Mary Jane Jacob and Eva M. Olson, *Culture in Action: A Public Art Program of Sculpture Chicago*, Bay Press, Seattle, 1995.

45 Ibid., p. 112

46 Stafford, op. cit., p. xxii

47 Ibid., 266

48 John Horgan, *The End of Science: Facing the Limits of Knowledge in the Twilight of the Scientific Age*, Helix Books, New York, 1996

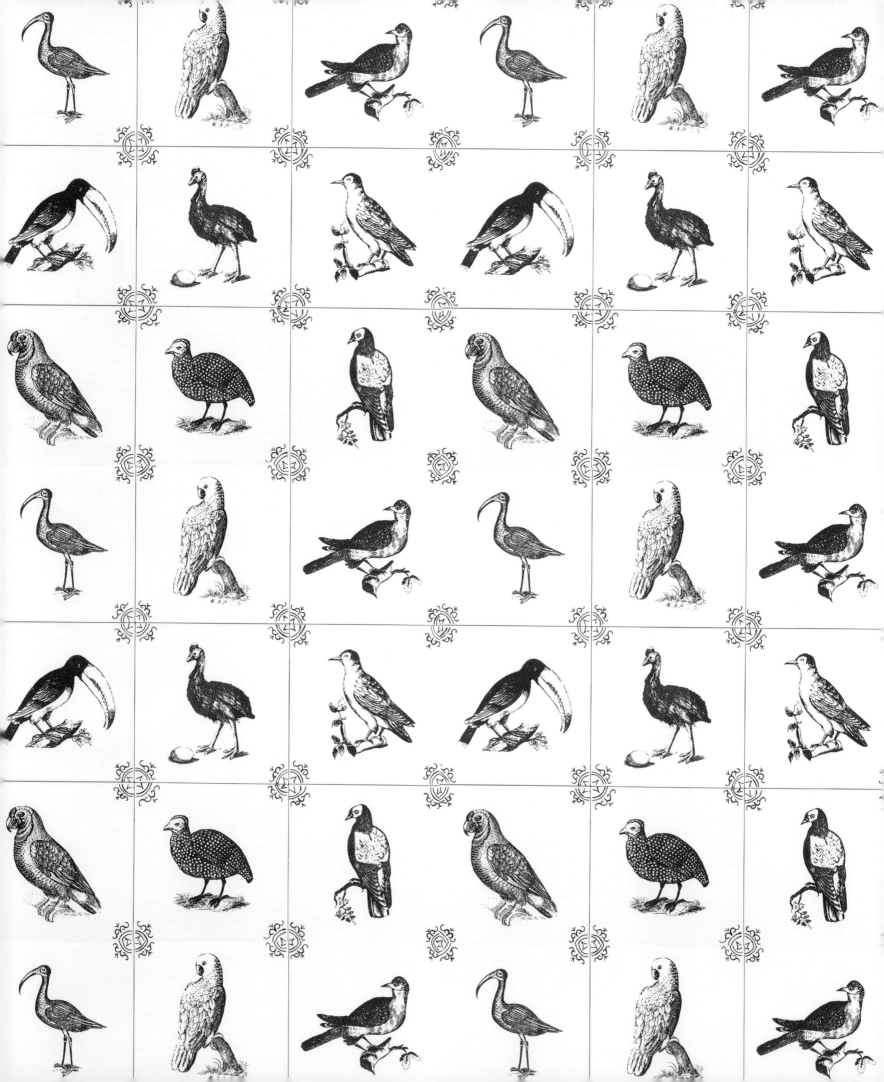

Contents

In 1993 Mark Dion created two projects for the city of Antwerp: *The Project for the Antwerp Zoo* and *The Library for the Birds of Antwerp*. Both concerned birds and the representation of birds. In the first, for the zoo's aviary Dion created designs for ten tiles based on Flemish woodcuts of the seventeenth century. They represented birds from the furthest reaches of what was once, in the heyday of Antwerp's prosperity, a thriving commercial empire: the guinea fowl from Central Africa, the cassowary from Australasia, the toucan from Central and South America, the imperial pigeon from South Asia. If the tiles spoke of an earlier period's engagement with birds – emblems of Antwerp's bygone glory – the birdhouse

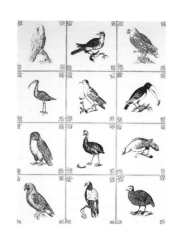

Project for the Antwerp Zoo
1993
Majolica tiles installed in birdhouse

itself was proudly modern. Gone were the mournful cages and stranded specimens of less enlightened times, for the birdhouse at Antwerp is famous for leading the way in modern aviary design, regulating light, humidity and temperature in dioramas complete with rocks and living plants. Placed as a border to the display cases, the tiles juxtaposed the preoccupations of one century against those of another: colonial exoticism versus environmental authenticity, imperial flamboyance versus ecological and technical finesse.

The woodcuts were a reminder that Antwerp's golden age had been an unmitigated disaster, at least in terms of the environment. In the Americas and Australia the arrival of the first explorers and settlers spelt extinction for uncounted numbers of bird species. In some cases – the moa, the great auk, the dodo, the pasture pigeon – the historical record enables us to glimpse and guess at what was lost, but mostly the species disappeared without trace, wiped out either by the settlers themselves or by the dogs, pigs and other domestic animals that accompanied them. Dion's installation at the birdhouse spoke of a barbarous past and of a present committed to environmental awareness; at some level viewers could

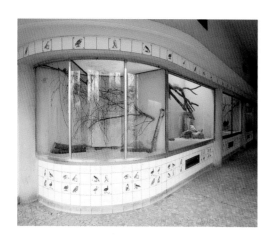

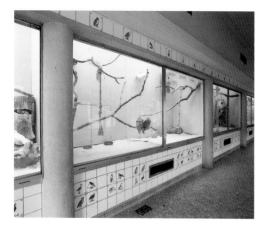

Frans Snyder
Concert of Birds
Early 17th c.
Oil on canvas
93 × 137 cm

Project for the Antwerp Zoo
1993
Majolica tiles
15 × 15 cm

perhaps take comfort that times had changed for the better.

But the juxtaposition of the different periods' attitudes towards birds – and by extension the natural world in general – suggested another, less reassuring possibility: that neither the woodcut drawings from the seventeenth century nor the modern dioramas supplied anything like an unmediated view of birds or their habitats. Both were artificial, deeply conventionalized systems of representation in which 'real' birds could feature only in a highly edited and culturally encoded fashion. What was problematized was the category of the real itself; though the birds that flew through the temperature-controlled atmosphere and perched on the simulated rocks and branches were indeed living creatures, their function was still that of representation. That was their job: to represent themselves, and their exotic habitats, before the enlightened gaze of the colonizers' latest descendants.

Dion's second project, *The Library for the Birds of Antwerp*, was based in the Museum of Contemporary Art. A new wing had recently been added to the museum; its circular space was opened to the public for the first time. White, vast and empty, it was not at first sight a particularly promising environment to house living birds, which need corners and points to orient themselves in space. But if the light could be concentrated inside the circular space, and dimmed at the entranceways, living birds could perhaps be persuaded to treat the museum as a temporary home. They did so, happily; for the duration of the exhibition, eighteen African finches flew, sang and perched on the branches of a large, tree-like structure at the centre of the installation.

Perhaps the birds would have trilled less sweetly had they recognized the paraphernalia that now surrounded them. Wooden cages and metal traps from Africa and America pointed to the lucrative trade in exotic birds which began in the sixteenth century and flourishes to this day in Antwerp's Vogelmarkt (where the finches were purchased). A

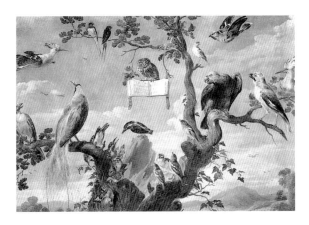

reproduction of Frans Snyders' *Concert of Birds*, in the Prado, portrays the birds' principal appeal to the painters and collectors of the golden age of mercantilism: the splendour and intense colouration of their plumage. Next to Snyders were placed emblems of capture (springs, traps, a photograph of the Antwerp zoo's birdhouse) and of death (cartridges of birdshot, a catapult, an axe). Canisters of DDT and an antiquated Flit gun indicated the various

contexts in which birds continue to be classed as pests or vermin. Humans are not the only predators indicated on the tree: we also see the skull of a cat, the suspended body of a rat, and a brown tree-snake, preserved in formaldehyde. Are these the birds' natural enemies from the dawn of time?

Hardly. Cats, like dogs and pigs, may familiarly feature as domestic animals – friends of man. But they also belong to what are called r-selected species, organisms that live habitually in the abode of other creatures that build 'nests'. Environments that have been disrupted by the advent of human culture contain few natural predators, and guarantee a dramatically increased food supply to the r-selected species (including rats, cats and cockroaches, as well as certain kinds of snake, such as the brown tree-snake). The image of the dodo, a creature destroyed by the Australian settlers' dogs and other domestic animals, and now known only through inaccurate and more or less comical illustrations, underlines that extinction can also be brought about indirectly, through the adaptive success of species that have formed symbiotic pacts with human life.

Signs of extinction are indeed everywhere in the work: in the texts dealing with birds from Central and South America, where species continue to disappear at a terrifying rate; as well as in other prominent titles in the library (including William Hornaday's *Our Vanishing Wildlife* and Coleridge's 'Ancient Mariner'). Extinction persists in Audubon's images of North American birds wiped out not long after the illustrations were made (the great auk and passenger pigeon are not recorded after 1914), and the idea is present, above all, in the tree that is at the centre of the installation. Tree of knowledge, tree of life, its Judeo-Christian associations point to the human species' supposed fall from nature into history and culture; phylogenetic tree, tree of Darwin, it stands both for the assumed basis of life in the competition for dominance, and the by now ironic image of man's place at the pinnacle of the evolutionary hierarchy.

The phylogenetic tree was an icon dear to the hearts and minds of Victorian – and later – naturalists. Though Darwin's theory exploded the idea of man as the centre of

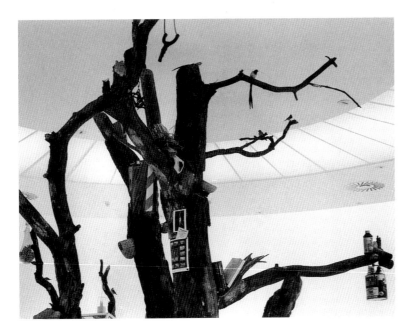

creation, just as the Copernican revolution had shattered the idea of the earth as the centre of the cosmos, Darwin's apologists and popularizers in the nineteenth century quickly reassembled the fragments into a new, consoling picture of man's place in the universal scheme. Too bad that we were no longer fashioned in the image of God – but a position at the top of the evolutionary ladder might be almost as good. Museums of natural history soon found ways to dramatise the new sovereignty. One preferred format was the horizontal 'March of Evolutionary Advance', from stooping primate to upright *Homo sapiens*. Or the same concept might be stated vertically, as the 'Ascent of Man', the evolutionary tree that rose up from a few primitive life forms at its base, through branches of increasing complexity, vertebrates and mammals and primates, to culminate at the apex of the tree in Man. Though upward 'growth' in the phylogenetic tree only described a movement from older to younger species, in the mythical or narcissistic understanding of the icon, 'up' also inevitably meant 'good'.

If the tree at the centre of Dion's installation resonates with the Darwinian icon of phylogenesis, the reference is surely sardonic; it is man's position as the dominant species that has now come to threaten the tree itself. Its trunk and branches appear diseased or lifeless, as though some kind of dry rot had crept in. What is significant, though, is not only the tone of irony but its mode, its reference to the disciplines of natural history, to evolutionary theory and its dissemination through conventionalized representations and institutions of knowledge. There is a simple way of apprehending Dion's installation, which I think would underestimate the work's complexity: to take it as a kind of ecological 'warning', in the manner of Rachel Carson's *Silent Spring* (which is indeed one of the texts the finches are encouraged to read). That is to say, an older system of knowledge, one that was both mistaken and dangerous, is now replaced with a truer, more scientific view, a modern ecological perspective that looks back on prior abuses of nature with alarm and remorse. The position assumed by the ecologically enlightened viewer would be quite straightforward: 'There used to be a time, in the benighted age before we came to understand the web of life,

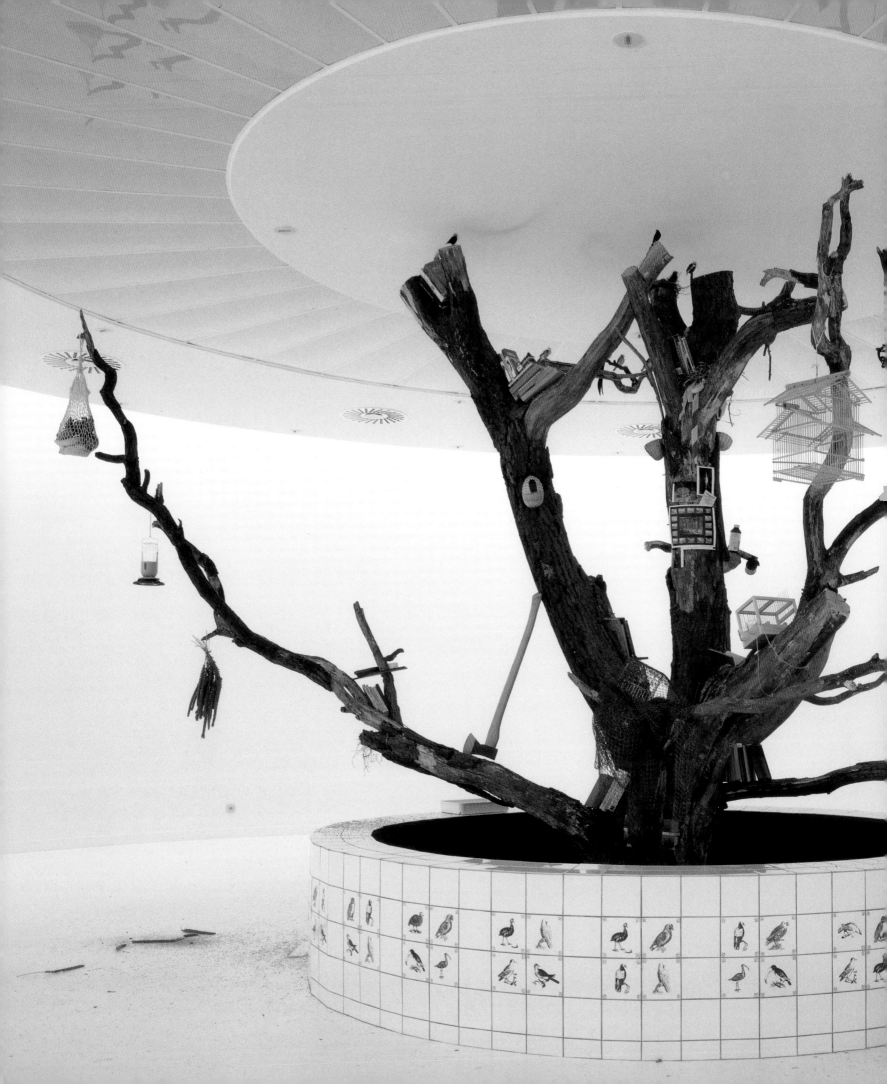

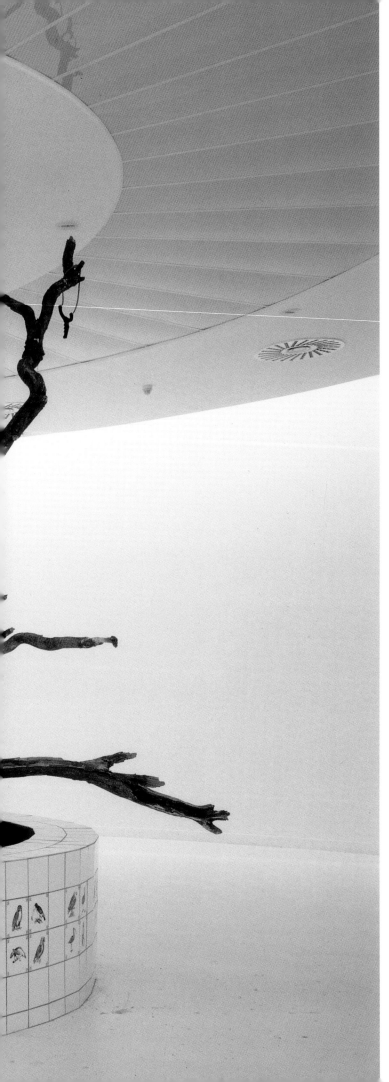

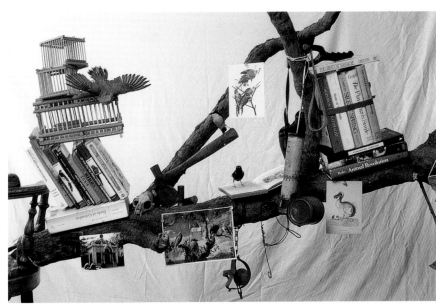

The Library for the Birds of Antwerp (detail)
1993

The Library for the Birds of Antwerp
1993
18 African finches, tree, ceramic tiles, books, photographs, birdcages, bird traps, chemical containers, rat and snake in liquid, shot gun shells, axe, nets, Audubon prints, bird nests, wax fruit, assorted objects
Installation, Museum van Hedendaagse Kunst, Antwerp

Alfred Hitchcock
The Birds
1963
119 mins., colour
Filmstill

when Western civilization attempted to instrumentalize nature, in the same way that it colonized territories outside Europe. Now we realize our folly: our work henceforth is to comprehend the magnitude of past errors, to trace their social and epistemological causes, and to begin to undo the damage we have done'.

What complicates that straightforward message is Dion's intense interest in the historicity of the schemes of knowledge that intervene between man and nature. In Dion's work, nature always appears in highly mediated guises, emerging from within organized systems of power/ knowledge that attempt to classify, taxonomize, tabulate and control the natural world. His interests belong to a later moment than that of the pioneer ecologists, such as Carson, whose chief goal had been to present 'better' information about nature and the environmental crisis. Dion's concern is with the role of system and representation in scientific thought, with the historicity of knowledge and the obsessive will-to-order (wonderfully parodied throughout his work) that typifies institutionalized forms of knowledge. His central gesture is to foreground not nature, but the interface between nature and the history of the disciplines and discourses that take nature as their object of knowledge – an interface that is typically subjected to parody and absurd humour. In this case the form assumed by the institutions of knowledge is a library for the birds. Through the conceit that the birds are readers, the library presents the reverse idea (closer to the truth): that for us, birds are unknowable outside the systems of knowledge we bring to bear upon them; that for creatures like ourselves whose primary habitat is comprised of linguistic and symbolic systems, unmediated reality is strictly for the birds.

Hence the paradoxical and unsettling status of the eighteen African finches in Dion's installation. For if all knowledge of the natural world is conditioned by institutions of knowledge with their own particular and parochial ways of producing truth, then the real – Nature – is not so much that which appears *in* representation, as that which remains always *outside* it. If the primary habitat of human beings is the order of symbols and communication

(the library), then nature can never be captured in any single representational system we may produce. The real exists as an excess lying beyond the scope of representation, as a reserve which the production of truth draws upon, but cannot exhaust or contain. Even the enlightened, morally indignant discourse of contemporary ecology would then be only one more institution of discourse, whose site for the production of truth happens to be, in the case, a museum of contemporary art.

The installation's central encounter between the library and the birds stages something like a return of the real: man-made systems of knowledge on one side, and on the other side a realm beyond those systems, a Nature whose properties remain radically unknown and unknowable. Strictly speaking, if we posit any kind of category lying beyond representation, by definition that category ('Nature') can have no content, remaining semantically null, void and without effects. Yet art is sometimes able to bend the rules of logic, and if Dion's installation could not represent the real directly, what it could do was to invoke the real in terms of the viewer's experience. For many visitors to the museum, it was *The Library*'s phenomenological aspect that powerfully moved them, its creation of a space without any of the normal barriers between the viewer and the birds themselves. One observer recalls 'the experience of entering the space through a blackened antechamber; the dawning awareness that one was surrounded by living flying creatures without protection from a cage or glass barrier; the fear of being touched or shat on by the birds while simultaneously being fascinated by them; and the excitement of being able to walk around a picture'.[1] As a piece of living sculpture, Dion's work invoked sensations and responses at a level distinct from its pictorial or iconographic aspect, and by releasing feelings of trepidation and wonderment, exhilaration and anxiety, the work staged for each of its viewers a certain pressure from the real, like a dream.

The living birds that flew and sang amidst the installation remained, then, as birds always do, beyond human grasp. Whatever discourses might be woven around them – whether old or new, barbarous or enlightened – the birds consistently escaped or evaded the discursive net cast over them. Rather than the advance of human knowledge, the birds marked the latter's limit or closure. Dion's work raises the possibility that in the era of managing resources now recognized to be limited, knowledge itself may be the resource whose historical limits we most urgently need to understand.

1 Iwona Blazwick in a letter to the author, December 1996

The nineteenth century, in western Europe and North America, saw the beginning of a process, today being completed by twentieth-century corporate capitalism, by which every tradition which has previously mediated between man and nature was broken. Before this rupture, animals constituted the first circle of what surrounded man. Perhaps that already suggests too great a distance. They were with man at the centre of his world. Such centrality was of course economic and productive. Whatever the changes in productive means and social organization, men depended upon animals for food, work, transport, clothing.

Yet to suppose that animals first entered the human imagination as meat or leather or horn is to project a nineteenth-century attitude backwards across the millennia. Animals first entered the imagination as messengers and promises. For example, the domestication of cattle did not begin as a simple prospect of milk and meat. Cattle had magical functions, sometimes oracular, sometimes sacrificial. And the choice of a given species as magical, tameable *and* alimentary was originally determined by the habits, proximity and 'invitation' of the animal in question [...]

'We know what animals do and what beaver and bears and salmon and other creatures need, because once our men were married to them and they acquired this knowledge from their animal wives'. (Hawaiian Indians quoted by Lévi-Strauss in *The Savage Mind*)

The eyes of an animal when they consider a man are attentive and wary. The same animal may well look at other species in the same way. He does not reserve a special look for man. But by no other species except man will the animal's look be recognized as familiar. Other animals are held by the look. Man becomes aware of himself returning the look.

The animal scrutinizes him across a narrow abyss of non-comprehension. This is why the man can surprise the animal. Yet the animal – even if domesticated – can also surprise the man. The man too is looking across a similar, but not identical, abyss of non-comprehension. And this is so wherever he looks. He is always looking across ignorance and fear. And so, when he is *being seen* by the animal, he is being seen as his surroundings are seen by him. His recognition of this is what makes the look

of the animal familiar. And yet the animal is distinct, and can never be confused with man. Thus, a power is ascribed to the animal, comparable with human power but never coinciding with it. The animal has secrets which, unlike the secrets of caves, mountains, seas, are specifically addressed to man.

The relation may become clearer by comparing the look of an animal with the look of another man. Between two men the two abysses are, in principle, bridged by language. Even if the encounter is hostile and no words are used (even if the two speak different languages), the *existence* of language allows that at least one of them, if not both mutually, is confirmed by the other. Language allows men to reckon with each other as with themselves. (In the confirmation made possible by language, human ignorance and fear may also be confirmed. Whereas in animals fear is a response to signal, in men it is endemic.)

No animal confirms man, either positively or negatively. The animal can be killed and eaten so that its energy is added to that which the hunter already possesses. The animal can be tamed so that it supplies and works for the peasant. But always its lack of common language, its silence, guarantees its distance, its distinctness, its exclusion, from and of man.

Just because of this distinctness, however, an animal's life, never to be confused with a man's, can be seen to run parallel to his. Only in death do the two parallel lines converge and after death, perhaps, cross over to become parallel again: hence the widespread belief in the transmigration of souls.

With their parallel lives, animals offer man a companionship which is different from any offered by human exchange. Different because it is a companionship offered to the loneliness of man as a species.

Such an unspeaking companionship was felt to be so equal that often one finds the conviction that it was man who lacked the capacity to speak with animals – hence the stories and legends of exceptional beings, like Orpheus, who could talk with animals in their own language.

What were the secrets of the animal's likeness with, and unlike-

Polar Bear (Ursus Maritimus)
The American Museum of Natural History, New York
1992
Black and white photograph
40 × 51 cm

Polar Bear (Ursus Maritimus)
Harvard University Museum of Comparative Zoology, Cambridge
1992
Black and white photograph
40 × 51 cm

Polar Bear (Ursus Maritimus)
The Chicago Academy of Science, Chicago
1992
Black and white photograph
40 × 51 cm

Ours blanc (Ursus Maritimus)
Musée de la Chasse et de la Nature, Paris
1992
Black and white photograph
40 × 51 cm

Isbjören (Ursus Maritimus)
Naturhistoriska Riksmuseet, Stockholm
1992
Black and white photograph
40 × 51 cm

Eisbär (Ursus Maritimus)
Naturhistorisches Museum der Burgergemeinde, Bern
1992
Black and white photograph
40 × 51 cm
Set of 20 black and white photographs, collection Kunsthaus Zürich, Zellweger-Luva Collection

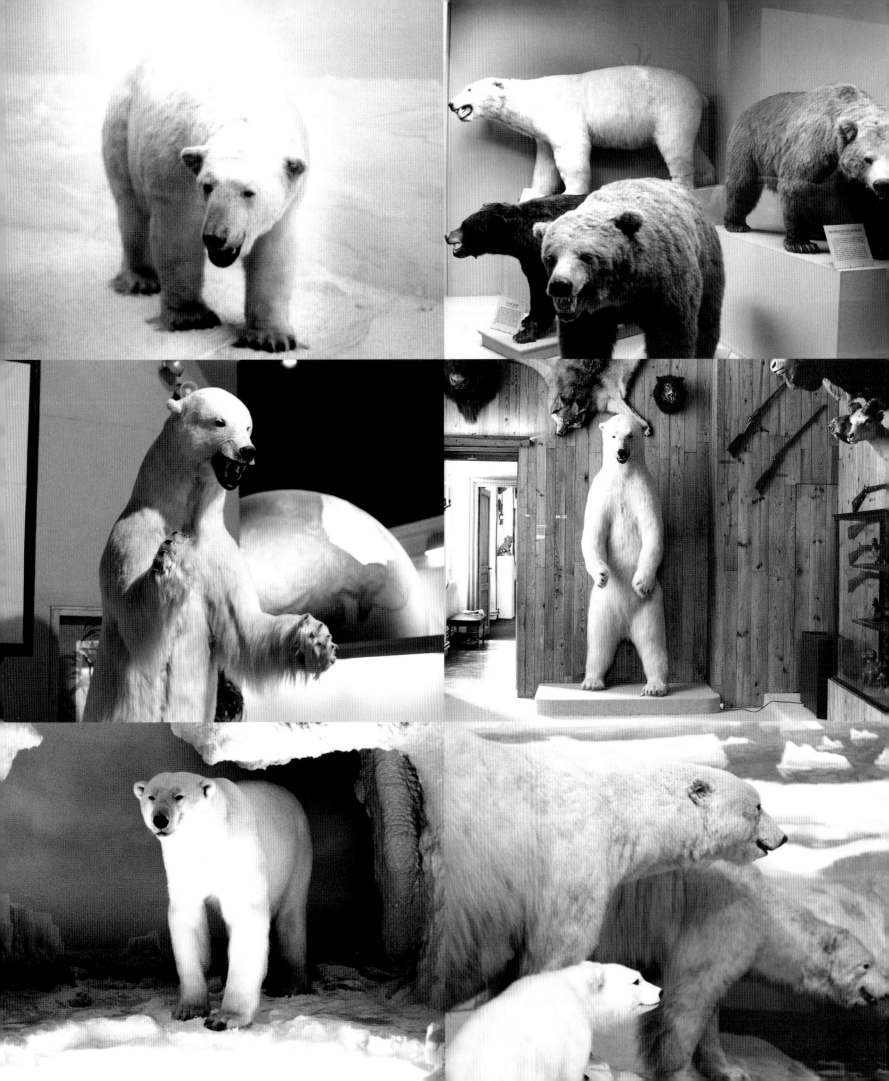

ness from, man? The secrets whose existence man recognized as soon as he intercepted an animal's look.

In one sense the whole of anthropology, concerned with the passage from nature to culture, is an answer to that question. But there is also a general answer. All the secrets were about animals as an *intercession* between man and his origin. Darwin's evolutionary theory, indelibly stamped as it is with the marks of the European nineteenth century, nevertheless belongs to a tradition, almost as old as man himself. Animals interceded between man and their origin because they were both like and unlike man.

Animals came from over the horizon. They belonged *there* and *here*. Likewise they were mortal and immortal. An animal's blood flowed like human blood, but its species was undying and each lion was Lion, each ox was Ox. This – maybe the first existential dualism – was reflected in the treatment of animals. They were subjected *and* worshiped, bred *and* sacrificed.

Today the vestiges of this dualism remain among those who live intimately with, and depend upon, animals. A peasant becomes fond of his pig and is glad to salt away its pork. What is significant, and is so difficult for the urban stranger to understand, is that the two statements in that sentence are connected by an *and* and not by a *but*.

The parallelism of their similar/dissimilar lives allowed animals to provoke some of the first questions and offer answers. The first subject matter for painting was animal. Probably the first paint was animal blood. Prior to that, it is not unreasonable to suppose that the first metaphor was animal [...]

Until the nineteenth century, anthropomorphism was integral to the relation between man and animal and was an expression of their proximity. Anthropomorphism was the residue of the continuous use of animal metaphor. In the last two centuries, animals have gradually disappeared. Today we live without them. And in this new solitude, anthropomorphism makes us doubly uneasy.

The decisive theoretical break came with Descartes. Descartes internalized, *within man*, the dualism implicit in the human

relation to animals. In dividing absolutely body from soul, he bequeathed the body to the laws of physics and mechanics, and, since animals were soulless, the animal was reduced to the model of a machine.

The consequences of Descartes' break followed only slowly. A century later, the great zoologist Buffon, although accepting and using the model of the machine in order to classify animals and their capacities, nevertheless displays a tenderness towards animals which temporarily reinstates them as companions. This tenderness is half envious. What man has to do in order to transcend the animal, to transcend the mechanical within himself, and what his unique spirituality leads to, is often anguish. And so, by comparison and despite the model of the machine, the animal seems to him to enjoy a kind of innocence. The animal has been emptied of experience and secrets, and this new invented 'innocence' begins to provoke in man a kind of nostalgia [...]

Although such nostalgia towards animals was a nineteenth-century invention, countless *productive* inventions were still necessary – the railway, electricity, the conveyor belt, the canning industry, the motor car, chemical fertilizers – before animals could be marginalized.

During the twentieth century, the internal combustion engine displaced draught animals in streets and factories. Cities, growing at an ever-increasing rate, transformed the surrounding countryside into suburbs where field animals, wild or domesticated, became rare. The commercial exploitation of certain species (bison, tigers, reindeer) has rendered them almost extinct. Such wild life as remains is increasingly confined to national parks and game reserves.

Eventually, Descartes' model was surpassed. In the first stages of the industrial revolution, animals were used as machines. As also were children. Later, in the so-called post-industrial societies, they are treated as raw material. Animals required for food are processed like manufactured commodities [...]

The cultural marginalization of animals is, of course, a more complex process than their physical marginalization. The

animals of the mind cannot be so easily dispersed. Sayings, dreams, games, stories, superstitions, the language itself, recall them. The animals of the mind, instead of being dispersed, have been co-opted into other categories so that the category *animal* has lost its central importance. Mostly they have been co-opted into the *family* and into the *spectacle*.

Those co-opted into the family somewhat resemble pets. But having no physical needs or limitations as pets do, they can be totally transformed into human puppets. The books and drawings of Beatrix Potter are an early example; all the animal productions of the Disney industry are a more recent and extreme one. In such works the pettiness of current social practices is *universalized* by being projected onto the animal kingdom [...]

The treatment of animals in nineteenth-century romantic painting was already an acknowledgement of their impending disappearance. The images are of animals *receding* into a wildness that existed only in the imagination. There was, however, one nineteenth-century artist who was obsessed by the transformation about to take place, and whose work was an uncanny illustration of it. Grandville published his *Public and Private Life of Animals* in installments between 1840 and 1842.

At first sight, Grandville's animals, dressed up and performing as men and women, appear to belong to the old tradition, whereby a person is portrayed as an animal so as to reveal more clearly an aspect of his or her character. The device was like putting on a mask, but its function was to unmask. The animal represents the apogee of the character trait in question: the lion, absolute courage; the hare, lechery. The animal once lived near the origin of the quality. It was through the animal that the quality first became recognizable. And so the animal lends it his name.

But as one goes on looking at Grandville's engravings, one becomes aware that the shock which they convey derives, in fact, from the opposite movement to that which one first assumed. These animals are not being 'borrowed' to explain people, nothing is being unmasked; on the contrary. These animals have become prisoners of a human/social situation into which they have been pressganged. The vulture as landlord is more dreadfully rapacious than he is as a bird. The crocodiles

at dinner are greedier at the table than they are in the river.

Here animals are not being used as reminders of origin, or as moral metaphors, they are being used *en masse* to 'people' situations. The movement that ends with the banality of Disney, began as a disturbing, prophetic dream in the work of Grandville [...]

'About 1867', according to the *London Zoo Guide*, '– a music hall artist called the Great Vance sang a song called *Walking in the zoo is the OK thing to do*, and the word "zoo" came into everyday use. London Zoo also brought the word "Jumbo" into the English language. Jumbo was an African elephant of mammoth size, who lived at the zoo between 1865 and 1882. Queen Victoria took an interest in him and eventually he ended his days as the star of the famous Barnum circus which travelled through America – his name living on to describe things of giant proportions'.

Public zoos came into existence at the beginning of the period which was to see the disappearance of animals from daily life. The zoo to which people go to meet animals, to observe them, to see them, is, in fact, a monument to the impossibility of such encounters. Modern zoos are an epitaph to a relationship which was as old as man. They are not seen as such because the wrong questions have been addressed to zoos.

When they were founded – the London Zoo in 1828, the Jardin des Plantes in 1793, the Berlin Zoo in 1844 – they brought considerable prestige to the national capitals. The prestige was not so different from that which had accrued to the private royal menageries. These menageries, along with gold plate, architecture, orchestras, players, furnishings, dwarfs, acrobats, uniforms, horses, art and food, had been demonstrations of an emperor's or king's power and wealth. Likewise in the nineteenth century, public zoos were an endorsement of modern colonial power. The capturing of the animals was a symbolic representation of the conquest of all distant and exotic lands. 'Explorers' proved their patriotism by sending home a tiger or an elephant. The gift of an exotic animal to the metropolitan zoo became a token in subservient diplomatic relations.

Yet, like every other nineteenth-century public institution, the

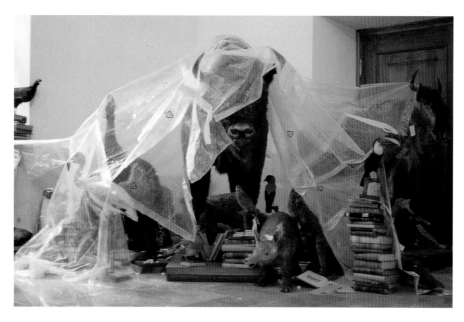

**An Account of Six Disastrous
Years in the Library for Animals**
1992
Taxidermic animals, plastic, books
Installation, Centrum Sztuki
Wspoteczesnej, Zamek
Ujazdowski, Warsaw

zoo, however supportive of the ideology of imperialism, had
to claim an independent and civic function. The claim was that
it was another kind of museum, whose purpose was to further
knowledge and public enlightenment. And so the first questions
asked of zoos belonged to natural history; it was then thought
possible to study the natural life of animals even in such unnat-
ural conditions. A century later, more sophisticated zoologists
such as Konrad Lorenz asked behaviouristic and ethological
questions, the claimed purpose of which was to discover more
about the springs of human action through the study of animals
under experimental conditions.

Meanwhile, millions visited the zoos each year out of a curiosity
which was both so large, so vague and so personal that it is hard
to express in a single question. Today in France 22 million people
visit the 200 zoos each year. A high proportion of the visitors
were and are children.

Children in the industrialized world are surrounded by animal
imagery: toys, cartoons, pictures, decorations of every sort.
No other source of imagery can begin to compete with that of
animals. The apparently spontaneous interest that children have
in animals might lead one to suppose that this has always been
the case. Certainly some of the earliest toys (when toys were
unknown to the vast majority of the population) were animal.

Equally, children's games, all over the world, include real or
pretended animals. Yet it was not until the nineteenth century
that reproductions of animals became a regular part of the decor
of middle class childhoods – and then, in this century, with the
advent of vast display and selling systems like Disney's – of all
childhoods [...]

The animals seldom live up to the adult's memories, whilst to the
children they appear, for the most part, unexpectedly lethargic
and dull. (As frequent as the calls of animals in a zoo, are the
cries of children demanding: Where is he? Why doesn't he move?
Is he dead?) And so one might summarize the felt, but not
necessarily expressed, question of most visitors as: Why are
these animals less than I believed?

And this unprofessional, unexpressed question is the one worth
answering.

A zoo is a place where as many species and varieties of animal as
possible are collected in order that they can be seen, observed,
studied. In principle, each cage is a frame round the animal
inside it. Visitors visit the zoo to look at animals. They proceed
from cage to cage, not unlike visitors in an art gallery who stop
in front of one painting, and then move on to the next or the
one after next. Yet in the zoo the view is always wrong. Like an
image out of focus. One is so accustomed to this that one
scarcely notices it any more; or, rather, the apology habitually
anticipates the disappointment, so that the latter is not felt.
And the apology runs like this: What do you expect? It's not a
dead object you have come to look at, it's alive. It's leading its
own life. Why should this coincide with its being properly visible?
Yet the reasoning of this apology is inadequate. The truth is
more startling.

However you look at these animals, even if the animal is up
against the bars, less than a foot from you, looking outward
in the public direction, *you are looking at something that has
been rendered absolutely marginal*; and all the concentration
you can muster will never be enough to centralize it. Why is this?

Within limits, the animals are free, but both they themselves,
and their spectators, presume on their close confinement. The

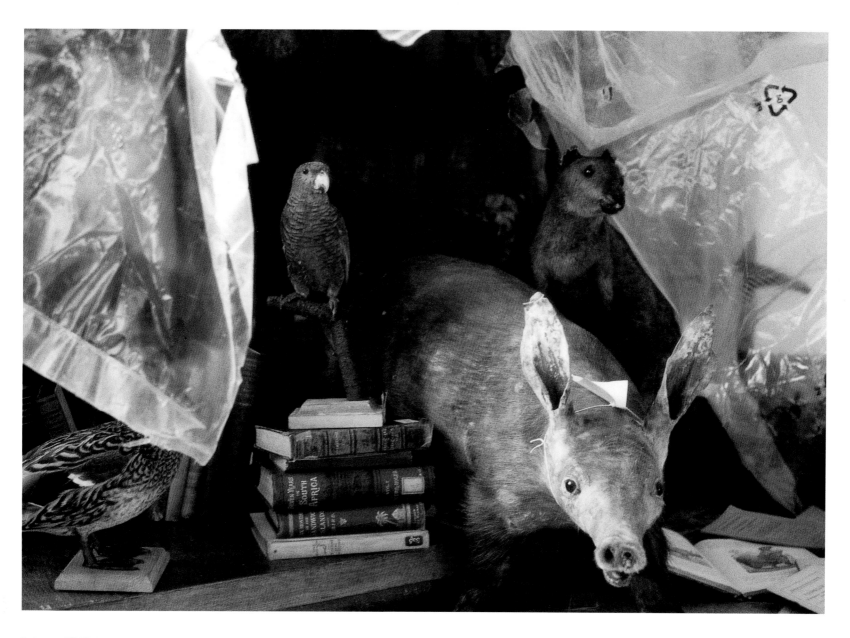

An Account of Six Disastrous
Years in the Library for Animals
(detail)
1992

Extinction Series: Cuban Macaw
(with Bob Braine)
1991
Colour cibachrome in frame with label
46 × 61 cm

Extinction Series: Quagga (with Bob Braine)
1991
Colour cibachrome in frame with label
46 × 61 cm

Extinction Series: Burchell's Zebra (with Bob Braine)
1991
Colour cibachrome in frame with label
46 × 61 cm

Extinction Series: Carolina Parakeet (with Bob Braine)
1991
Colour cibachrome in frame with label
46 × 61 cm

visibility through the glass, the spaces between the bars, or the empty air above the moat, are not what they seem – if they were, then everything would be changed. Thus visibility, space, air, have been reduced to tokens.

The decor, accepting these elements as tokens, sometimes reproduces them to create pure illusion – as in the case of painted prairies or painted rock pools at the back of the boxes for small animals. Sometimes it merely adds further tokens to suggest something of the animal's original landscape – the dead branches of a tree for monkeys, artificial rocks for bears, pebbles and shallow water for crocodiles. These added tokens serve two distinct purposes: for the spectator they are like theatre props; for the animal they constitute the bare minimum of an environment in which they can physically exist [...]

All sites of enforced marginalization – ghettos, shanty towns, prisons, madhouses, concentration camps – have something in common with zoos. But it is both too easy and too evasive to use the zoo as a symbol. The zoo is a demonstration of the relations between man and animals; nothing else. The marginalization of animals is today being followed by the marginalization and disposal of the only class who, throughout history, has remained familiar with animals and maintained the wisdom which accompanies that familiarity: the middle and small peasant. The basis of this wisdom is an acceptance of the dualism at the very origin of the relation between man and animal. The rejection of this dualism is probably an important factor in opening the way to modern totalitarianism. But I do not wish to go beyond the limits of that unprofessional, unexpressed but fundamental question asked of the zoo.

The zoo cannot but disappoint. The public purpose of zoos is to offer visitors the opportunity of looking at animals. Yet nowhere in a zoo can a stranger encounter the look of an animal. At the most, the animal's gaze flickers and passes on. They look sideways. They look blindly beyond. They scan mechanically. They have been immunized to encounter, because nothing can any more occupy a *central* place in their attention.

Therein lies the ultimate consequence of their marginalization. That look between animal and man, which may have played a crucial role in the development of human society, and with which, in any case, all men had always lived until less that a century ago, has been extinguished. Looking at each animal, the unaccompanied zoo visitor is alone. As for the crowds, they belong to a species which has at last been isolated.

This historic loss, to which zoos are a monument, is now irredeemable for the culture of capitalism.

For Gilles Aillaud, from **About Looking**.

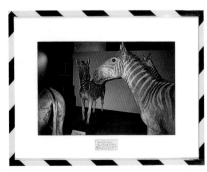
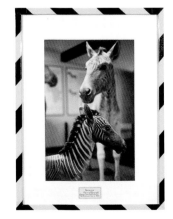
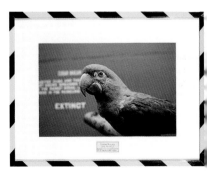

It rained off and on for most of that afternoon. The down-
pours made it an uneventful day. I also took it easy and
was glad to be feeling better by the late afternoon. Finished
A confederacy of Dunces.

Day 17, March 24

The day started with Shark making yet another of his
large and delicious breads for breakfast. He has slowly, for
the better welfare of the entire group, taken over the meals.
Last night he proved that Paca flesh is indeed savory, after
Bob and I ruined the first one. Shark's was excellent, tender
and very like pork, not at all that grey tasteless thing we
made.

Later I made my through the dense scrub to the spot where
I had seen the feeding blue-headed parrots yesterday. Feathers
would have been a nice reward for so much hacking. No luck, but
I did find an impressive walking stick insect.
Our trip to Sam Island was delayed by the
threat of rain.

Later while Bob spent his usual hour and a half fucking
around ~~with~~ with his equipment. ~~~~
~~~~ Alexis, Shark and I took a brief tour of the island next
door. It could not have been different from our base camp - it is
a place of the deepest forest cover, high canopy very old trees
with huge buttress roots. Even though most of the valuable hardwoods
had been harvested long ago, this island still seemed untouched.

At one point Shark hacked a sapling with a hornet's nest
attached. It flew right in our faces. We were not stu-

Contents

**Economic Recovery**
1984
Magazine illustration
2 (8.5 × 13) cm
'A German genre scene (61 × 38
cm) painted in appoximately 1825
by an anonymous artist'.

An inexperienced DEALER is excited about the Nineteenth-Century German genre
painting he purchased from a large AUCTION HOUSE at surprisingly little expense.
RESTORER regretfully informs DEALER that what he has mistaken for an oil painting
(in the profitable sense, that is, oil on canvas, oil on panel, oil on tin, etc.) is in truth
a print on board. Though not the most exacting form of forgery, it was effective in the
1800s to glue prints onto larger boarders or canvas, paint over them, and sell them
as original oil paintings. Now, after about one hundred and fifty years the edges of the
print have lifted from the board, foiling the deception and makings the work practically
unsaleable as anything but a cheap curio. RESTORER, having dealt with similar
situations before, assures DEALER there is still a way to make substantial financial gain.
The print is cut from the board, relined onto a new canvas, restored and stretched onto
a period stretcher. It is undetectable as a print. The print that was a painting, then a
print, is once again a painting (although quite a bit smaller). The painting is framed and
sold. The original COLLECTOR, the AUCTION HOUSE, the RESTORER, and the DEALER
have all made a good deal of money off a Nineteenth-Century scam.

*Real Life Magazine*, New York, no. 14, 1988, pp. 10-13

## Project for the Belize Zoo   1990

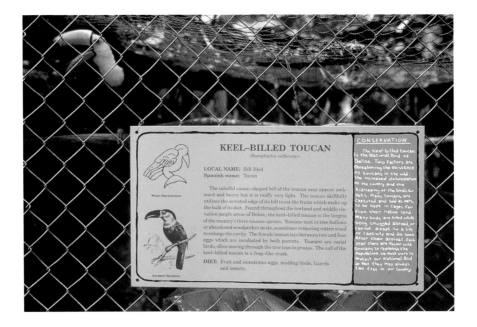

Project for the Belize Zoo
(Keel-Billed Toucan)
1990
Silkscreen enamel on aluminum
30.5 × 56 cm

Belize is an anomaly in Central America. It is a newly independent, English-speaking, liberal democracy with a low population density and large areas of neo-tropical wilderness. For its size, Belize contains a suprising variety of rare habitats including mangrove swamps, the world's second largest barrier reef, savannahs, deciduous forests, mountain coniferous woodland and rainforests. Animal and plant species which have disappeared from other Central American countries can still be found in healthy numbers in Belize. While much of Central America suffers from deforestation and soil erosion, 60-70% of Belize is intact and unspoiled forest. The double pressures of a growing population (both internally and from refugees) and foreign investment interests present new challenges to the government and numerous conservation organizations working in the country.

The Belize Zoo and Tropical Education Center is playing a critical role in the debates the country faces at the crossroads of development. Sharon Matola, the Zoo's director, uses the Zoo's status as one of the country's major cultural attractions, to openly advocate conservation and alternative resource projects. One of the strengths of its educational approach is that the Zoo only displays native wildlife, which are exhibited in large, naturalistic settings. Through school field trips and rural outreach programs , the Zoo reaches an enormous percentage of the country's population. Training programs expose the Zoo staff to wildlife and resource management projects throughout the U.S. and Central America and have increased the number of skilled Belizian conservation professionals. The Zoo is an education success story and can take credit for affecting the conservation attitudes of the entire nation.

In addition to education programs, the Zoo maintains an endangered species breeding program and leads research projects in the field of appropriate technology-sustainable agriculture. One such project is led by Zoo curator Tony Garel. The Belize Zoo Iguana Breeding Program examines the possibility of raising captive bred lizards as both a food source and a method of reducing the pressure on wild populations.

The sign project for the Zoo is my attempt to assist in continuing the Zoo's commit-ment to education, conservation and regional focus. I worked with the Zoo staff to develop an appropriate series of graphics which would synthesize the Zoo's concerns. The texts for the signs were all approved by the Zoo director and appropriate changes were made. About half of the graphics are currently installed at the Zoo and the rest will be part of the Zoo's relocation in late 1991.

Project for the Belize Zoo
(Jaguar)
1990
Silkscreen enamel on aluminum
30.5 × 56 cm

Project for the Belize Zoo
(Mealy Parrot)
1990
Silkscreen enamel on aluminum
30.5 × 56 cm

Project for the Belize Zoo
(Coati)
1990
Silkscreen enamel on aluminum
30.5 × 56 cm

Project for the Belize Zoo
(Tapir)
1990
Silkscreen enamel on aluminum
30.5 × 56 cm

# Taxonomy of Non-endangered Species 1990

Taxonomy of Non-endangered
Species
1990
Toy animals conserved in alcohol,
animated Mickey Mouse figurine,
ladder, shelves, glass containers,
audiotape
89 × 150 × 250 cm

Taxonomy, the classification of the natural world, is a theory of order imposed by man, not an objective reflection of what is present in nature. The categories are actively imposed and contain the assumption, values and associations of human society.

To Baron Cuvier, nature was subject to strict laws which man could discover through careful observation. Order was the key concept to Cuvier's interpretation of the natural realm and management of the cultural sphere. Like most political conservatives who lived through the revolution, he feared anarchy and rejected any suggestion of vagueness, disorder or discord. As a major public figure and superintendent of France's non-Catholic schools, he strived to bring universality, strength and authority of law to the political empire as well as to the intellectual empire. It was widely rumoured that Cuvier's true love was not zoology but the daily structure of minute administrative affairs. It is here, in the coherent hierarchical interpretation of culture and of nature, that Disney the architect approaches Cuvier the scientist. As the goal of Natural History was to interpret the Universe, the intention of Disney was to produce one of his own. Disney, both man and corporation, constructed a microcosm which functioned according to a set of laws, a systematic imposition of will and vision over the previously organic framework of society. What is the Disneyland concept if not an exercise in the total control over everything – nature, man, culture, history, geography and even the future.

Disneyland was Walt's gift to himself and to the world. It is a living monument to his values. Not since Versailles has there been greater extention of an individual personality. The theme parks are conscious expressions of everything important and good to Disney. Walt successfully colonized the globe by remaking the world in his own image – a warmhearted, futuristic, authoritarian world, which embraced and constructed the nostalgic virtue of 'the good old days'.

Disney's dream project was the EPCOT Center – an Experimental Prototype Community of Tomorrow. Originally planned as a working city, EPCOT was to be an experiment in absolute monarchy. The city of the future was to lack everything Disney despised: dirt, crime, discord, bureaucracy and democracy. It was to be a showcase for American industry and research. What EPCOT turned out to be was a vehicle for corporate apology and the dissemination of company propaganda. In the EPCOT Center, General Electric (the world's largest arms producer) gets to present the history of progress. Exxon provides us with their version of the history and future of energy. The Kraft corporation tells us of the world of food and so on. It is only appropriate that, without missing a beat, Disney the man became Disney the corporation, mirroring the

trend of the death of individual innovation in the face of new corporate allegiance.

Walt envisioned a world where the trains ran on time, where all surprises were planned. The friendliest undemocratic society on earth. Don't be fooled by the prototype utopian rhetoric. EPCOT, Disneyland, Disneyworld and Euro-Disneyland are not non-profit organizations. They are the largest tourist destinations on earth. Between sixteen and eighteen million people visit Disney parks each year. One-tenth of the U.S. population each year. These environments are designed to handle vast numbers of people, channelling them through a series of long lines, restaurants and stores, while maintaining a happy spending mood. Indeed, if one took away the concessions of thematically organized commodities, Disneyland would appear rather thin. No options exist in the Disneyland monopoly. One must buy the company food and goods. Every plastic trinket and food item is codified with geographical or historical characters of related significance to give the illusion of choice.

There is no dissent or disorder in Disneyland.

Be cautious, for this world is inflexible but may never show it. Here we are frozen by so many rules that if one moves the wrong way the entire ice block may crack. We might just ruin everyone's special day. This hierarchy must not readily betray itself. Security by habit. But, should the system of implicit authoritarianism exceed itself, or the ordered character of the landscape become apparent (based on sheer force, both physical and psychological on the one hand, and passivity and unconsciousness on the other), it might just rain on the magic kingdom.

In Disneyland there is little that is more subversive than a service closet left open exposing a mop and bucket.

Recorded text 'spoken' by animated Mickey Mouse figure in *Taxonomy of Non-endangered Species* at 'Extinction, Dinosaurs and Disney: The Desk of Mickey Cuvier', Galerie Sylvana Lorenz, Paris, 1990. Performed by Nicholas Bourriaud (in French) and Nils Norman (in English).

## M. Cuvier 'Discovers' Extinction 1990

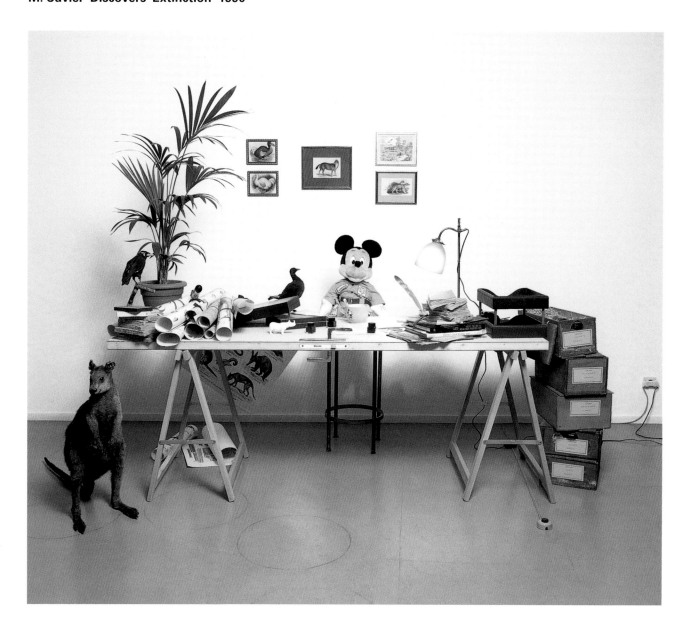

Baron Georges Cuvier is without doubt one of the most eminent zoologists of all time. His immediate successors referred to him as the Aristotle of France. A widely recognized master dissector, Cuvier virtually founded the science of comparative anatomy and contributed to it the law of the 'correlation of parts'. He revised the taxonomy of animals from an anthropomorphic rank of lower to higher (with man on top) to a system of classification based on function. He also established Palaeontology – the scientific study of the fossil record, and the belief that the Earth's history could be calibrated by reckoning the life span of fossil animals. Perhaps Cuvier's greatest contribution to the world of science was in establishing the fact of extinction.

Through the study of France's fossilized tapirs and mammoths, Cuvier first understood that animals from previous ages had died out, leaving no living specimens. Comparative anatomy was the major tool in theorizing extinction, and it was precisely this emphasis on hands-on lab work which separated Cuvier from the armchair natural philosophers of the period. Species death or phylogenic death supported existing notions of geological or deep time, and this latter concept was necessary to the development of serious evolutionary thought. What's more, with the recognition of species death the metaphor of the endless chain of life had been broken, and scientists were horrified by the notion that links were indeed missing. The omniscient Maker they

M. Cuvier 'Discovers' Extinction
1990
Solid door, 2 wooden horses,
stool, animated Mickey Mouse
figure, potted plant, framed
illustrations, taxidermic animals,
plaster rhinoceros figurine, desk
lamp, in-trays, specimen boxes,
books, quill pen, bottled ink,
ceramic cup, posters, audiotape
129.5 × 140 cm

had imagined had allowed for apparently aimless disappearances; the Baron had uncovered a vast and uncertain history of the Earth in the rocks. This history threatened to be one in which man's role would lose the significance which had always been attached to it.

The establishment of the fact of extinction seems strange to us since we recognize that probably 99.99% of all species that have ever existed on earth are now extinct. The fossil record clearly indicates that extinction is the norm, and survival the exception, and that once a species dissappears it does not reappear. There is no shame in phylogenic death. It is not an issue of judgement. Under normal environmental conditions extinction is a natural process. Indeed we owe our own existence to the extinction of our ancestors and their competitors. But the biodiversity of the planet is currently facing a crisis, the likes of which has not been seen since the great extinction of the Cretaceous epoch (which led the dinosaurs to oblivion). Human populations are growing so rapidly and disrupting environments so drastically that the earth is witnessing the first mass extinction episode caused by the global spread of only one species – our own.

It is a great scientific embarrassment that we still do not know for sure if there are three, five, thirty or eighty million species on earth. But if the estimate of thirty million for the world's total species is correct, then the plants and animals are becoming extinct at a rate of about 150,000 per year or seventeen per hour. By the turn of the century over one fifth of all plant and animal species alive in 1980 will have vanished. Most of those animal species are invertebrates and will never have been named, preserved or studied in any way, and most of them are found in tropical rainforests. The rainforests of the world cover only 6% of the land mass, yet they hold up to half of all known species. A single tree in the Peruvian Amazon may house more beetle species than can be found in all of France.

Nevertheless the rainforests are being destroyed at an astounding rate. Each second an area the size of a football field is lost forever. In 1988 alone an area the size of Austria, Belgium, Denmark and Switzerland combined was deforested. Anywhere from 6,000 to 150,000 species of plants and animals become extinct from tropical rainforest destruction each year. That rate of extinction is 10,000 times greater than before the appearance of man: *Homo sapiens* have had the greatest ecological impact on a broader frontier than any other animal in the 4.7 billion years of the planet's existence.

Recorded text 'spoken' by animated Mickey Mouse figure in *M. Cuvier 'Discovers' Extinction* at 'Extinction, Dinosaurs and Disney: The Desk of Mickey Cuvier', Galerie Sylvana Lorenz, Paris, 1990. Performed by Olivier Zahm (in French) and Nils Norman (in English).

# Concrete Jungle: A Discussion with Alexis Rockman (extract) 1991

## Introduction I

Prosperous New York drug manufacturer Eugene Scheifflin had two great passions: ornithology and the study of the works of William Shakespeare. As the leader of the American Acclimatization Society, Scheifflin spent a small fortune synthesizing his interests. He compiled a precise list of the names of every bird mentioned in the plays and sonnets of Shakespeare. His intention was to import and naturalize populations of each listed bird species. Unfortunately for the farmers and indigenous North American birds, the play *Henry IV* contains the line:

'Nay, I'll have a starling shall be taught
to speak nothing but "Mortimer".'

On March 6th, 1890, Scheifflin released forty pairs of European starlings (*Sturnus vulgaris*) into Central Park. He repeated this act the next year. One year later, the birds had already colonized Staten Island. By 1896 they had become a common sight in Brooklyn. New Jersey, Delaware and Pennsylvania all hosted starling populations by the turn of the century. From New York, it took the birds fifty-five years to establish themselves from coast to coast all the way north to Alaska.

The starlings immediately became an agricultural pest. These aggressive birds exerted sharp selective pressures on native species. Their superior strength and ferocity gave them the competitive edge in both nest site selection and in limited food situations. Soon many North American bird populations, such as the Eastern Bluebird, were in serious decline.

## Introduction II

The plants and animals we usually encounter in our daily urban existence are those that are classified by biologists as the r-selected species. By no means limited to the cities, these highly opportunistic species have colonized all areas of human habitation. Some of the most successful organisms ever to inhabit the planet, they feature extremely high reproductive rates. Most r-selected species are characterized by having short lives, breeding regardless of season and producing large numbers of offspring.

They are specialists at non-specialization. With an ability to occupy a wide range of ecological niches, they can rush into newly disturbed environments, quickly disperse, aggressively displace, outcompete and prey upon the indigenous plant and animal communities. Numerous, mobile and adaptable, these organisms demonstrate an

Concrete Jungle (The Birds)
1992
Taxidermic birds, cardboard boxes, tyres, toy truck, wash basin, motor oil cannister, chair cushion, rolled carpet, linoleum flooring, wooden crates, aluminium cans, newspaper, plastic bags, containers, cups, bottles, other assorted rubbish
150 × 420 × 130 cm

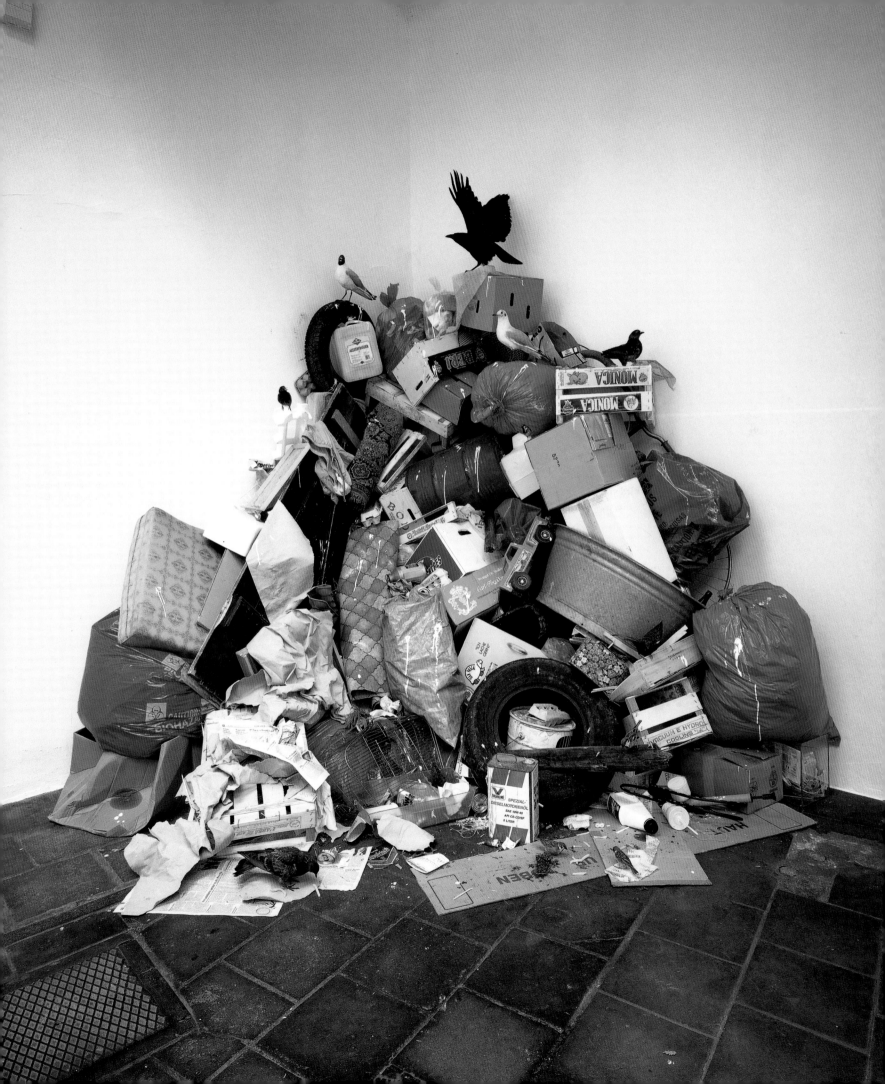

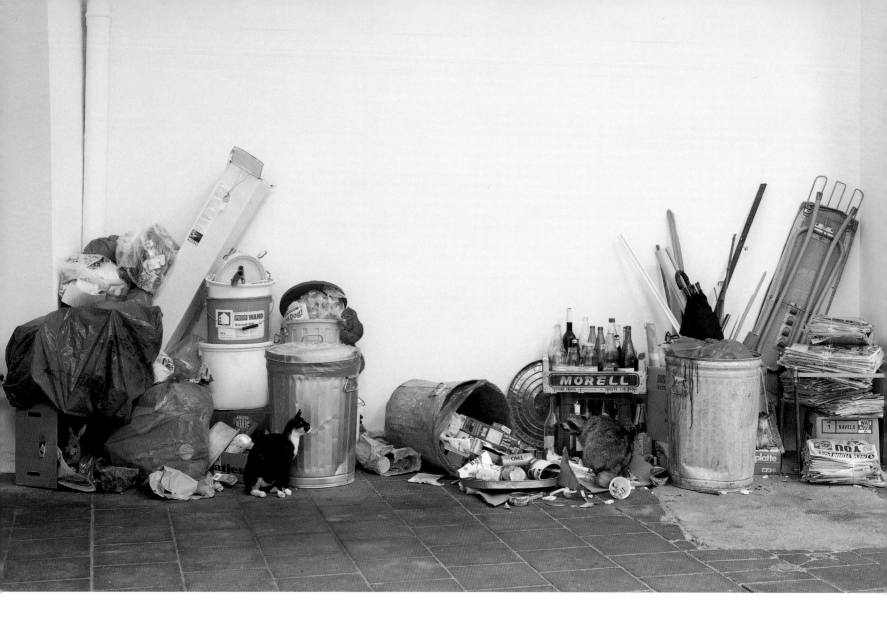

ability to take the fullest advantage of humanized environments. Habitats disrupted by humans contain few or no natural predators and provide an increased food supply [ … ] They share our 'nests', without providing any benefit to us. We know them simply as the 'pest' species (e.g., cockroaches, rats, pigeons, weeds).

The r-selected species are significant not merely because of the human suffering they have caused through the spread of disease or the destruction of crops, but they also have contributed to the drastic decline in biological diversity. Defined as the variety and variability of living organisms, biodiversity functions to indicate the health and stability of an ecosystem. As humans destroy fragile relationships within ecosystems, the aggressive r-selected species replace local plant and animal populations. Responsible for many extinctions already, these species may continue to proliferate and dominate the biological world of the future.

Mark Dion  The idea of both of us working collaboratively on a project may surprise some people. Our work represents opposite positions in terms of presentational methods. Yet we are both fascinated by this issue of r-selected species. I imagine this is because these animals and plants have a direct relationship to the theme of extinction – the focus of both of our practices for several years. I'm certain that you share my view that the loss of biodiversity is a critically underestimated ecological issue. For some time now we have known that life is based on complex webs of interrelationships. By destroying elements within those interrelationships we reduce our options for

**the future and threaten to disrupt the natural processes that keep the life-cycle going. Just how many pieces from the puzzle can you remove before you lose the picture?**

**Alexis Rockman**  Of course no one knows, and it's hard to decide what the picture is or was. Our relationship to this issue is based upon late twentieth-century conceptions, and the closest thing we have to a laboratory is the introduction of Europeans into the New World in 1492. There is every indication that the track record for dealing with native peoples and species of plants and animals is atrocious. I view the r-selected species as symptomatic of Western intolerance and arrogance. It's surprising to think that most of the species synonymous with American history were deliberately introduced by Europeans. The horse, the pig and cattle all outcompeted the indigenous species. There is, of course, an even darker side to the equation. With the Europeans came a host of freeloading inquiline species: rats, roaches, pigeons, European sparrows. It's like the return of the repressed; no matter how controlled or controlling, there is always a fly in the ointment. This reminds me of the movie *Creepshow* where the protagonist quarantines himself in his modernist box penthouse and the water bugs still find a way to come up through the drain.

**Dion You're right when you suggest that the European invasion of the Americas presents a test case for the introduction of r-selected species. The Europeanization of the 'New World' ecosystems was well underway by 1500, and by 1550, North and South American flora and fauna were irrevocably altered. In the same way that we can never piece together a clear picture of pre-Columbian cultures before the disease, ethnocide and genocide perpetrated by the Europeans, we also will never know exactly what and how many plant and animal species (in particular, birds and reptiles) were driven to extinction during the first one hundred years of the European conquest.**

**Rockman**  Back to the question of our involvement with ecological issues ... There are several differences regarding the way in which we approach such problems. You seem to come to them from a more clinical, methodological position wherein you generate a revisionist 'official story' of natural history in a pseudo-documentary format. My position is more about ambivalence. I see these organisms as symptomatic of our own arrogance and vulnerability [ ... ] These symbolically marginalized species are considered ruthless and out of control. But this perception is really symptomatic of our inability to control nature. I admire their power and adaptability

Dion  You've touched on exactly what makes these organisms so detestable in our culture. These creatures are constant reminders of our part in the biological contract. They remind us that, like all animals, we are implicated in a set of relations with other animals – and that we do not benefit from some of those relationships. The modernist cube, which you referred to earlier, is an example of the denial of the biological contract. It is the environment without nature. In the same way that our culture does not acknowledge shit, distances itself from the production of food or denies the processes of aging, these animals remind us that we too are animals – and therefore mortal. You mentioned that my approach is related to documentary. I view my practice as closely akin to documentary. In the 1960s, documentary film was dissected and then reinvented. And in the 1970s the use of photodocumentary was examined. I'm interested in a different site for the production of truth – the pedagogical institution of the museum. Since, like you, my main interest is the question of the representation of nature, it is the natural history, ethnographic, and history museums – as well as the zoological and botanical parks – that interest me. These are fascinating institutions because they represent a society's 'official story', all the conventions and assumptions of what gets to stand for nature at a particular time for a particular group of people [ … ]

Rockman  Although we share an enthusiasm for the traditional language of natural history representations, the differences in our methods are quite radical. You tend to use the format of the installation to collect and re-frame taxidermic specimens, signs, didactic diagrams and other elements in order to construct an engaging framework of investigation and information. I use empirical studies of botanical and zoological illustrations and the great mural cycles depicting the natural world produced during the early part of the century as primary models [ … ]

Dion  I think we both have an interest in challenging institutional forms of knowledge, representation and information. The natural history museum, as a cultural construct, often remains under the spell of an ideology of pure scientific objectivity, even though scientists such as Stephen Jay Gould and Robert Barker represent clear departures from this tradition. Anyone interested in working within these institutions soon finds a lack of tolerance for anything but the most authoritarian method of presentation. Metaphor, irony, humour and self-reflexivity are all strategies outside their notion of how information should be organized. The exhibition of science imagines its expression existing outside the realms of politics and popular culture. Yet, quite recently, there

Desk for the Assistant Director of the Brooklyn Museum of Natural History
1992
Barrel with text, wooden crate, 'Police Line' plank, cat skeleton, fly specimen, taxidermic sparrow, preserved carp specimen in jar
Dimensions variable

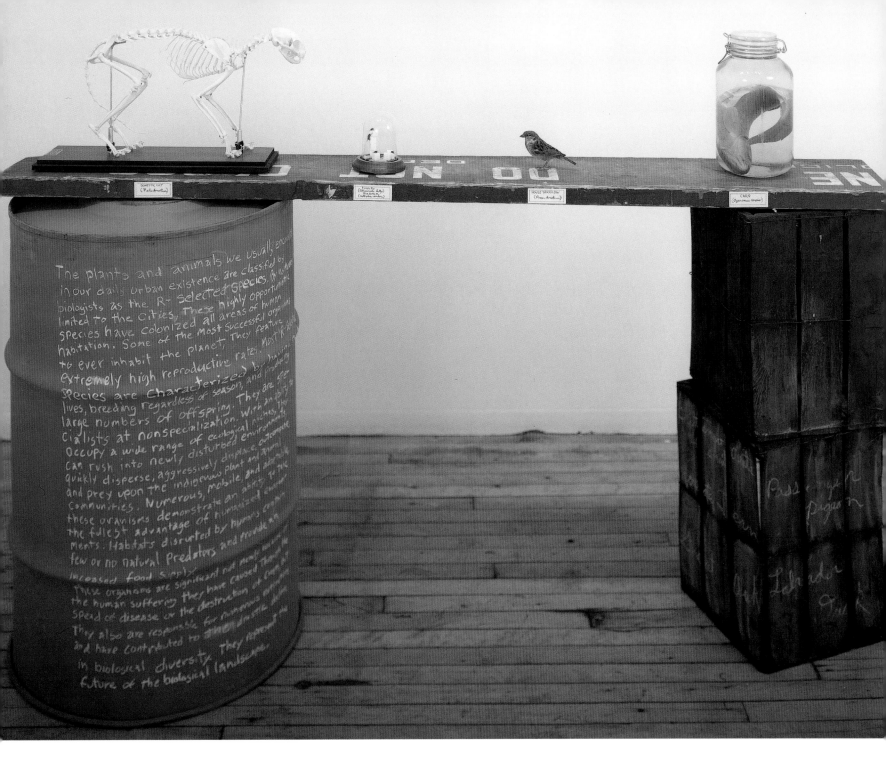

have been some encouraging signs of change within the institutional framework. But as artists, we have a certain advantage over the conventional methods because we are not necessarily inclined to accept the notion that scientific discourse should be isolated; also, we are not obliged to produce logical equations that add up in an entirely rational manner. I'm convinced that our method of organizing information can be much more compelling and challenging. For me, making a point is the easy part of a project – it is just the beginning [ … ]

*Journal of Contemporary Art*, New York, Spring/Summer, 1991, pp. 24-33. Reprinted in *Concrete Jungle*, Mark Dion, Alexis Rockman and Bob Braine, Ezra and Cecile Zikha Gallery, Center for the Arts, Wesleyan University, Middletown, Connecticut, 1993, pp. 6-10.

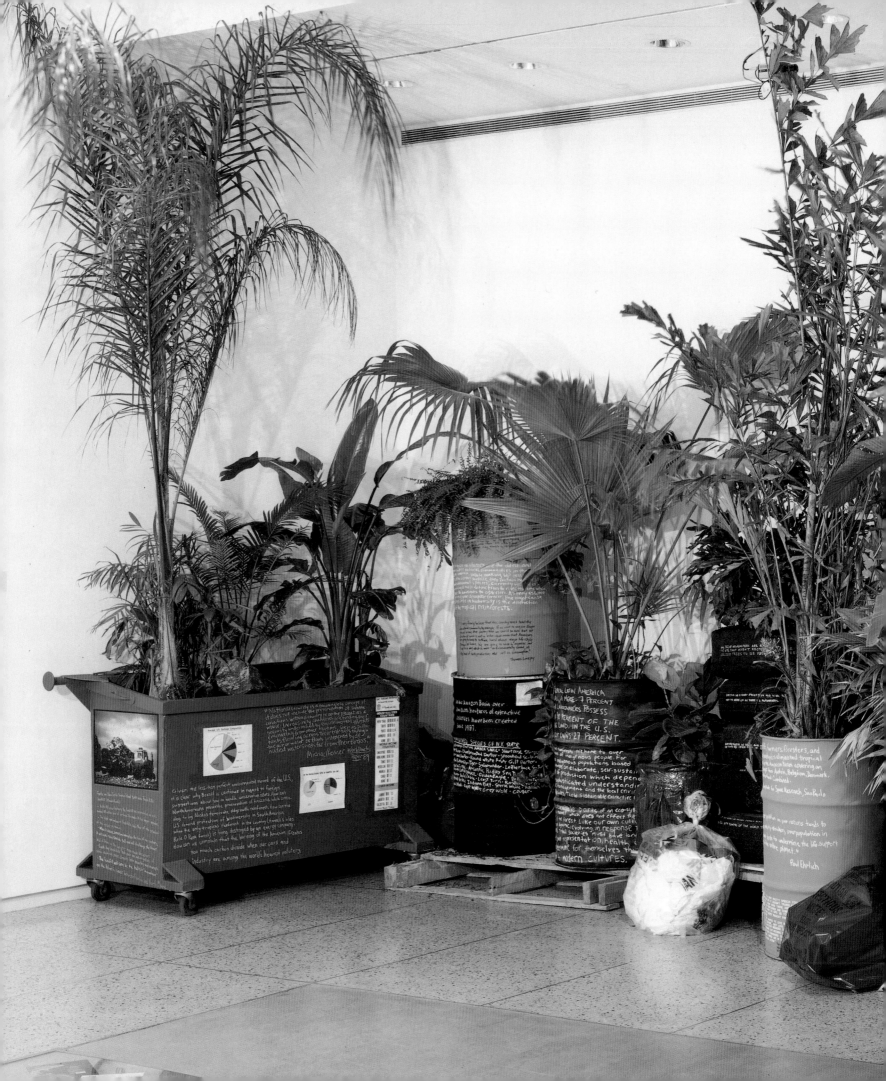

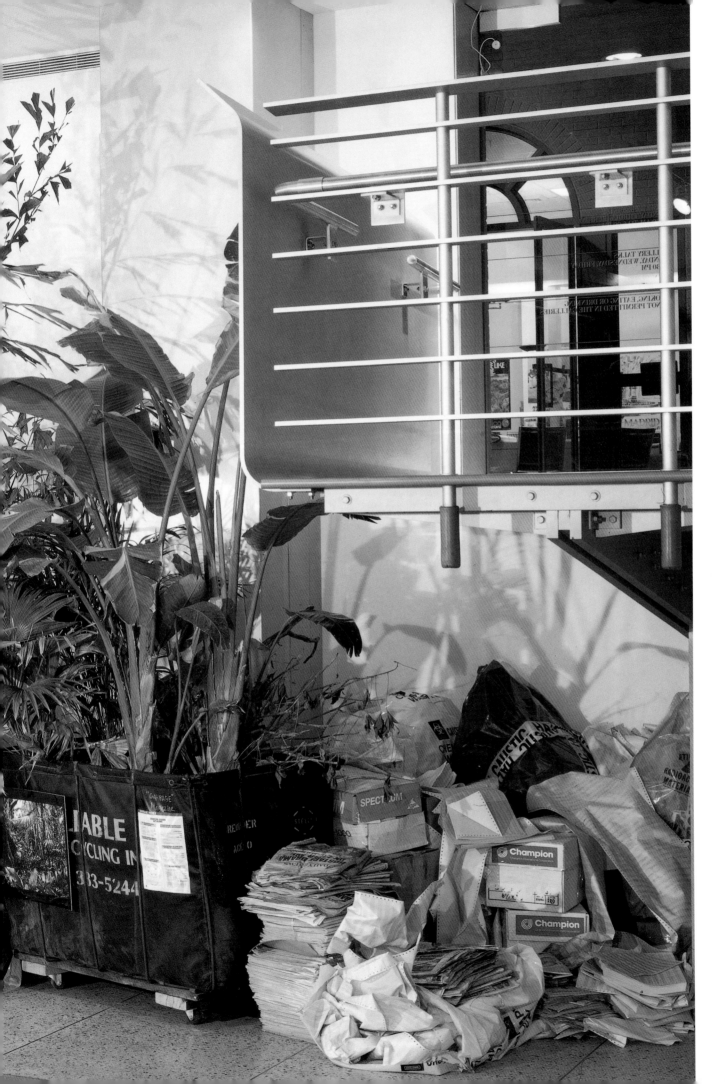

**Under the Verdant Carpet:**
**The Dreams of Mount Koch**,
with William Schefferine
1990
Barrels and rubbish bins with
text, potted plants, plastic bags,
newspapers, cardboard boxes, pie
chart illustrations, coloured
photograph
Installation, Whitney Museum of
American Art at Federal Plaza,
New York

## The Delirium of Alfred Russel Wallace  1994

The Delirium of Alfred Russel
Wallace
1994
Blue and red crayon on paper
4 (12 × 13) cm

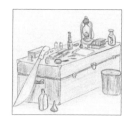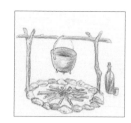

The Delirium of Alfred Russel
Wallace (detail)
1994

Bloody malaria. This is the third time this year I've been stricken by a fit or fever, and 1858 has just begun. Bedridden, I've had to cease all collecting and travel, but even worse is the infernal inability to concentrate. The moment I begin to focus my mind, I am unwittingly whisked off to a world of unwelcome thoughts – ideas unproductive and downcast. My illness only exaggerates the disordered state of mind into which one is plunged by the prolonged abnormality of the way of life.

In lonely moments such as now, I suffer most inconveniently from the difficulty of getting news from the civilized world, from the irregularity of mail steamers with their precious cargo of letters, parcels, books and periodicals. When a newspaper should appear, I devour it. First, I read the most interesting articles three times each; second, the whole remainder; and third, each small advertisement is carefully studied from beginning to end.

For one full year I did not receive a single object from Europe, and towards the end of this time my clothes had worn to rags and I was barefoot, a great inconvenience in the tropical forests. I was then in ill health arising from bad or insufficient food. Worst of all was the want of intellectual society, and of the varied excitements of European life. This lack was most acutely felt, and rather than deaden with time increased until it became almost insupportable. I was obliged, at last, to conclude that the contemplation of Nature alone is not sufficient to fill the human heart and mind.

I am not without companions, but they are local people and, though intelligent and kind, they know not the slightest of European ways. For four years I've not met a man who has heard of Aristotle or Shakespeare. My education is my own isolation. And yet the more I see of uncivilized people the better I think of human nature, and the essential differences between savage and civilized men seem to disappear. Unlike my distinguished colleagues who write from their London apartments about the immorality of the uncivilized races, I have traveled among illiterate people for nine years and have found them to be of high moral character. In fact, not once have I ever carried a gun for self-protection, nor have I ever locked my cabin door at night.

More often than not, native people have welcomed me. I have witnessed in this part of the world a paradox of civilization. Rather than feel the presence of the Europeans here as a positive and civilizing factor, I have found it often contributes to increased wretchedness. We have done our best to eliminate the very imperfections of savage society which give it those elements of charm and flavour that bind. While I mark my own experiences here as objective and without lasting consequence, I cannot deny the feeling that my very presence in some small way contributes to the degeneration

of the whole.

Why did I come to such a place? To what end? What is, in point of fact, a naturalist's investigation? Is it the exercise of a profession like any other, differentiated only by the fact that home and office are several thousand miles apart? In London my more ambitious and astute colleagues climb the ladders to prestigious positions in various museums and societies, while I lie ill in the jungles of Malaysia. Does my decision to be here bespeak a profound incapacity to live on good terms with my own social group? In England I am sometimes seen as quite the loony. I am awkward and shy, unable to negotiate civil society. Here, my eccentricities fade into my overall strangeness. There is no other white man to which to compare me.

How can the naturalist, the anthropologist, the traveller become free of the contradictions implicit in the circumstances of his choice? He has, after all, abandoned his environment, his friends and his habits, spent a considerable amount of money and time, and compromised his health. And the only apparent results are a few hundred

**The Delirium of Alfred Russel Wallace**
1994
Hammock, mosquito net, dead tree, palm tree, taxidermic animals, trunk, butterfly nets, gas lantern, book, cooking utensils, hat, binoculars, wooden barrel, clothing, bottle, magnifying glass, back pack, specimen boxes, maps, written material, spreading boards, entomological equipment, shot gun, vasculum, plant press, pot and cup, plastic ants, beans, salt, tree stump, machete, hatchet, umbrella, spy glass, drafting set, candles, insects, glassware, other assorted objects
Installation, Galerie Metropol, Vienna

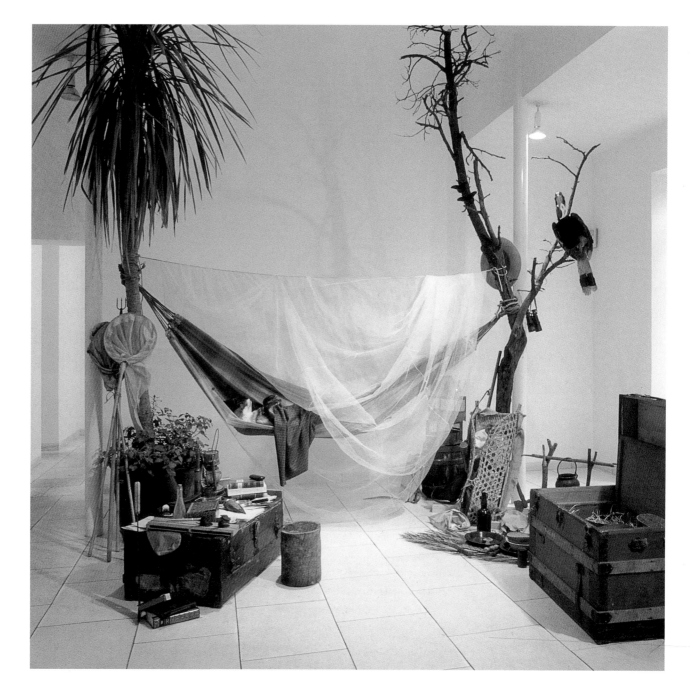

specimens and a pocketful of theories to be aired to the dull ears of a handful of specialists in a bleak museum auditorium. Were he instead a missionary, a colonial administrator, a plantation owner, or even a soldier he could be presumed to act on behalf of, and indeed to represent, his own society. But the naturalist is independent, with no national interests in mind. He may have been driven to such a life by disdain or hostility towards his own milieu. Perhaps he is so ill-suited to his own world that he must live in isolation?

Then why does his homeland obsess him so? As I travel through a variety of landscapes – the shoreline, jungles, volcano tops, green seas – they seem more and more to lose their meaning, or at least the meaning I had hoped to find in them. Disappointingly, the past haunts my immediate present. Sometimes it is as if I were a schoolboy daydreaming of the country woods, yet for me the situation is reversed. I will often set foot on land which no European eye has beheld, or see animals unknown to our world, or be treated to customs completely alien in origin; yet none of it stands in the foreground of my mind. My thoughts may be occupied by visions of the English countryside, or filled with fragments of an absurd and detestable children's song, running a course in my head. London Bridge is falling down. For days I will turn over and over a silly limerick or the call of a Piccadilly barker.

Is this what is meant by travel? It is an exploration of deserts of memory, rather than of those rich forests around me? The farther my travels take me, the deeper inward I also recede. It is as if my journey were two journeys: one which takes me away from the society into which I was born and another that is thickly settled with signposts telling only of where I have already been.

At times I can lose myself in the pleasure of the quest, and become focused. Yesterday I found a perfectly new and most magnificent species of butterfly. The beauty and brilliancy of this insect are indescribable, and none but a naturalist can understand the intense excitement I experienced. On extracting it from my net and opening the glorious wings, my heart began to beat violently, blood rushing to my head, and I felt like fainting. So great was the excitement, produced by what will appear to most people an inadequate cause. Even in taking its life, there was the thrill that in death this creature's beauty would last forever.

So many wondrous forms of life. I am convinced that within the amount of individual variation my own collections have shown me, an answer to the species question might be found.

Recorded text 'spoken' by fox in *The Delirium of Alfred Russel Wallace*. Performed by Henry Bond and Alison Jacques.

## A Little Bird Told Me 1995

*In the Sixth Book of* The Aeneid, *Virgil wrote the famous line: 'Easy is the descent into Hell' ('facilis descensus Averno'). Avernus was Virgil's portal to Hades, a noxious lake in the Italian Campania where fumes from the fetid waters were supposed to kill all the birds that flew over it or frequented the shore. The lake received its name from the Greek –* Aornos *– a in Greek meaning* not *and* ornos *or* ornis, *a bird. Hell was construed as a place without birds; a world without birds would be hell'.*
– David M. Lank[1]

What is a bird? Regarding this question there is pleasing agreement: a bird (class *aves*) is a warmblooded vertebrate with feathers and forelimbs adapted for flight (even if no longer used for flight). If I instead ask the questions *what does a bird mean?*, or *what is the value of a bird?* I depart the realm of consensus for the stormy ocean of contention. These questions consider the much more complex dispute over what stands for nature at a particular time for a particular group of people. Rather than struggle through that quagmire, I choose to stick to talking about birds.

Birds don't speak back to us (as far as we know) however we speak to them, but more often the case is that we speak about them. We speak to ourselves through them (as in La Fontaine, Keats or Hitchcock). Considering the abundant aesthetic, political and economic energy surrounding our avian compatriots, any investigation into the social history of birds and their representations and uses should reveal potent clues regarding our constantly shifting relationship with the natural world. Our association with birds is curiously different from that with other animals, and with nature as something somewhere *out there*, for birds live among us; they share our urban landscapes and backyards more than any other class of wild animal and are a part of our everyday lives.

*It's hard to tell the purpose of a bird;*
*for relevance it does not seem to try.*
*No line can trace, no flute exemplify*
*its travelling; it darts without the word.*
*Who will devoutly to absorb contain,*
*birds give him pain.*
– Richard Wilbur, *The Beautiful Changes*

**Life Raft (Zurich)**
1995
Tree, leaves, plants, grass, stones, taxidermic animals, wooden bird house with shingles, wooden planks, barrels
3.5 × 3.5 × 4.5 cm
Installation, Kunsthalle Zürich

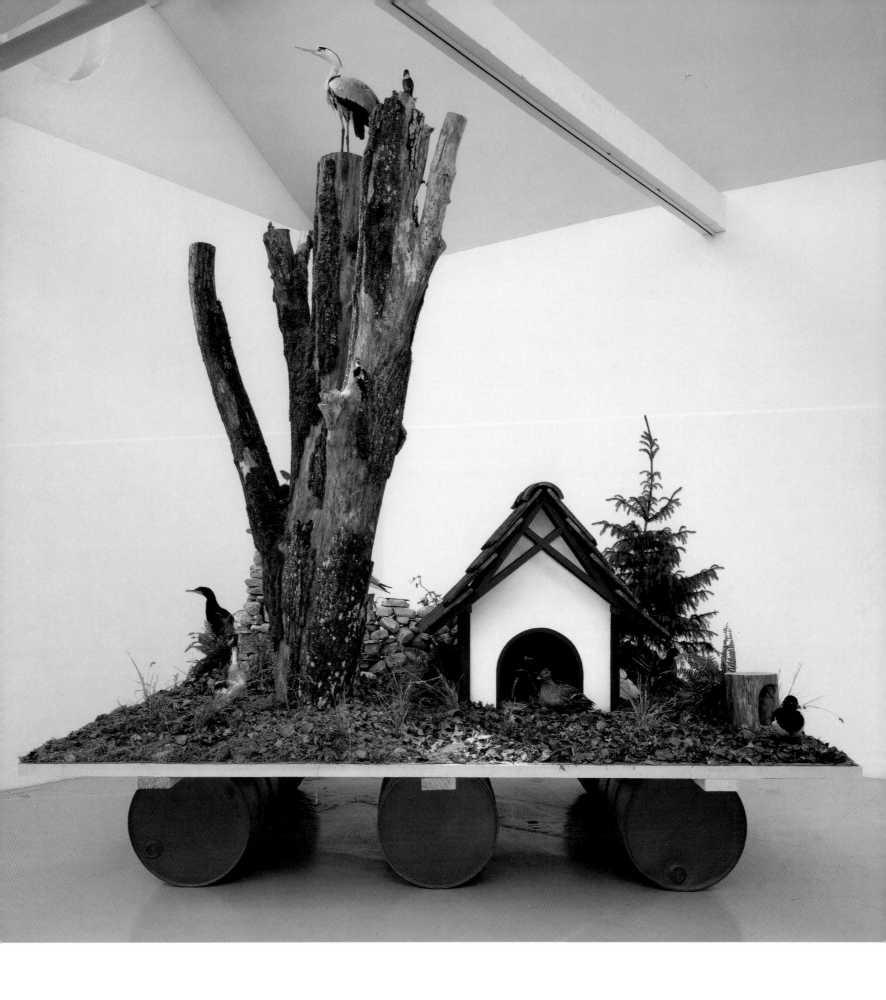

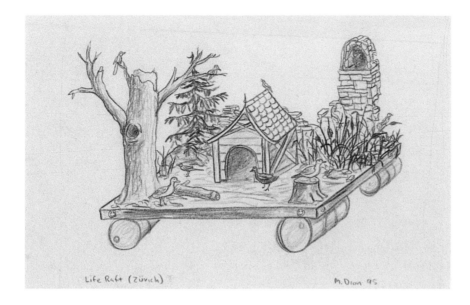

Life Raft (Zürich)    M. Dion. 95

*What does little birdie say*
*in her nest at peep of day?*
– Lord Alfred Tennyson, *Sea Dreams*

My fascination with the feathered tribes of Zurich came from two experiences distinct yet proximate geographically. The first encounter is one which any birdwatcher, even one as lazy as myself, could not help but remark the impressive collection of waterfowl which winter on the rivers and lake in Zurich. The areas from the end of Platzspitz to near the train station and continuing to Bellevue are particularly extraordinary for the number and diversity of water birds, many of which are difficult to see in most other parts of Europe. The highly developed bird culture of scientific monitors, birdwatchers, casual feeders and disturbingly over-invested disciples is as beguiling as the ducks, divers and coots.

The second flock to capture my interest resides in the halls of the Landesmuseum, where one finds birds painted, carved, sculpted and embroidered onto every imaginable aspect of the language of the decorative arts. Here we find birds at the service of society – decorative, gastronomical, sporting, spiritual, economic, allegorical, anthropomorphic – and as social appendages.

Through artefacts of pageantry, heraldic symbolism and domestic life, birds provided a vocabulary and collection of traits which describe and classify human qualities.

*For my part, I wish the bald eagle had not been chosen as the representative of our*
*country; he is a bird of bad moral character; he does not get his living honestly …*
– Benjamin Franklin

*It is a foul bird that defileth his own nest.*
– John Heywood

Neither the same as humans, nor entirely dissimilar, birds offer an almost inexhaustible bank of symbolic meanings and uses. The ancient Romans followed the flight and songs of birds to foretell the future and no major endeavor was embarked upon without first consulting the birds.[2] Later folk attitudes tended to attribute to all animals reason, intelligence, language and indeed almost every human ability. 'The song of wild birds was often interpreted anthropomorphically by country people. The great titmouse said "sit ye down"; the quail cried "wet my lips! wet my lips"; and the chaffinch sang

"pay your rent!" The bird-fanciers even believed that birds sang in local dialect'.[3] Later theological doctrine would insist on a natural philosophy, practical and utilitarian, in which all nature existed for the service of humankind, be it as food, comfort or moral instruction. Indeed songbirds were viewed as existing to entertain and delight. The Cartesian separation of humans and the rest of nature rendered animals not only without souls but also incapable of speech, reasoning and even sensation. The virtuoso, Sir Kenelm Disby, following the Cartesian view of animals lacking any soul or spiritual dimension, did not hesitate to describe birds as mere machines, and their actions of nest building and feeding of their young were no different from the actions of clockworks. The singing of the bird was the same as the ringing of an alarm.[4]

*A bird knows nothing of gladness,*
*Is only a song machine.*
– George MacDonald

*The plain man would persist in believing that there was a difference between the town*
*bull and the parish clock.*
– Bolingbroke

The current disposition of bird art, bird science, bird literature and popular enthusiasm is rooted in developments in the last century. The romantic poets made frequent use of birds, while the study of birds developed into a professional science: ornithology. By the end of the century the ecological importance and fragility of wild bird populations was best appreciated by those who observed birds for recreation and curiosity, and it was they who mobilized their influence to pass a large number of international measures to protect wild bird populations. In this century popular interest in birds has increased to mammoth proportions. Worldwide there are hundreds of bird clubs and ornithological societies, and thousands of publications for birders are produced each year, as well as films and recordings.[5]

*There is a special interest and excitement in watching a bird which you have never seen*
*before. Such excitement is greatest when you know that the species is so rare that it*
*may soon become extinct and future generations may never have the opportunity to*
*enjoy the sight of it.*
– Edward A. Armstron

*Thou wast not born for death, immortal Bird!*
*No hungry generations tread thee down;*
*The voice I hear this passing night was heard*

**The Library for the Birds
of New York**
1996
Tree, books, bird cages, fruit,
photographs, wood, string, nests,
duct tape, framed illustrations,
tarred and feathered bird, bottle,
net, pail
323 × 286.5 × 143 cm

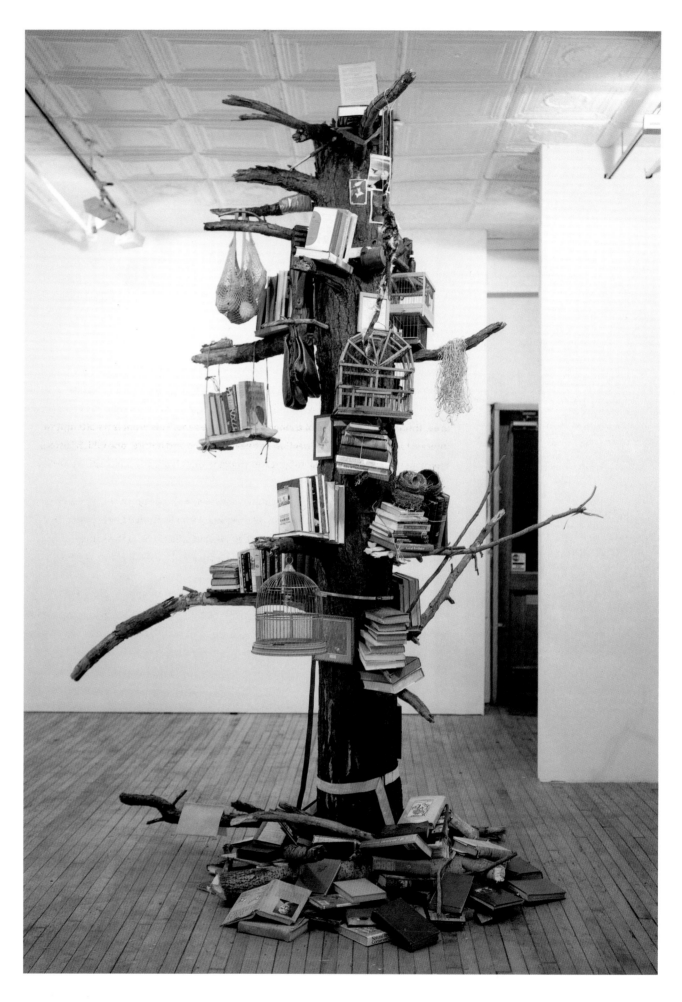

Bookcase for the Practical
Ornithologist (for Rachel
Carson)
1993-94
Bookcase, 22 stuffed birds, books
183 × 90.5 × 40 cm

*In ancient days by emperor and clown …*
– John Keats, *Ode to a Nightingale*

It is the current state of bird life and lore in Zurich which my project germinated from.
How birds have continued to factor into the landscape of Platzspitz and the surrounding
area, through the centuries of change has captivated me. This work is an attempt to
intersect another type of interaction between humans and nature, one which fosters
biological diversity while playfully acknowledging our historical constructions and
fantasies around it.

To return to my initial questions about the value and meaning of birds, we clearly
find ourselves in a paradox: on one hand there has never in human history been such
a concern for debates about the rights and welfare of wild birds, at the same moment
there has never been a greater threat to their existence globally. In the past, birds
have been used to symbolize imperial power, divinity, the human soul, good and ill
luck; today birds overwhelmingly indicate a single thing: the health of any particular
environment. Thus all of the historical allegories have been replaced by a single humble
example: the miner's canary.

*Science grows and Beauty dwindles.*
– Lord Alfred Tennyson

*I suggest that as biological knowledge grows the ethic will shift fundamentally so that
everywhere, … the fauna and flora of a country will be thought part of the national
heritage as important as its art, its language and that astonishing blend of achievement
and force that has always defined out species.*
– Edward O. Wilson[6]

1    David M. Lank, *Great Bird Painting of the World, Volume I,* Christine Jackson, ed., Antique Collector's Club,
       Woodbridge, 1993

2    Edward A. Armstron, *The Life and Love of the Bird in Nature, Art, Myth and Literature,* Crown Inc., New York, 1975

3    Keith Thomas, *Man and the Natural World,* Pantheon Books, New York, 1983

4    Ibid.

5    Robert Henry Welker, *Birds and Men: American Birds in Science, Art, Literature and Conservation, 1800-1900,*
       The Belnap Press, Cambridge, 1955

6    Edward O. Wilson, *Biophilia,* Harvard University Press, Cambridge, Massachusetts, 1984

*Platzwechsel*, Kunsthalle Zürich, June-July, 1995, pp. 90-101

## The Natural History Box: Preservation, Categorization and Display 1995

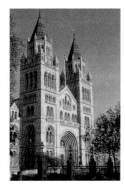  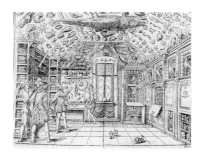

*'A historical materialist views (cultural treasures) with cautious detachment. For without exception the cultural treasures he surveys have an origin which he cannot contemplate without horror … There is no document of civilization which is not at the same time a document of barbarism. And just as such a document is not free of barbarism, barbarism taints also the manner in which it is transmitted from one owner to another.'*
– Walter Benjamin

These lecture situations generally proceed with the artist coming up here on stage and clicking through various slides and rambling on about what they have done and when and where they did it. Rather than adhere to the formula, I'd prefer to start by talking about a subject I never tire of, a topic I always find most compelling – those didactic institutions mandated to collect, define and represent the natural world: the Museums of Natural History. These Museums are one of the most essential sites for any investigation into how a dominant cultural group constructs and demonstrates its truth about nature. It is here we find 'the official story'.

As in the case of all museums, the Natural History Museum is first and foremost a container for a collection. While the exterior of this container may greatly vary, the structure's dual purpose of holding and protecting the collection, and displaying and comprehensibly arranging nature for public education, unites all of these institutions. In fact, we may say that the museum is really two institutions, one for scientific research into evolutionary science and the other a pedagogic exhibition hall about biology. Just as the museum's architecture changes to reflect shifts in style and method of design, so too must the museum's system of organization change with development of scientific knowledge and public sentiment. These changes reflect the instability of the social category of nature.

Let us imagine for a moment that we have been given an exceptionally large box – a museum – and a vast collection of various materials to put inside. Already, before we can even begin, we have a problem: What gets to stand for nature? What is a 'natural specimen'? In the U.S.A., Natural History is a discipline which includes cultural anthropology and so the material cultures of other people are found in the Museum. This is rarely the case in European museums where ethnography gets its own large box.

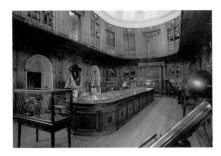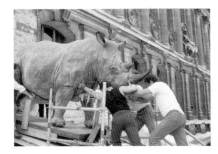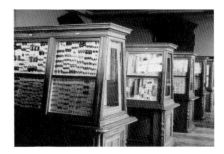

Rather than already getting bogged down, let us first look at how we can organize our collection. Perhaps we should start where museums start: with the curiosity cabinets of the sixteenth to eighteenth centuries. These collections were shockingly numerous; for example, from 1586 to 1735 over 200 private collections existed in the Netherlands alone. They housed natural objects or specimens, artefacts, art, Greek or Roman antiques, ethnographic objects and new technologies. These assemblages were marked by a passion for the rare and novel, such as fresh items (natural and man-made) from the New World, or nature's anomalies. These were sometimes arranged in what I like to call the 'I forgot to clean my closet' or 'bunch of stuff' method. However they may also be organized around astoundingly complex encyclopedic or cosmological methods. Often the collection was intended as a microcosm; a diminutive gathering of all the world, including symbols for forces such as the humours, passions and spirits. The items making up these collections defy our current classifications. They were obtuse and complex, having both material value and a pragmatic, fetishistic or magical value. The obvious reflection of wealth projected onto the collector is also an important clue as to the cabinet's far-reaching role in diplomacy and pomp.

I must confess a fondness for curiosity cabinets particularly since they most closely resemble the surrealistic quality of the back room of many museums, rather than the exhibition galleries.

The period of transition from curiosity cabinet to scientific Museum proper is exemplified by one intact institution – the Teyler Museum of Haarlem. Saved from disastrous renovation by a lack of funding, this remains one of Europe's best preserved historical Museums. Like many cabinets of curiosities, the direction of this museum was influenced by its founders' interests; however, this museum was built for the purpose of education. Its collections were intended to demonstrate the latest technologies and discoveries in science for a larger 'public' rather than a special society or club. It also promoted art with a collection of drawings and prints which local artists, who could not get to France or Italy could use for reference and inspiration. With its mandate to further the arts and sciences in Haarlem, this museum became one of the first organized around the purpose of public education, even if the 'public' in 1784 was limited to the enlightened bourgeoisie. While this museum is very much a museum of a museum, it also maintains a very active collecting profile, specializing in old scientific

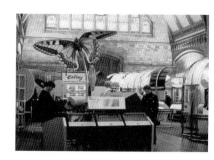

instruments, fossils and contemporary artists drawings. I thoroughly recommend a trip to the Teyler Museum; one can see it today in much the same state as Napoleon did on his visit.

These interiors are from the Grand Gallery of Zoology at Paris' Museum of Natural History, which opened in the 1880s but was organized around the more spectacular principles of the previous century. Thus the visual power of the exotic was more primary than any overlaying system of display based on scientific knowledge. The museum was mocked by Paris' scientific community as soon as it opened its doors. These photos are from the very last days of the historical installation. It had been closed for over twenty years, and I was one of the last people lucky enough to see it before it was emptied for Michel von Praet's reconstruction based on ecology and evolution. When I saw the gallery, it was the kind of place where you leave footprints in the dust.

A mere five years after the Grand Gallery of Zoology was ridiculed, France's zoologists' Gallery of Comparative Anatomy was realized. This museum answered disorder with extreme precision, and it remains one of the world's most fantastical museums. The central gallery holds the articulated skeletons of most large vertebrates, from kangaroos to tigers and whales, while the glass cases lining the walls contain the preserved organs. One vitrine may contain hearts, another eyes, another lungs and so on. Imagine the brains of a rabbit, a bat, an ape, a human infant and of an elephant side by side in a single display. The museum stands as a homage to the skill of France's exceptional comparative anatomist Georges Cuvier (1769-1832). This is not a museum for the squeamish.

This is Vienna's Museum of Natural History, the most impressive monument to the science of taxonomy or the systematic: the laws or principles of the classification of organisms into categories based on common anatomical characteristics. This massive museum, the twin to the Art History (Kunst-historisches) Museum, is organized entirely around the comprehensive system of hierarchical, orthodox taxonomy. One starts with simple, single-celled organisms and works one's way through vast interconnecting halls, to end with the last specimen, a human skeleton. This echoes the structure of most biology text books. One begins in the invertebrate halls, arthropods get a separate room, then to the hall of fishes, amphibians and reptiles, on to the birds and at last the mammals. For most of the previous century and much of our own, this

 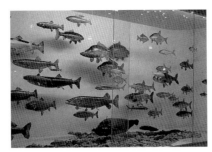 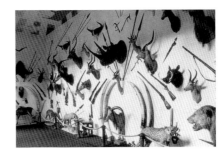

taxonomic arrangement of the collection has been standard. It is the logical extension of the museum's scientific duties of naming and classifying specimens. There is more than a little of the symbolic 'chain of being' in this method in which *Homo sapiens* seem the pinnacle of all life forms. Through naming, classifying and making groups, seemingly logical hierarchy firmly seats man in the throne of the animal kingdom.

There is still yet another way to organize our museum: the zoogeographical or biogeographic system. This method places organisms together based on region. Thus all Australian animals, birds, reptiles, mammals etc. are in one exhibit. These examples are from the Hessisches Landesmuseum of Darmstadt, which is most remarkable for its overall arrangement of a zoological museum on the grand floor, a paleontology exhibit above that and a huge Beuys collection topping it all off.

In the early half of this century the habitat group or diorama display became a dominant model. These hyperrealistic presentations allow a view into an idealized vision of nature, a world without human taints or influence. The best examples of dioramas are found in Chicago and New York and speak of an American affinity to cinematographic space and expensive spectacle. More importantly they represent the acceptance and integration of evolution and ecology into the museum. Animals are presented in the environments which produce them and which they, too, shape. These exhibits are extraordinarily labour intensive, and since they represent a technological apex, they are rarely replaced. Dioramas function as time machines, not only to the place and period they represent but also to the particular moment of their construction.

The 1960s museums have changed drastically in at least two ways. Firstly, museums have shifted to becoming educational institutions for younger visitors. As museums have focused more exclusively on children, many have become dumber and more dull for adult viewers. The second major change has been the development of temporary thematic exhibits which utilize sophisticated electronic technology. Curiously, these exhibits while being state of the art often become obsolete faster than older exhibits. This is because the technology is very quickly outpaced, and also because the exhibits take such a beating from the frantic pushbutton kids. While these exhibits are strong on concept they often fail to inspire, since they ask as well as answer the questions and do not realize that the museum experience is only powerful when it is different from television and computer game play. Since these exhibits are

often conceived to be temporary, they can reflect more current issues and interests, like global warming or rainforest ecology. They tend to focus on human interactions with nature rather than searching for an articulation of nature as autonomous.

Of course there exist hybrid museums which are not strictly Natural History Museums but contain some of the same materials. These museums concentrate on uses of nature or on a specific aspect of our relationship to it, such as a farm museum or a hunting museum, where there seems to be no distinction between natural and cultural artefacts: everything is a trophy.

During this brief survey of Natural History Museums' techniques of display there has been no time to discuss the ideological aspects of the institutions; what each of these methods promote or conceal, what fantasies are encompassed and encouraged with each example. Any close examination of the changes in museum method clearly chart shifts in the construction of the social category of nature and how that category has been employed in the rationalization of the dominant social order. There are many out there working not only to analyze theories of animal and human society for critical appraisal, but also in the hopes of constructing new ways of adequately imagining future positions with regard to science and nature.

In New York we have an interesting problem regarding the American standard of including Anthropology into the category of Natural History. On the west side of Central Park one finds the American Museum of Natural History, which contains the material culture of various people, ancient and modern, which somehow gets to stand for nature. On the park's east side stands the Metropolitan Museum of Art which houses other people's material culture (indeed sometimes the same people's stuff) which gets to stand for art. What is an art object and what is an ethnographic artefact depends on which side of the park you find yourself.

Going back to the west side, today the American Museum of Natural History is comprised of 38 major exhibition halls, a planetarium, an excellent research library, an education department, research laboratories and a vast storage area for its over 36 million specimens. Among these specimens one can find over 2 million butterflies, 100 complete elephant skeletons (including the famous Jumbo), the world's largest collection of non-Western smoking pipes, the Star of India sapphire, a stuffed parrot that belonged to Houdini, more than 600,000 fishes in liquid preservative and a lot of other

stuff.

Most large museums are divided into eleven divisions or departments. These are:

| | |
|---|---|
| *Astronomy* | the study of the Universe, galaxies, stars, planets and the solar system. |
| *Mineral Sciences* | the study of the formation and composition of rocks, minerals, gems and meteorites. |
| *Paleontology* | the division which studies the fossil record. |
| *Botany* | the field of plant life. |
| *Invertebrates* | the study of animals without backbones. |
| *Entomology* | the study of insects and arachnids. |
| *Ichthyology* | the department specializing in the study of fishes. |
| *Herpetology* | the study of reptiles and amphibians. |
| *Ornithology* | the study of birds. |
| *Mammology* | the study of warm-blooded animals with hair and milk glands. |
| *Anthropology* | the division dealing with the physical make-up, evolution and cultural life of Homo sapiens. |

Most museums today see themselves as organizations devoted to the understanding of *evolution* and to the education of the public around that central issue. Thus concludes our brief tour of the Museums of Natural History.

*'a historical materialist views (cultural treasures) with cautious detachment, for without exception the cultural treasures he surveys have an origin which he cannot contemplate without horror ... there is no document of civilization which is not at the same time a document of barbarism. And just as such a document is not free of barbarism, barbarism taints also the manner in which it is transmitted from one owner to another.'*
– Walter Benjamin *Illuminations*

From a lecture given in conjunction with the exhibition 'Wunderkammer des Abendlandes', Kunst und Ausstellunghalle der BRD, Bonn, 1995

The Tasting Garden
1996
Gouache on paper
30.5 × 61 cm

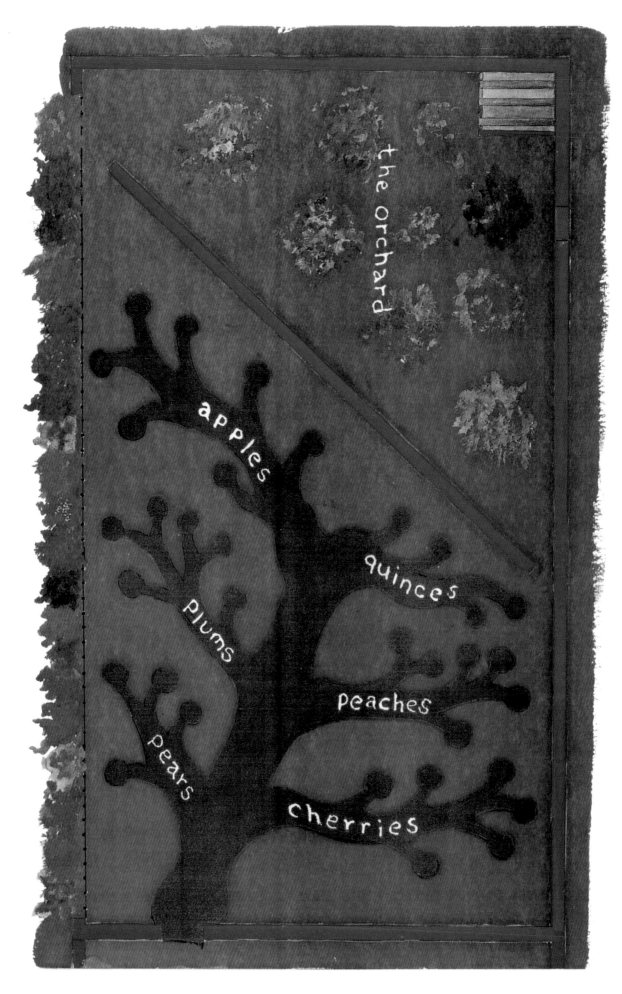

THE TREE OF SCIENCE

The Tree of Science, from 'The Golden Encyclopedia' 1959

The goal of *The Tasting Garden* is to produce a complementary addition to the Harewood Estate, which would take into consideration not only the historical purpose of the walled garden, but would also embody one of the most powerful principles of the contemporary ethos – that of the conservation of biological diversity. *The Tasting Garden* would harmoniously blend Harewood's commitment to both historical preservation, as represented by the house and grounds, with that of biological protection, as exemplified by the bird garden. However, the solutions featured in this new project would not be characterized by an historical reconstruction, but rather a bold contemporary design based on the contributions of the artful science of arbourculture.

*The Tasting Garden* is to occupy the vast and abandoned western half of the walled garden. The archway in the dividing wall of the two derelict grounds would suffice as an entrance and link to the conceptually supportive arrangement of Christian-Philipp Müller.

From the slightly elevated position of the entrance, the viewer overlooks an enormous branching pathway: essentially a network of paths forming a tree-like structure. The main path constitutes the tree trunk and the side paths its branches. These also deviate into smaller paths which terminate in semi-circular areas. In this area one encounters a rectangle of stone set into the ground and inscribed with the name of a fruit tree variety, followed with an odd and anachronistic description of the qualities of the fruit, particularly the taste. Behind this inlaid tablet stands a short (four-foot) concrete column bearing a bronze plate, upon which sits an oversized bronze fruit. Immediately behind the column and a short distance off the pathway is the tree itself. These trees come in three forms: a newly planted sapling, an adult tree or a withered and bare bronze trunk.

The tree forms the central metaphor of the work: the tree of life, the tree of knowledge, the family tree, the phylogenetic tree of evolutionary development. The main branches of the tree pathway represent the major northern fruit crop trees: apples, quinces, pears, plumbs, peaches and cherries. The terminal nodes are distinct varieties. Each of these varieties is marked by the status of rare, threatened, endangered or extinct. These are agricultural plants which have become extirpated or endangered by the general shift to monoculture agricultural production or other trends

which result in the production of higher yields of marketable fruit but less diversity of species. Large scale agri-business privileges only a handful of plants which exhibit desirable traits, such as long shelf-life, large yields, sweeter taste, and pest-resistance. Long neglected have been a number of breeds which not only demonstrate a more expansive and challenging taste spectrum, but also make up an important reservoir of genetic material.

When coming to the end of one of the pathway branches, the visitor encounters a description of the taste of one of these rare fruits. Humans, being creatures which favour sight over all other senses, have merely a few impoverished adjectives for taste. Descriptions confronting the viewer of the stones are derived from mostly eighteenth and nineteenth century sources and they seem to strain acrobatically in an attempt to translate objectively the sense of taste. The next element evokes the notion of the monument, or even the grave marker. The scale of the ridiculously oversized fruit exemplifies its status as the representative of the entire breed or variety. The shapes of the fruit will of course speak of the variety of tradition. Finally, there is the tree itself, standing a short distance off the path. Where possible, adult trees transplanted from other parts of the grounds should be used. Young nursery trees fill in where mature trees are not available. It may take a decade before the garden can be optimally viewed. The extinct breeds shall be represented by dark macabre casts of dead trunks. These grim surrogates will most powerfully speak when the living trees bare fruit or blossoms.

Beyond the massive diagonal wall which bisects the western half of the garden a separate but equally important feature of *The Tasting Garden* is located. An orchard maintained to propagate and preserve those agricultural varieties most threatened with extinction will function as an agricultural equivalent to the aims of the endangered species breeding programme of the bird garden. Visitors can stroll through the orchard unguided.

A critical aspect of both the tree walkway and the orchard enjoyed by guests is the ability to pick and eat fruit. The public will be encouraged to sample ripe fruit directly from the trees, or fruit could be made available through the restored kitchen or other already established outlets at Harewood. *The Tasting Garden* makes available rare and challenging flavours and textures, normally inaccessible to all but a handful of expert cultivators. It demonstrates the loss of genetic diversity succinctly through the

dead trunk of an
extinct species
(bronze)

Over sized fruit of
the tree on a shallow
dish (bronze)

four foot column (poured concrete)

Stone carved with a description
of the taste and character of
the fruit

Short hedge

Path of chipped wood

lawn

**The Tasting Garden**
1996
Gouache on paper
30.5 × 61 cm

activation of one of the most under-utilized senses in art. Whatever fruit remains
uneaten due to over-abundance of late maturity could be put to the service of
Harewood's livestock farmers.

Completing the composition of *The Tasting Garden* is an element best described as
a folly. *The Arborculturist's Work Shed* is a diminutive monument acknowledging the
grand achievements and skills of the men and women who laboured in the walled
garden to feed the estate, as well as those today who maintain the grounds and
gardens. Highlighted in this tribute are the tools of the trade: spades, books, watering
cans, chemicals, horticulturalist shears etc. Indeed, it is not as much the alchemist's
studio as it is a functioning work shed. Not obvious to the visitor is the fact that this
structure is a carefully conceived and composed installation. While each inch of the
interior can be viewed through the many windows, the building can not be entered. The
arrangement of objects within the structure constructs an elaborate narrative,
foregrounding the romance of horticulture as a profession bridging art and science. The
work emphasizes the human aspect of an endeavour as monumental and seemingly
timeless as the construction of the Harewood landscape. Included within *The
Arborculturist Work Shed* are drawings, photographs and other artefacts of the garden
staff, past and present.

Proposal for Harewood House, Leeds, for 'Art Transpennine'

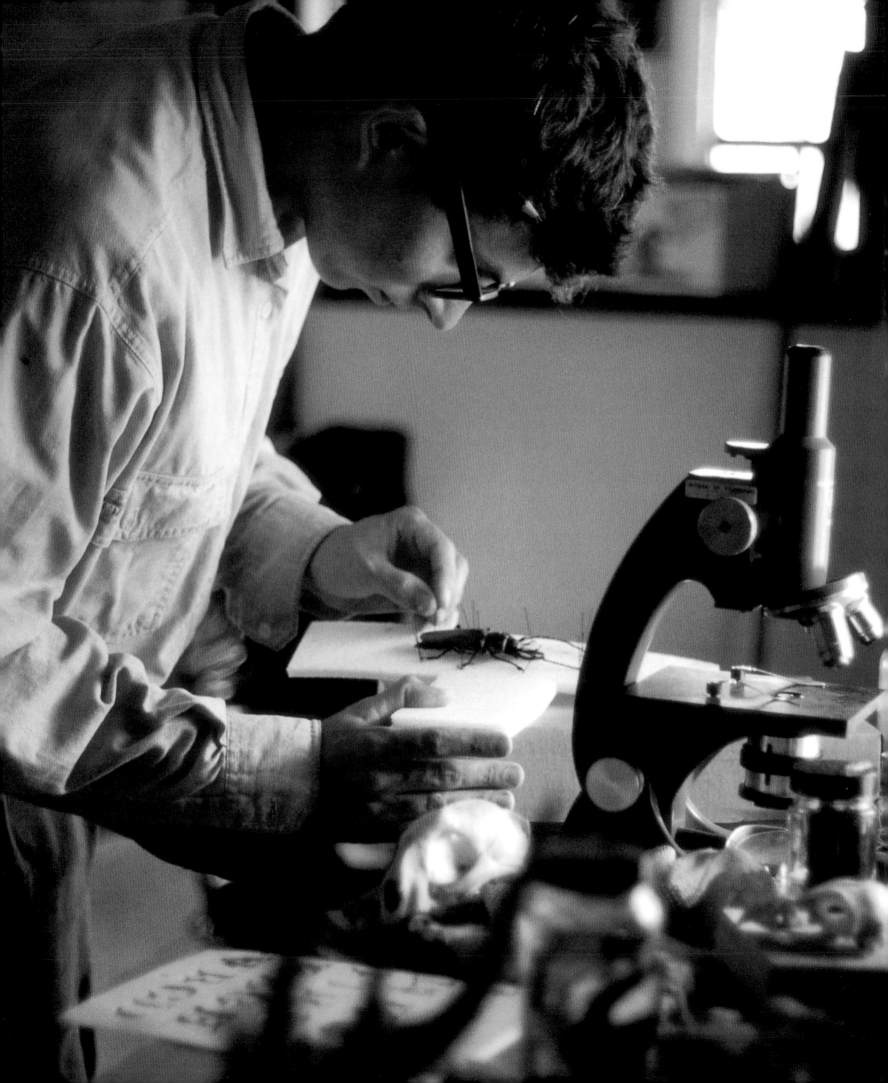

# Contents

## Selected exhibitions and projects
### 1981-87

**1981-2**
Studies Fine Art, **Hartford Art School, University of Hartford,** Connecticut

Meets Bob Braine and Jackie McAllister

**1982-84**
Studies Fine Art, **School of Visual Arts,** New York

Meets Andrea Fraser, Gregg Bordowitz and Fareed Armaly

Works in art restoration studio

**1984-85**
Independent Study Program/Studio, **Whitney Museum of American Art,** New York

Meets Jason Simon, Joshua Decter and Ashley Bickerton

Attends Craig Owens' reading group with Bordowitz and Simon

**1985-86**
Studies Fine Art, B.F.A., **Hartford Art School, University of Hartford,** Connecticut

**1985**
**Four Walls,** Hoboken, New Jersey (group)

'Whitney Independent Study Program Show',
**Whitney Museum of American Art,** New York (group)

'Transitional Objects',
**Philip Nelson Gallery,** Lyon, France (group)

**1986-90**
Works as studio assistant to Ashley Bickerton, meets Bill Schefferine there in 1988

**1986-92**
Shares an apartment on West 143rd Street, New York, with Cathy Scott and Simin Farkhondeh, members of the Paper Tiger Television Collective

**1986**
'Rooted Rhetoric',
**Castel dell'Ovo,** Naples (group)
Cat. *Rooted Rhetoric,* Castel dell'Ovo, Naples, text Gabriele Guercio

'Cutting 'Em Off at the Pass',
**Thirty-Third Arts Festival of Atlanta,** Georgia (group)
Cat. *Cutting 'Em Off at the Pass,* Thirty-Third Arts Festival of Atlanta, Georgia, text Ronald Jones

'The Fairy Tale: Politics, Desire and Everyday Life',
**Artists Space,** New York (group)
Cat. *The Fairy Tale: Politics, Desire and Everyday Life,* Artists Space, New York, texts Jean Fisher, Fredric Jameson, Jack Zipes

**1987**
'Fake',
**The New Museum of Contemporary Art,** New York (group)

at FOUR WALLS
a one day exhibition of work by

**GREG BORDOWITZ**
**JASON SIMON**
Installation

**MARK DION**
Arrangement

**KENDALL BUSTER**
Installation & Presentation

**ANDREA FRASER**
Posters

**PAULA CRAWFORD**
Sculpture

**MARSHA GINZBURG**
Photography

**JASON SIMON**
Film

Sunday, March 3, 1985    5-8 p.m.
1023 Clinton Street    1st Floor    Hoboken, N.J.

A decision to produce critical work can lead to a wide range of practices. If art works are addressing and analyzing both the world in which we live and the very context which establishes them as art works, then strategies will develop. Presentation and discussion will begin at 6:30.

201-659-5950                                                    Donation: $2

OCTOBER 30 - NOVEMBER 26
**EXHIBITION**

**the fairy tale:**
**Politics, Desire,**
**and Everyday life**

*Vito Acconci, Belshe/Prown, Ericka Beckman Bratton/Goldson, Ana Busto, James Casebere Gregg Bordowitz, Mark Dion, Andrea Fraser Felix Gonzalez-Torres, Perry Hoberman Jake Kadel, Hilary Kliros, Mary Kelly Silvia Kolbowski, Louise Lawler, Robin Michals Aimee Rankin, Juan Sanchez, Steven Schiff*

**VIDEO**
**A Video Program in The Lower Gallery**
*Norman Cowie, Sarah Drury, Jacqueline Frazier Joan Jonas, Ardele Lister, Bruce Yonemoto Norman Yonemoto, and others*

NOVEMBER 1 & 2,
**FILM**
**Film Screenings at The Collective for Living Cinema, 41 White St.**
*Saturday, November 1, 8PM, $5
"Cinderella" (Sneak Preview) by Ericka Beckman (1986)
"Rapunzel Let Down Your Hair" by The London Women's Film Group (1978)
Sunday, November 2, 5PM, $5
"The Frog Prince" by Lotte Reiniger (1954)
"The Machine to Kill Bad People" by Roberto Rossellini (1948)*

# ARTISTS SPACE
223 WEST BROADWAY
NEW YORK 10013

## Selected articles and interviews
### 1981-87

1986

1986

Zipes, Jack, 'Fairy Tale as Myth/Myth as Fairy Tale', *New Observations*, No 45, New York, 1987
Heartney, Eleanor, 'Review: Toys Are Us', *Afterimage,* Rochester, New York, March, 1987

1987

## Selected exhibitions and projects
### 1987-89

Cat. *Fake*, The New Museum of Contemporary Art, New York, texts William Olander, Lynne Tillman

'The Castle',
exhibition by Group Material for Documenta VIII, **Museum Fridericianum**, Kassel, Germany (group)
Cat. *Documenta VIII*, Museum Fridericianum, Kassel, Germany, text Peter Weiermeier

**303 Gallery**, New York (group)

'New Concepts of Art in Public Space',
**Sonne Gallery**, Berlin, with Simin Farkhondeh (group)

### 1988
Meets Roddy Bogawa, Moyra Davey and Helen Molesworth while completing the film 'Artful History: A Restoration Comedy', in San Diego

Meets Colin de Land of American Fine Arts Co., New York

Meets Christian Nagel in New York

'The Pop Project Part IV, Nostalgia as Resistance',
**The Clocktower Gallery, The Institute for Contemporary Art**, New York (group)
Cat. *Modern Dreams: The Rise and Fall and Rise of Pop*, The Institute for Contemporary Art, New York, and MIT Press, Cambridge, Massachusetts, text Thomas Lawson

'Poetic Justice',
**Ward-Nasse Gallery**, New York (group)

'Artists & Curators',
**John Gibson Gallery**, New York (group)

Text, 'Tales from the Dark Side', *Real Life Magazine*, No 14, New York

### 1989
Travels to Central America with Bob Braine, Laura Emrick, Simin Farkhondeh and Bill Schefferine, meets Sharon Matola of the Belize Zoo and Tropical Education Center and Ernesto Saqui of the Cockscomb Basin Wildlife Sanctuary

Film, 'Artful History: A Restoration Comedy', with Jason Simon, premiere at **Collective for Living Cinema**, New York

**Xavier Hufkens Gallery**, Brussels (group)

'After the Gold Rush',
**Milford Gallery**, New York, with William Schefferine (group)

'Pathetique',
**Galerie Schmela**, Düsseldorf (group)

'Here and There: Travels',
**The Clocktower Gallery, The Institute for Contemporary Art**, New York, with William Schefferine (group)

303GALLERY513East6thStreetNewYorkNY10009

Fareed Armaly   Mark Dion   Silvia Kolbowski
Gregg Bordowitz (with Testing The Limits)
Andrea Fraser   Collier Schorr   Marianne Weems

June25thruJuly26 600to800pm 212 477 4917

POETIC JUSTICE

JESSICA DIAMOND
MARK DION
JUDITE DOS SANTOS
PERRY HOBERMAN
HILARY KLIROS
JOHN MILLER
AIMEE RANKIN
JOHN STRAUSS

## Selected articles and interviews
### 1987-89

Indiana, Gary, 'Agitations', *The Village Voice*, New York, 28 July

### 1988

Schwendenwien, Jude, 'The Pop Project Part IV: Nostalgia as Resistance', *Artscribe*, London, November/December

### 1989

Dargis, Manohla, 'Counter Currents: F for Fake', *The Village Voice*, New York, 31 January
Cembalest, Robin, 'Restoration Tragedies', *ArtNews*, New York, May

Mahoney, Robert, 'Galleries: Real America', *New York Press*, 1 March

Weaver, Frank, 'Review: Pathetique at Gallery Schmela', *Flash Art*, No 149, Milan, November/December

Levin, Kim, 'Earthworks', *The Village Voice*, New York, 4 July

**The Clocktower Gallery**
108 Leonard Street
13th Floor
New York, NY
10013-4050
(212) 233-1096

*Exhibition:*
May 18–July 2, 1989
Thursday–Sunday, 12–6 pm

*Opening:*
Thursday, May 18, 5–7 pm

**Spring 1989**

**Here and There:** **Travels**
Part Four

*Lower Gallery:*
Mark Dion and
William Schefferine
Kate Ericson and
Mel Ziegler
Francoise Schein

*Tower Gallery:*
Competition Diomede

A RESTORATION COMEDY
a film by
JASON SIMON & MARK DION

**American Fine Arts Co.**, New York (group)

'The Desire of the Museum',
**Whitney Museum of American Art, Downtown at
Federal Reserve Plaza**, New York (group)
Cat. *The Desire of the Museum*, Whitney Museum of
American Art, New York, texts Catsou Roberts, Timothy
Landers, Marek Wieczorek, Jackie McAllister, Benjamin
Weil

'Le Magasin L'École L'Exposition',
**Le Magasin**, Grenoble, France (group)
Cat. *Le Magasin L'École L'Exposition*, Le Magasin,
Grenoble, texts by artists

'Perspektivismus',
**Galerie Bleich-Rossi**, Graz, Austria (group)

'The Elements: Sex, Politics, Money & Religion',
**Real Art Ways**, Hartford, Connecticut (group)

'End of the Weather',
**Randolph Street Gallery**, Chicago (group)
Pamphlet, *The End of the Weather As We Know It*,
Randolph Street Gallery, Chicago, texts Mitchell Kane,
Dan Peterman

Interview, 'Ashley Bickerton: Une conversation avec
Mark Dion,' *Galeries Magazine*, No 33, Paris,
October/November

**1990**
Meets Alexis Rockman in Paris

Visits Fareed Armaly and Christian Nagel in Cologne,
and meets Stephan Dillemuth, Christian Philip Müller
and Josef Strau

Travels with Bob Braine and installs 'Project for the
Belize Zoo', in Belize

'Commitment',
**The Power Plant**, Toronto (group)
Cat. *Commitment*, The Power Plant, Toronto, text Tom
Folland

**American Fine Arts Co.**, New York, with William
Schefferine (group)

**MARK DION**
WITH
**WILLIAM SCHEFFERINE**

MARCH 17 — APRIL 7
AMERICAN FINE ARTS, CO.
COLIN DE LAND FINE ART
40 WOOSTER ST, NYC 10013 (212) 941-0401
RECEPTION SATURDAY, MARCH 17 6PM

'The Köln Show',
Cologne (group)
Cat. *Nachschub*, Spex, Cologne, ed. Isabelle Graw

'Videoworks',
**Galleri Nordanstad-Skarstedt**, Stockholm (group)

'Biodiversity: An Installation for the Wexner Center',
**Wexner Center for Visual Arts**, Columbus, Ohio, with
William Schefferine (group)
Pamphlet, *Biodiversity: An Installation for the Wexner
Center*, Wexner Center for Visual Arts, Columbus, Ohio,
texts Mark Dion, William Schefferine

'The (Un)Making of Nature',

Smith, Roberta, 'The Whitney Interprets Museums'
Dreams', *The New York Times*, 23 July

Mark Dion and William Schefferine during 'Biodiversity: An Installation for the Wexner Center for the Arts', 1990
**1990**

Matola, Sharon, 'Belize Zoo:
Construction/Conservation Update', *On The Edge*,
Wildlife Preservation Trust International, Philadelphia,
Summer

Lewis, James, 'Mark Dion with William Schefferine,
American Fine Arts Co.', *Artforum*, New York,
September
Decter, Joshua, 'New York in Review', *Arts Magazine*,
New York, Summer

Avgikos, Jan, 'The (Un)Making of Nature', *Artforum*,

## Selected exhibitions and projects
## 1990-91

**Whitney Museum of American Art, Downtown at
Federal Reserve Plaza**, New York; **Whitney Museum of
American Art**, Stamford, Connecticut, with William
Schefferine (group)
Cat. *The (Un) Making of Nature*, Whitney Museum of
American Art, New York, texts Julia Einspruch, Helen
Molesworth, James Marcovitz, Elizabeth Finch, Lydia
Yee

'Extinction, Dinosaurs and Disney: The Desks of Mickey
Cuvier',
**Galerie Sylvana Lorenz**, Paris (solo)

'Art Supplies and Utopia',
**Galerie Ralph Wernicke**, Stuttgart (group)
Cat. *Art Supplies and Utopia*, Galerie Ralph Wernicke,
Stuttgart, text John Miller

'In the Beginning',
**Cleveland Center for Contemporary Art**, Ohio (group)

**Diane Brown Gallery**, New York (group)

Interview with Michel von Praet, 'Renovating Nature',
*Flash Art*, No 155, Milan, November/December

**1991**
Travels with Alexis Rockman to Belize

Frequents **Friesenwall 120**, Cologne, an exhibition
space and archive organized by Stephan Dillemuth and
Josef Strau

Travels with Bob Braine in the Amazonas territory,
Venezuela

'Die Botschaft als Medium',
project for **Museum in Progress**, published in *Der
Standard* and *Cash Flow*, Vienna

'Frankenstein in the Age of Biotechnology',
**Galerie Christian Nagel**, Cologne (solo)
Cat. *Daily Planet - Science of the Planet*, Galerie
Christian Nagel, Cologne, text Mark Dion

'Counter-Media',
**Key Gallery**, Richmond, Virginia (group)

## Selected articles and interviews
## 1990-91

New York, November
Bright, Deborah, 'Paradise Recycled; Art, Ecology and
the End of Nature [sic]', *Afterimage*, Rochester, New
York, September
Zimmer, William, 'Conceptual Works Issue Dire
Warnings', *The New York Times*, 28 October

Zahm, Olivier, 'Mark Dion at Galerie Sylvana Lorenz',
*Flash Art*, No 154, Milan, October

Jones, Nancy, 'Junk Art', *New York Woman*, April
Graw, Isabelle, 'Jugend forscht (Armaly, Dion, Fraser,
Müller)', *Texte zur Kunst*, No 1, Cologne, Autumn
Bourriaud, Nicolas, 'The Signature Game', *Flash Art*, No
155, Milan, November/December
Decter, Joshua, 'De-Coding The Museum', *Flash Art*, No
155, Milan, November/December
Graw, Isabelle, 'Field Work', *Flash Art*, No 155, Milan,
November/December
Clothier, Peter, 'For Love Not Money: L.A. Collects',
*ArtNews*, New York, December

**1991**

Diederichsen, Diedrich and Jutta Köther, 'Die Nagel
trifft den Kopf', *Spex*, Cologne, April
Kroll, Petra, 'Kunst und Dokumentation', *Prinz*,
Hamburg, 4 April
Germer, Stefan, 'Im Sichtfeld des Feindes', *Texte zur
Kunst*, Cologne, Summer
Maier, Anne, 'Premierentage in Kölns Galerien', *Kunst-
Bulletin*, Zürich, June
Schumacher, Rainald and Heike Kempken, 'Mark Dion
bei Christian Nagel', *Kritik Köln*, Cologne, 12 April

Frisbee, Langley, 'Message is the Medium', *Style
Weekly*, Vol IX, No 13, 26 March
Proctor, Roy, 'Counter-Media is Ambitious
Undertaking', *The Richmond News Leader*, Virginia,
9 March

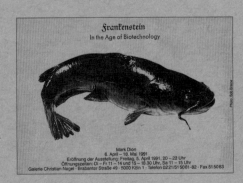

Frankenstein
In the Age of Biotechnology

Mark Dion
6. April – 18. Mai 1991
Eröffnung der Ausstellung: Freitag, 5. April 1991, 20 – 22 Uhr
Öffnungszeiten: Di – Fr 11 – 14 und 15 – 18.30 Uhr, Sa 11 – 15 Uhr
Galerie Christian Nagel · Brabanter Straße 49 · 5000 Köln 1 · Telefon 0221/51 50 81-82 · Fax 51 50 83

## Selected exhibitions and projects
### 1991-92

'Sweet Dreams',
**Barbara Toll Fine Art**, New York (group)

'Arte Joven en Nueva York',
**Consejo Nacional de la Cultura, Sala Mendoza and Sala R.G.**, Caracas, Venezuela (group)

'Art ... Not News',
**Real Art Ways**, Hartford, Connecticut, project conceived by Mark Dion, coordinated by Anne Pasternak, published in *The Hartford Courant*, 16-22 June
Cat. *Art ... not News*, Real Art Ways, Hartford, text Joshua Decter

'True to Life',
**303 Gallery**, New York (group)

'The Hirsch Farm Project',
Hillsboro, Wisconsin (group)
Cat. *Mud*, The Hirsch Farm Project, Hillsboro, text Mitchell Kane

'Launching',
**Shark Editions, Spring Street Lounge**, New York (solo)

Text with Alexis Rockman, 'Concrete Jungle', *Journal of Contemporary Art*, Vol 4, No 1, New York, Spring/Summer

### 1992
Travels to Spitzbergen, Norway

Travels to Belém, Brazil, works with entomologist William L. Overall from Museu Paraense Emilio Goeldi

Works for four months on The Visitor Center of the Cockscomb Basin Wildlife Sanctuary in Belize, meets anthropologist Paul Towell

Text with Alexis Rockman, 'Concrete Jungle', *Heaven Sent*, No 3, Frankfurt, February

**Galleri Nordanstad-Skarstedt**, Stockholm (solo)

'Concrete Jungle',
**Tanja Grunert Galerie**, Cologne, with Bob Braine and Alexis Rockman (group)

'Wohnzimmer/Büro',
**Galerie Christian Nagel**, Cologne (group)

**American Fine Arts Co.**, New York (solo)

## Selected articles and interviews
### 1991-92

Invitation card, Shark Editions, Spring Street Lounge, New York

Avgikos, Jan, 'Green Piece', *Artforum*, New York, April
Vogel, Sabine B., 'Verortungen Installationen', *Arts*, Hamburg, June
Fuenmayor, Jesús, 'Meyer Vaisman en Español', *Estilo*, Caracas, Venezuela, February/March/April

### 1992

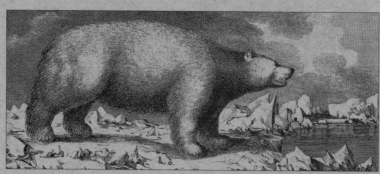

Smolik, Noemi, '"Concrete Jungle" at Tanja Grunert Galerie', *Artforum*, New York, Summer

**Concrete Jungle**, in progress

'Goings On About Town: Art', *The New Yorker*, May
Bourdon, David, 'Mark Dion at American Fine Arts Co.', *Art in America*, New York, July
Decter, Joshua, 'Mark Dion at American Fine Arts Co., *Flash Art*, Milan, Summer
Kwon, Miwon; Marcovitz, James; Molesworth, Helen, 'Confessions of an Amateur Naturalist', *Documents*, New York, Fall/Winter

'Animals',
**Galerie Anne de Villepoix**, Paris (group)

'Molteplici Culture',
**Convento di S. Egidio**, Rome (group)

'Nos Sciences Naturelles',
**Fri-Art Centre D'Art Contemporain Kunsthalle**,
Fribourg, Switzerland (group)
Cat. *Nos Sciences Naturelles*, Fri-Art Centre D'Art
Contemporain Kunsthalle, Fribourg, Switzerland, text
Michel Ritter

NOS SCIENCES NATURELLES
PATRICK CORILLON, MARK DION, NANA PETZET, HINRICH SACHS

'Arte Amazonas',
**Museu de Arte Moderna**, Rio de Janeiro; **Staatliche
Kunsthalle**, Berlin (group)
Cat. *Arte Amazonas*, Museo de Arte Moderna, Rio de
Janeiro, texts Alfons Hug, Nikolaus A. Nessler

'Translation',
**Centrum Sztuki Wspoteczesnej, Zamek Ujazdowski**,
Warsaw (group)
Cat. *Translation*, Centrum Sztuki Wspoteczesnej, Zamek
Ujadowski, Warsaw, text Kim Levin

'Americas/Plus Ultra',
**Monasterio de Santa Clara**, Moguer, Spain (group)
Cat. *Americas/Plus Ultra*, Monasterio de Santa Clara,
Moguer, texts Berta Sichel, Susanna Toruella, Mar
Villaespesa

'Forgiving Ground: Symposia on Engaging the Public
and Rethinking Exhibition Approaches',
**Thread Waxing Space**, New York (group)

'Animals',
**Kubinski Köln**, Cologne (group)

'Natural Science',
**John Gibson Gallery**, New York (group)

'Oh! Cet écho!',
**Le Centre Culturel Suisse**, Paris (group)
Cat. *Oh! Cet écho!*, Le Centre Culturel Suisse, Paris,
texts Bice Curiger, Bernard Marcadé, Hans-Ulrich
Obrist, Anton C. Meier

'Proiezioni',
**Buchholz und Buchholz**, Cologne (group)

'Twenty Fragile Pieces',
**Galerie Analix-B & L Polla**, Geneva (group)
Cat. *Twenty Fragile Pieces*, Galerie Analix- B & L Polla,
Geneva, text Gianni Romano

'True Stories: Part II',
**Institute of Contemporary Arts**, London, with Renée
Green (group)
Cat. *True Stories*, Institute of Contemporary Arts,
London, texts Iwona Blazwick, Emma Dexter

'Animals, Anne de Villepoix, Paris', *Flash Art*, Milan,
October

Boller, Gabrielle, 'Nos Sciences Naturelles', *Art Press*,
No 172, Montreal
Jaunin, Françoise, 'Nos Sciences Naturelles: cherchez
l'erreur', *Voir: Le Magazine des Arts*, September
Fleury, Jean-Damien, 'Sciences et art main dans la
main pour trois expositions-événements', *La Liberté*,
Switzerland, 1 June
'Kunst und Wissenschaft vereinen', *Freiburger
Nachrichten*, Fribourg, Switzerland, 3 June
Riedo, Romano, 'Kunst und Wissenschaft im Dialog',
*Berner Zeitung*, Switzerland, 23 June
Imbach, Jost Martin, 'Die Kunst treibt Wissenschaft
mit der Natur', *LNN*, Switzerland, 2 July

'A Natureza na Arte de Mark', *O Liberal*, Belém, Brazil,
23 May

Marcel Broodthaers, *The Manuscript Found in a Bottle*, 1974
courtesy Galerie Michael Werner, Cologne
top: Renée Green, *Import/Export Funk Office*, 1992
courtesy Christian Nagel Gallery, Cologne
bottom: Mark Dion, *The History of a Natural History*, 1990
courtesy American Fine Arts, New York

16 SEPTEMBER – 6 DECEMBER 1992

True Stories

Part II: 4 November - 6 December
Mark Dion, Renée Green

Marcel Broodthaers

*Complete Prints and Multiples*

You are invited to the private view of the exhibitions
on Tuesday 3 November from 18.00 until 21.00 hrs.
Bar until midnight.

**ICA**
Institute of Contemporary Arts
The Mall, London SW1  Telephone 071 930 3647

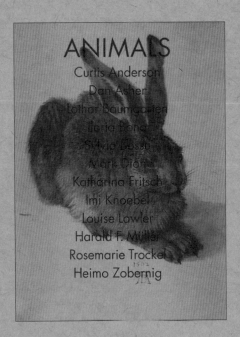

ANIMALS
Curtis Anderson
Dan Asher
Lothar Baumgarten
Ilaria Bonal
Sylvia Bossu
Mark Dion
Katharina Fritsch
Imi Knoebel
Louise Lawler
Harald F. Müller
Rosemarie Trockel
Heimo Zobernig

## Selected exhibitions and projects
### 1992-93

'Proposals for The Museum of Natural History',
**Pat Hearn Gallery**, New York, with students of Cooper
Union (group)

### 1993
Travels with Jessica Rath and fourteen high school
students from Chicago to Belize as part of 'Sculpture
Chicago'

**Annina Nosei Gallery**, New York (group)

'Simply Made in America',
**The Aldrich Museum for Contemporary Art**,
Ridgefield, Connecticut (group)
Cat. *Simply Made in America*, Aldrich Museum for
Contemporary Art, text Barry A. Rosenberg

**Galerie Max Hetzler**, Cologne (group)

'Travelogue/Reisetagebuch',
**Hochschule für Angewandte Kunst** in collaboration
with **Galerie Metropol**, Vienna (group)
Cat. *Travelogue/Reisetagebuch*, Institut für
Museologie, Hochschule für Angewandte Kunst,
Vienna, text Jackie McAllister

'The Great Hunter, The Marine Biologist, The
Paleontologist and the Missionary',
**Galerie Marc Jancou**, Zürich (solo)

'Parallax View: Köln-New York',
**P.S. 1 Museum, The Institute for Contemporary Art**,
Long Island City; **Goethe House**, New York, with Josef
Strau (group)
Cat. *Parallax View: Köln-New York*, P.S. 1 Museum, New
York, text Daniela Salvioni

'Culture in Action',
**Sculpture Chicago**, Illinois, with The Chicago Urban
Ecology Action Group (group)
Cat. *Culture in Action*, Bay Press, Seattle, texts Mary
Jane Jacob, Michael Brenson, Eva M. Olson

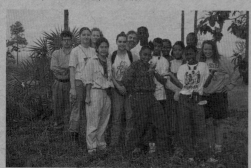

Mark Dion with members of The Chicago Urban Ecology Action Group
'Animals',
**Galerie Tanya Rumpff**, Haarlem, The Netherlands
(group)

## Selected articles and interviews
### 1992-93

Graw, Isabelle, 'Short Story, An Interview with
Christian Nagel', *Forum International*, Antwerp,
January
Dawidoff, Nicholas, 'Queen of the Jungle', *Sports
Illustrated*, New York, 9 March

### 1993

Kurjakovic, Daniel, Zürich: Mark Dion bei Marc Jancou',
*Kunst-Bulletin*, Zürich, April
Kurjakovic, Daniel, 'Jagen, Tauchen, Ausgraben,
Bekehren', *Zürichsee-Zeitung/Allgemeiner
Anzeiger/Grenzpost*, Switzerland, 24 March

Bonami, Francesco, 'Parallax View, P.S. 1, Goethe
Institute, New York', *Flash Art*, Milan, October

Heartney, Eleanor, 'The Dematerialization of Public
Art', *Sculpture Magazine*, Washington, D.C.,
March/April
Cameron, Dan, 'Culture in Action, Eliminate the
Middleman', *Flash Art*, Milan, November/December
'Sculpture Chicago', *ArtNews*, Chicago, May
Kimmelman, Michael, 'Of Candy Bars and Public Art',
*The New York Times*, Sunday, 26 September
Scanlan, Joseph, 'Culture in Action', *Frieze*, London,
November/December
Matre, Lynn Van, 'Carving a Niche', *Chicago Tribune*, 3
June
Corrin, Lisa and Gary Sangster, 'Culture is Action:
Action in Chicago', *Sculpture*, Washington, D.C.,
March/April, 1994
Huebner, Jeff, 'Chicago Students Green Their Habitat',
*E Magazine*, Chicago, January/February, 1994
Stevens, Liz, 'Environment as Art', *New City*, Chicago,
22-28 April

## Selected exhibitions and projects
### 1993

**Künstlerhaus Bethanien**, Berlin (group)

'Spielhölle: Esthétique et Violence',
**Galerie Sylvana Lorenz**, Paris (group)

'Project Unité',
**Unité d' Habitation**, Firminy, France, with Art Orienté
Objet (group)
Cat. *Project Unité*, Firminy, France, text Yves
Aupetitallot

'Sonsbeek 93',
Arnhem, The Netherlands (group)
Cat. *Sonsbeek 93*, Stichting Sonsbeek Arnhem and
Snoeck-Ducaju & Zoon, Ghent, ed. Valerie Smith, Jan
Brand, Catelijne de Muynck

'Kinder',
**Galerie Rüdiger Schöttle**, Munich (group)

'Grafica 1',
Innsbruck, Tyrol, Austria (group)

'Naturkunden',
**Paszti-bott Galerie**, Cologne (group)

'Restaurant',
**La Bocca**, Paris (group)
Cat. *Restaurant*, Galerie Marc Jancou, Paris, texts Marc
Jancou, Jan Avgikos, Yves Aupetitallot, Terry R. Myers,
Frank Perrin

'Art-Culture-Ecology',
**Bea Voigt Galerie**, Munich (group)

'What Happened to the Institutional Critique?',
**American Fine Arts Co.**, New York (group)
Cat. *What Happened to the Institutional Critique?*,
American Fine Arts Co., New York, text James Meyer

Installation, 'Project for the Birds of Antwerp Zoo',
'On taking a normal situation and retranslating it into
overlapping and multiple readings of conditions past
and present', **Museum van Hedendaagse Kunst
Antwerpen**, Belgium (group)
Cat. *On taking a normal situation and retranslating it
into overlapping and multiple readings of conditions
past and present*, Museum van Hedendaagse Kunst
Antwerpen, texts Bart Cassiman, Carolyn Christov-
Bakargiev, Iwona Blazwick, Yves Aupetitallot, Bruce
Ferguson, Reesa Greenberg, Sandy Nairne, Homi K.
Bhabha, Mauro Ceruti, Hugo Soly

'Kontext Kunst: Kunst der 90er Jahre',
**Neue Galerie am Landesmuseum Joanneum**, Graz,
Austria (group)
Cat. *Kontext Kunst: Kunst der 90er Jahre*, Neue Galerie
am Landesmuseum Joanneum, Graz and DuMont
Verlag, Cologne, ed. Peter Weibel

'Concrete Jungle',
**Ezra and Cecile Zilkha Gallery**, Center for the Arts,
Wesleyan University, Middletown, Connecticut, with

## Selected articles and interviews
### 1993

Lebovici, Elisabeth, 'Au débotté chez Le Corbusier',
*Liberation*, Paris, 23 June
Pencenat, Corine, 'Unité D'Habitation, Septième Rue',
*Galeries Magazine*, Paris, Summer
'Projet Unité', *Purple Prose*, Paris, Summer
Graw, Isabelle, 'La Culture, Zur Ausstellung "Project
Unité" in Firminy', *Artis*, Hamburg, September
Decter, Joshua and Olivier Zahm, 'Back to Babel,
Project Unité, Firminy', *Artforum*, New York, November

Lambrecht, Luk, 'Sonsbeek 93', *Flash Art*, Milan,
October

Bestuur en directie van Sonsbeek 93 nodigen u uit
voor de officiële opening van de internationale tentoonstelling
Sonsbeek 93
op vrijdag 4 juni om 15.30 uur bij de Villa in Park Sonsbeek.

In verband met de komst van Hare Majesteit de Koningin
verzoeken wij u vriendelijk uiterlijk om 15.15 uur
aanwezig te zijn.

Deze uitnodiging is geldig voor twee personen
en dient getoond te worden bij de ingang
van Park Sonsbeek.
De hoofdsponsors van Sonsbeek 93 zijn PGEM, stichting VSB fondsen
stichting Herinneringsfonds Vincent van Gogh.

The Board and the Director of Sonsbeek 93 cordially invite you
for the official opening of the international art exhibition
Sonsbeek 93
on Friday the 4th of June 1993 at 3.30 pm next to the Villa
in Park Sonsbeek.
Due to the presence of Her Majesty the Queen we kindly request
that you arrive no later than 3.15 pm.
This invitation is valid for two persons.
Please present it at the entrance of Park Sonsbeek.
The main sponsors of Sonsbeek 93 are PGEM, stichting VSB fonds, and
Stichting Herinneringsfonds Vincent van Gogh.

*"Vertrekken vanuit een normale situatie
en deze hervertalen
in elkaar overlappende en meervoudige lezingen
van condities uit heden en verleden"*

*"On taking a normal situation
and retranslating it
into overlapping and multiple readings
of conditions past and present"*

JUDITH BARRY
ZARINA BHIMJI
SYLVIA BOSSU
PATRICK CORILLON
FAUSTO DELLE CHIAIE
MARK DION
EUGENIO DITTBORN
JIMMIE DURHAM
MARIA EICHHORN
ANDREA FRASER
RENÉE GREEN
BETHAN HUWS
ANN VERONICA JANSSENS
LAURIE PARSONS
MATHIAS POLEDNA
LUCA VITONE

**THE ART OF THE 90's**

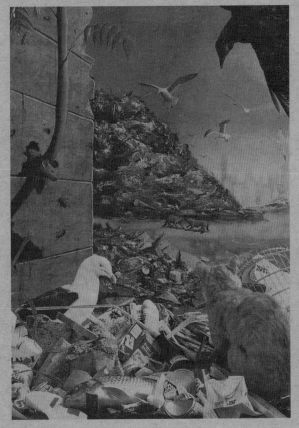

Invitation card, Ezra and Cecile Zilkha Gallery

## 1993-94

Bob Braine and Alexis Rockman (group)
Cat. *Concrete Jungle*, Wesleyan University, texts Klaus Ottmann, Mark Dion, Alexis Rockman

'The Great Munich Bug Hunt',
**K-Raum Daxer**, Munich (solo)
Cat. *Die Wunderkamer*, K-Raum Daxer, texts Karola Grässlin, Miwon Kwon, Carolyn Gray Anderson, Helen Molesworth

'Fireproof/Feuerfest',
**Wandelhalle, Forum für Kunst**, Gereonswall 15, Cologne (group)

'Transgressions in the White Cube: Territorial Mappings',
**Bennington College**, Vermont (group)
Cat. *Transgressions in the White Cube:Territorial Mappings*, Bennington College, Vermont, text Joshua Decter

'Das Fremde – Der Gast',
**Offenes Kulturhaus**, Linz, Austria (group)
Cat. *Das Fremde - Der Gast*, Offenes Kulturhaus, Linz, and Turia & Kant, Vienna, ed. Wolgang Pircher

**1994**
Travels with Bob Braine and Alexis Rockman to Guyana, South America

Participates in Sommerakademie München, organized by Stephan Dillemuth, **Kunstverein Munchen**

Meets J. Morgan Puett, New York

'Living in Knowledge: An Exhibition About Questions Not Asked',
**Duke University Museum of Art**, Durham, North Carolina (group)
Cat. *Living in Knowledge: An Exhibition About Questions Not Asked*, Duke University Museum of Art, texts Rebecca Katz, Jane McFadden

'Pro-Creation?',
**Fri-Art Centre D'Art Contemporain Kunsthalle**, Fribourg, Switzerland (group)
Cat. *Pro-Creation?*, Fri-Art Centre D'Art Contemporain Kunsthalle, Fribourg, text Robert A. Fischer

'Aristoteles, Rachel Carson, Alfred Russel Wallace',
**Galerie Metropol**, Vienna (solo)

## Selected articles and interviews

## 1993-94

Hoffman, Justin, 'Jäger der Verborgenen Tier-Welt', *Heaven Sent*, Frankfurt, February, 1994
Hoffman, Justin, 'Ein Gesprach mit Mark Dion', *Kunst-Bulletin*, Zürich, March, 1994

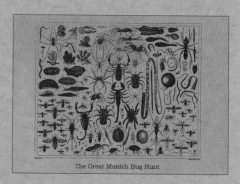

The Great Munich Bug Hunt

Archer, Michael, 'Renée Green, Mark Dion und der Einfluß von Marcel Broodthaers', *Texte zur Kunst*, Cologne, March
Saunders, Wade, 'Making Art, Making Artists: Interviews with 23 Artists', *Art in America*, New York, January
Troncy, Eric, 'Naakt en Kneedbaar', *Metropolis M*, No 3, Utrecht
Kwon, Miwon, 'Unnatural Tendencies: Scientific Guises of Mark Dion', *Forum International*, Antwerp, May/August
Coelewig, Leontine, 'Wie mag er in de Ark?', *Metropolis Museum*, Amsterdam, April

**1994**

*l. to r.*, Alexis Rockman, Bob Braine, Mark Dion in Mazaruni, Guyana, 1994

Mark Dion in abandoned gold miners' camp, Mazaroni, Guyana, 1994

Krumpl, Doris, 'Meister Reineke, mit vielen Dioptrien', *Der Standard*, Vienna, 20 July
Horny, Henrietta, 'Ein Fuchs macht Urlaub oder die andere Naturgeschichte', *Kurier*, Vienna, 25 July

## Selected exhibitions and projects
### 1994-95

''When Dinosaurs Ruled the Earth (Toys 'R' U.S.)'',
**American Fine Arts Co.**, New York (solo)

'Don't Look Now',
**Thread Waxing Space**, New York (group)
Cat. *Don't Look Now*, Thread Waxing Space, New York,
text Joshua Decter

'Services',
**Kunstverein München**, Munich (group)

'Temporary Translation(s) Sammlung Schurmann',
**Deichtorhallen**, Hamburg (group)
Cat. *Temporary Translation(s) Sammlung Schurmann*,
Deichtorhallen Hamburg, interview with Christian
Nagel and Wilhelm Schürmann

'Garbage!',
**Real Art Ways**, Hartford, Connecticut (group)

'Grreen',
**Torch**, Amsterdam (group)
Cat. *Grreen*, Torch, Amsterdam, text Bert Jansen

'Angelica Point',
**Galleria Emi Fontana**, Milan (solo)

'The Media and Art Exhibition '94',
**Magic Media Company**, Cologne (group)

'Concrete Jungle',
**Marc Jancou Gallery**, London, with Bob Braine and
Alexis Rockman (group)

'Frauenkunst/Männerkunst',
**Kunstverein Kippenberger, Museum Fridericianum**,
Kassel, Germany (group)

'Cocido y Crudo',
**Museo Nacional Centro de Arte Reina Sofía**, Madrid
(group)
Cat. *Cocido y Crudo*, Museo Nacional Centro de Arte
Reina Sofia, Madrid, texts Jerry Saltz, Mar Villaespesa,
Gerardo Mosquera, Jean Fisher, Dan Cameron

### 1995
Travels with Paul Towell to Borneo

'Mapping: A Response to MoMA',
**American Fine Arts Co.**, New York (group)
Cat. Mapping: A Response to MoMA, American Fine Arts
Co., New York, texts Peter Fend et al.

'Zeichen und Wunder/Signos y Milagros',
**Kunsthaus Zurich**, Zurich; **Centro Galego De Arte
Contemporanea**, Santiago De Compostela, Spain
(group)
Cat. *Zeichen und Wunder/Signos y Milagros*, Cantz
Verlag, ed. Bice Curiger
'It's Not a Picture',
**Galleria Emi Fontana**, Milan (group)

'Unseen Fribourg',

Mark Dion

Da giovedi 3 novembre 1994, ore 19.
Inaugurazione venerdi 18 novembre 1994 ore 19.

Galleria Emi Fontana   Viale Bligny 42   20136 Milano   tel/fax 02-58306855

## Selected articles and interviews
### 1994-95

Hofleitner, Johanna, 'Mark Dion', *Flash Art*, Milan,
November/December
Decter, Joshua, 'Mark Dion at Galerie Metropol',
*Artforum*, New York, January 1995

Tager, Alexandra, 'Review of Concrete Jungle', *Art and
Auction*, New York, December

| KUNSTHAUS ZÜRICH | Mario Airò |
| --- | --- |
| | Stephan Balkenhol |
| | Mark Dion |
| | Peter Fischli / David Weiss |
| Wir laden Sie herzlich ein | Katharina Fritsch |
| zur Eröffnung | Robert Gober |
| und zum anschliessenden Fest | Damien Hirst |
| der Ausstellung | Ilya Kabakov |
| | Mike Kelley |
| ZEICHEN & WUNDER | Karin Kneffel |
| NIKO PIROSMANI (1862–1918) | Jeff Koons |
| UND DIE KUNST DER GEGENWART | Jean-Luc Mylayne |
| | Tony Oursler |
| Donnèrstag, 30. März 1995, 20.00 Uhr | Sigmar Polke |
| Einführung: Bice Curiger | Paul Ramirez-Jonas |
| | Pipilotti Rist |
| Die Ausstellung dauert bis zum 18. Juni 1995 | Tim Rollins + K.O.S |
| Zürcher Kunstgesellschaft | Klara Schilliger und Valerian Maly |
| | Cindy Sherman |
| Eine Performance von Klara Schilliger und Valerian Maly findet | Roman Signer |
| am Samstag, 1. April, 10–17 Uhr, in der Ausstellung statt. | Lily van der Stokker |

**Fri-Art Centre D'Art Contemporain Kunsthalle**,
Fribourg, Switzerland (solo)
Cat. *Unseen Fribourg*, Fri-Art Centre D'Art
Contemporain Kunsthalle, Fribourg, text Christoph
Bauer

'Searching for Sabah',
**Sabah Museum**, Sabah, Malaysia, with Paul Towell
(group)

'Platzwechsel',
**Kunsthalle Zürich**, Zurich (group)
Cat. *Platzwechsel*, Kunsthalle Zurich, texts Bernhard
Bürgi, James Meyer et al.

'Schoharie Creek Field Station',
**Art Awareness**, Lexington, New York, with Bob Braine
and J. Morgan Puett (group)

'A Vital Matrix',
**Domestic Setting**, Los Angeles (solo)
Cat. *A Vital Matrix*, Domestic Setting, Los Angeles, text
Tobey Crockett

'Das Ende der Avant Garde: Kunst als Dienstleistung',
**Kunsthalle der Hypo-Kulturstiftung**, Munich (group)
Cat. *Das Ende der Avant Garde: Kunst als Dienstleistung*,
Kunsthalle der Hypo-Kulturstiftung and Richter
Verlag, text Katharina Hegewisch

**American Fine Arts Co.**, New York (solo)

'Dodo',
**Galerie Tanya Rumpff**, Amsterdam (solo)

'Flotsam and Jetsam (The End of the Game)',
**De Vleeshal**, Middleburg, The Netherlands (solo)
Cat. *Flotsam and Jetsam*, Vleeshal Middleburg, text
Mark Dion

'Aufforderung in schönster Weise',
**Galerie Christian Nagel**, Cologne (group)

Text, 'Füllung des Naturhistorischen Museums', *Texte
zur Kunst*, Cologne, November

**1996**
Designed sets for Gregg Bordowitz's film, 'The Suicide'

'Guyana',
*WORD magazine*, http://www.word.com, with Bob
Braine and Alexis Rockman

Leturcq, Armelle, 'Mark Dion', *Blocnotes*, 21, Paris
Krebs, Edith, 'Fribourg: Mark Dion im Centre D'Art
Contemporain Kunsthalle', *Kunst-Bulletin*, Zürich,
October
Salvadé, Christine, 'Quand un artiste new-yorkais
gratte le sol de Fribourg', *Le Nouveau Quotidien*, Paris,
4 October
Ursprung, Philip, 'Mark Dion: Unseen Fribourg',
*Springer*, Vienna, November
J.D.F., 'Le New-Yorkais Mark Dion se penche sur l'homo
friburgensis', *La Liberté*, Switzerland, 1 September
J.D.F., 'Entre Berlin et Rio, Mark Dion sonde l'invisible
qui respire sous nos pieds', interview, *La Liberté*,
Switzerland, 9-10 September

Volkart, Yvonne, 'Platzwechsel', *Springer*, Vienna,
September

Simon, Jason, 'Jean Painlevé and Mark Dion, *Parkett*,
No 44, Zürich
Gorney, S.P., 'Mark Dion', *Juliet*, Paris, June
Germer, Stefan, 'Unter Geiern, Kontext-Kunst im
Kontext', *Texte zur Kunst*, Cologne, August

**1996**

Chervokas, Jason and Watson, Tom , 'Guyana: 3 Artists
Thrash Romance in Trek Through Heart of Darkness',
*The New York Times Cyber Times*, 26 August

## Selected exhibitions and projects
### 1996-97

Book, *Concrete Jungle*, Juno Books, New York, co-editor with Alexis Rockman

'Two Trees',
**American Fine Arts Co.**, New York (solo)

'Vehicle',
**Paolo Baldacci Gallery**, New York (group)

'Multiple Pleasure',
**Tanya Bonakdar Gallery**, New York (group)

'A Tale of Two Seas: An Account of Stephan Dillemuth's and Mark Dion's Journey Along the Shores of the North Sea and Baltic Sea and What They Found There',
**Galerie Christian Nagel**, Cologne (solo)

Abb., Rosemarie Trockel: Künstler/in-Wissenschaftler/in, 1995

15. 5.–21. 7. 96        Berechenbarkeit der Welt

**BONNER KUNSTVEREIN**

'Berechenbarkeit der Welt',
**Bonner Kunstverein**, Bonn (group)
Cat. *Berechenbarkeit der Welt*, Bonner Kunstverein, text Annelie Pohlen

'Cabines de Bain',
**Piscine de la Motta, Fri-Art**, Centre D'Art Contemporain-Kunsthalle, Fribourg, Switzerland (group)

'Hybrids',
**De Appel**, Amsterdam (group)

'21st Century Sculpture',
**John Gibson Gallery**, New York (group)

'Campo 6',
**Galleria Civica D'Arte Moderna e Contemporanea**, Torino (group)
Cat. *Campo 6*, Galleria Civica D'Arte Moderna e Contemporanea, text Francesco Bonami, Ellen Dissanayake, Vittorio Gregotti

'Lets' Talk About Art,'
**Art Metropole**, Toronto (group)

'25th Anniversary: 25 Younger Artists',
**John Weber Gallery**, New York (group)

Text, 'Den naturhistoriske kasse-Konservering, Kategorisering og udstillung', *Øjeblikket: Tidsskrift for Visuelle Kulturei*, Copenhagen, Summer

**MARK DION** Trophies & Souvenirs
January 18 - March 1 1997

**LONDON PROJECTS**

### 1997
'The Spiral Village',
**Bonnefanten Museum**, Maastricht, The Netherlands (group)

'Trophies & Souvenirs',
**London Projects**, London (solo)

## Selected articles and interviews
### 1996-97

Levin, Kim, 'Mark Dion', *The Village Voice*, New York, 30 January
Karmel, Pepe, 'Mark Dion', *The New York Times*, 2 February
Schwendener, Martha, 'Mark Dion', *Time Out New York*, 7-14 February
Turner, Grady T., 'Mark Dion at American Fine Arts Co.', *Art in America*, New York, May

Theewen, Gerhard, 'Das Kunstkabinett als Ausstellung', exhibition presentation issue, *Salon Verlag*, Cologne
Theewen, Gerhard, 'Mark Dion, Where are You Now?: The Attempt to Correspond with a Travelling Artist', *Künstlerhaus Bethanien*, Berlin

**HYBRIDS**
DE APPEL 1 JUNI - 18 AUGUSTUS

DE APPEL
NIEUWE SPIEGELSTRAAT 10
1017 DE AMSTERDAM
TEL +31 (0)20 625 5651
FAX +31 (0)20 622 5215
DINSDAG T/M ZONDAG 12.00 - 17.00 UUR
TUESDAY THROUGH SUNDAY 12 - 5 PM

Litz, Christine, 'Das Pippi-Langstrumpf-Prinzip', *Rhein Art*, Germany, June
Runnette, Charles, 'Pictures from an Expedition', *New York Magazine*, September

Williams, Gilda, 'Mark Dion, London Projects, Ikon Gallery, Birmingham', *Art Monthly*, London, March

Selected exhibitions and projects
**1997**

'Mark Dion: The Museum of Natural History and Other
Fictions,'
**Ikon Gallery**, Birmingham; **Kunstverein**, Hamburg
(solo)
Cat. *Mark Dion: The Museum of Natural History and
Other Fictions*, Ikon Gallery, Birmingham; Kunstverein,
Hamburg, texts John Leslie, Saskia Bos, Carolyn
Christov-Bakargiev, Miwon Kwon, Helen Molesworth,
Simon Morrissey, Jackie McAllister, Erhard Schüttpelz,
Jason Simon

'Homage – Jean-Henri Faber',
**Galerie des Archives**, Paris (solo)

'Città Natura',
**Palazzo delle Esposizioni e** and **Museo Zoologico**,
Rome (group)

'Veilleurs du Monde',
**Centre Culturel Français,** Cotoriuo, Benin, with Olu
Oguibe (group)

'Curiosity Cabinet for the Wexner Center for the Arts',
**Wexner Center for the Arts,** Columbus, Ohio (solo)

'Venice Biennale',
**Nordic Pavilion,** XLVII Venice Biennale (group)

'Skulptur Projekte in Münster',
Münster, Germany (group)

Selected articles and interviews
**1997**

MacRitchie, Lynn, 'Stuff of Life', *The Guardian*, London,
28 January

Meyer, James, 'The Macabre Museum', *Frieze*, London,
January

Archer, Michael, 'Renée Green, Mark Dion und der Einfluß von Marcel Broodthaers', *Texte zur Kunst*, Cologne, March 1993

Aupetitallot, Yves, *Project Unité*, Firminy, France, 1993

Aupetitallot, Yves, *On taking a normal situation...*, Museum van Hedendaagse Kunst Antwerpen, 1993

Avgikos, Jan, 'The (Un)Making of Nature', *Artforum*, New York, November 1990

Avgikos, Jan, 'Green Piece', *Artforum*, New York, April 1991

Bauer, Christoph, *Unseen Fribourg*, Fri-Art Centre D'Art Contemporain Kunsthalle, Fribourg, 1995

Bhabha, Homi K, *On taking a normal situation...*, Museum van Hedendaagse Kunst Antwerpen, 1993

Blazwick, Iwona, *True Stories*, Institute of Contemporary Arts, London 1992

Blazwick, Iwona, *On taking a normal situation...*, Museum van Hedendaagse Kunst Antwerpen, 1993

Bos, Saskia, *Mark Dion: The Museum of Natural History and Other Fictions*, Ikon Gallery, Birmingham; Kunstverein, Hamburg, 1997

Bourdon, David, 'Mark Dion at American Fine Arts Co.', *Art in America*, New York, July 1992

Braine, Bob, 'Guyana', *WORD magazine*, http://www.word.com, 1996

Brenson, Michael, *Culture in Action*, Bay Press, Seattle, 1993

Bright, Deborah, 'Paradise Recycled; Art, Ecology and the End of Nature [sic]', *Afterimage*, Rochester, New York, Sept 1990

Cameron, Dan, 'Culture in Action, Eliminate the Middleman', *Flash Art*, Milan, November/December 1993

Cameron, Dan, *Cocido y Crudo*, Museo Nacional Centro de Arte Reina Sofia, Madrid, 1994

Cassiman, Bart, *On taking a normal situation...*, Museum van Hedendaagse Kunst Antwerpen, 1993

Cembalest, Robin, 'Restoration Tragedies', *ArtNews*, New York, May 1989

Ceruti, Mauro, *On taking a normal situation...*, Museum van Hedendaagse Kunst Antwerpen, 1993

Christov-Bakargiev, Carolyn, *On taking a normal situation...*, Museum van Hedendaagse Kunst Antwerpen, 1993

Christov-Bakargiev, Carolyn, *Mark Dion: The Museum of Natural History and Other Fictions*, Ikon Gallery, Birmingham; Kunstverein, Hamburg, 1997

Corrin, Lisa and Gary Sangster, 'Culture is Action: Action in Chicago', *Sculpture*, Washington, D.C., March/April, 1994

Crockett, Tobey, *A Vital Matrix*, Domestic Setting, Los Angeles, 1995

Dargis, Manohla, 'Counter Currents: F for Fake', *The Village Voice*, New York, 31 January 1989

Decter, Joshua, 'New York in Review', *Arts Magazine*, New York, Summer 1990

Decter, Joshua, 'De-Coding The Museum', *Flash Art*, No 155, Milan, November/December 1990

Decter, Joshua, *Art ... not News*, Real Art Ways, Hartford, 1991

Decter, Joshua, 'Mark Dion at American Fine Arts Co.', *Flash Art*, Milan, Summer 1992

Decter, Joshua, 'Mark Dion at Galerie Metropol', *Artforum*, New York, January 1995

Dexter, Emma, *True Stories*, Institute of Contemporary Arts, London 1992

Dion, Mark, 'Tales from the Dark Side', *Real Life Magazine*, No 14, New York, 1988

Dion, Mark, 'Ashley Bickerton: Une conversation avec Mark Dion', *Galeries Magazine*, No 33, Paris, October/November 1989

Dion, Mark, *Biodiversity: An Installation for the Wexner Center*, Wexner Center for Visual Arts, Columbus, Ohio, 1990

Dion, Mark, Interview with Michel von Praet, 'Renovating Nature', *Flash Art*, No 155, Milan, November/December, 1990

Dion, Mark, *Daily Planet – Science of the Planet*, Galerie Christian Nagel, Cologne, 1991

Dion, Mark, 'Concrete Jungle', *Journal of Contemporary Art*, Vol 4, No 1, New York, Spring/Summer 1991

Dion, Mark, 'Concrete Jungle', *Heaven Sent*, No 3, Frankfurt, February 1992

Dion, Mark, *Concrete Jungle*, Wesleyan University, 1993

Dion, Mark, *Flotsam and Jetsam*, Vleeshal Middleburg, 1995

Dion, Mark, 'Füllung des Naturhistorischen Museums', *Texte zur Kunst*, Cologne, November 1995

Ferguson, Bruce, *On taking a normal situation...*, Museum van Hedendaagse Kunst Antwerpen, 1993

Fisher, Jean, *The Fairy Tale: Politics, Desire and Everyday Life*, Artists Space, New York, 1986

Fisher, Jean, *Cocido y Crudo*, Museo Nacional Centro de Arte Reina Sofia, Madrid, 1994

Grässlin, Karola, *Die Wunderkamer*, K-Raum Daxer, 1993

Graw, Isabelle, 'Field Work', *Flash Art*, No 155, Milan, November/December 1990

Gray Anderson, Carolyn, *Die Wunderkamer*, K-Raum Daxer, 1993

Greenberg, Reesa, *On taking a normal situation ...*, Museum van Hedendaagse Kunst Antwerpen, 1993

Heartney, Eleanor, 'Review: Toys Are Us', *Afterimage*, Rochester, New York, March 1987

Heartney, Eleanor, 'The Dematerialization of Public Art', *Sculpture Magazine*, Washington, D.C., March/April 1993

Hofleitner, Johanna, 'Mark Dion', *Flash Art*, Milan, November/December 1994

Huebner, Jeff, 'Chicago Students Green Their Habitat', *E Magazine*, Chicago, January/February, 1994

Jacob, Mary Jane, *Culture in Action*, Bay Press, Seattle, 1993

Jameson, Fredric, *The Fairy Tale: Politics, Desire and Everyday Life*, Artists Space, New York, 1986

Kane, Mitchell, *Mud*, The Hirsch Farm Project, Hillsboro, 1991

Kwon, Miwon; Marcovitz, James; Molesworth, Helen, 'Confessions of an Amateur Naturalist', *Documents*, New York, Fall/Winter

Kwon, Miwon, *Die Wunderkamer*, K-Raum Daxer, 1993

Kwon, Miwon, 'Unnatural Tendencies: Scientific Guises of Mark Dion', *Forum International*, Antwerp, May/August 1993

Kwon, Miwon, *Mark Dion: The Museum of Natural History and Other Fictions*, Ikon Gallery, Birmingham; Kunstverein, Hamburg, 1997

Lawson, Thomas, *Modern Dreams: The Rise and Fall and Rise of Pop*, The Institute for Contemporary Art, New York, and MIT Press, Cambridge, Massachusetts, 1988

Leslie, John, *Mark Dion: The Museum of Natural History and Other Fictions*, Ikon Gallery, Birmingham; Kunstverein, Hamburg, 1997

Leturcq, Armelle, 'Mark Dion', *Blocnotes*, 21, Paris, 1995

Levin, Kim, 'Earthworks', *The Village Voice*, New York, 4 July 1989

Levin, Kim, 'Mark Dion', *The Village Voice*, New York, 30 January 1996

Lewis, James, 'Mark Dion with William Schefferine, American Fine Arts Co.', *Artforum*, New York, September 1990

Matola, Sharon, 'Belize Zoo: Construction/Conservation Update', *On The Edge*, Wildlife Preservation Trust International, Philadelphia, Summer 1990

McAllister, Jackie, *Travelogue/Reisetagebuch*, Institut für Museologie, Hochschule für Angewandte Kunst, Vienna 1993

McAllister, Jackie, *Mark Dion: The Museum of Natural History and Other Fictions*, Ikon Gallery, Birmingham; Kunstverein, Hamburg, 1997

Meyer, James, 'The Macabre Museum', *Frieze*, London, January, 1997

Meyer, James, *What Happened to the Institutional Critique?*, American Fine Arts Co., New York, 1993

Molesworth, Helen, *Die Wunderkamer*, K-Raum Daxer, 1993

Molesworth, Helen, *Mark Dion: The Museum of Natural History and Other Fictions*, Ikon Gallery, Birmingham; Kunstverein, Hamburg, 1997

Morrissey, Simon, *Mark Dion: The Museum of Natural History and Other Fictions*, Ikon Gallery, Birmingham; Kunstverein, Hamburg, 1997

Mosquera, Gerardo, *Cocido y Crudo*, Museo Nacional Centro de Arte Reina Sofia, Madrid, 1994

Nairne, Sandy, *On taking a normal situation...*, Museum van Hedendaagse Kunst Antwerpen, 1993

Olander, William, *Fake*, The New Museum of Contemporary Art, New York, 1987

Olson, Eva M, *Culture in Action*, Bay Press, Seattle, 1993

Ottmann, Klaus, *Concrete Jungle*, Wesleyan University, 1993

Rockman, Alexis, *Concrete Jungle*, Wesleyan University, 1993

Rockman, Alexis, 'Guyana', *WORD magazine*, http://www.word.com, 1996

Rockman, Alexis, *Concrete Jungle*, Juno Books, New York, 1996

Saltz, Jerry, *Cocido y Crudo*, Museo Nacional Centro de Arte Reina Sofia, Madrid, 1994

Schefferine, William, *Biodiversity: An Installation for the Wexner Center*, Wexner Center for Visual Arts, Columbus, Ohio, 1990

Schüttpelz, Erhard, *Mark Dion: The Museum of Natural History and Other Fictions*, Ikon Gallery, Birmingham; Kunstverein, Hamburg, 1997

Simon, Jason, 'Jean Painlevé and Mark Dion', *Parkett*, No 44, Zürich, 1995

Simon, Jason, *Mark Dion: The Museum of Natural History and Other Fictions*, Ikon Gallery, Birmingham; Kunstverein, Hamburg, 1997

Smolik, Noemi, '"Concrete Jungle" at Tanja Grunert Galerie', *Artforum*, New York, Summer 1992

Soly, Hugo, *On taking a normal situation...*, Museum van Hedendaagse Kunst Antwerpen, 1993

Tager, Alexandra, 'Review of Concrete Jungle', *Art and Auction*, New York, December 1994

Theewen, Gerhard, 'Mark Dion, Where are You Now?: The Attempt to Correspond with a Travelling Artist', *Künstlerhaus Bethanien*, Berlin, 1996

Tillman, Lynne, *Fake*, The New Museum of Contemporary Art, New York, 1987

Turner, Grady T, 'Mark Dion at American Fine Arts Co.', *Art in America*, New York, May 1996

Ursprung, Philip, 'Mark Dion: Unseen Fribourg', *Springer*, Vienna, November 1995

Villaespesa, Mar, *Cocido y Crudo*, Museo Nacional Centro de Arte Reina Sofia, Madrid, 1994

Williams, Gilda, 'Mark Dion, London Projects, Ikon Gallery, Birmingham', *Art Monthly*, London, March 1997

Zahm, Olivier, 'Mark Dion at Galerie Sylvana Lorenz', *Flash Art*, No 154, Milan, October 1990

Zimmer, William, 'Conceptual Works Issue Dire Warnings', *The New York Times*, 28 October 1990

Zipes, Jack, *The Fairy Tale: Politics, Desire and Everyday Life*, Artists Space, New York, 1986